# An American Vision

Tom Beck
Phd.
4/20/90

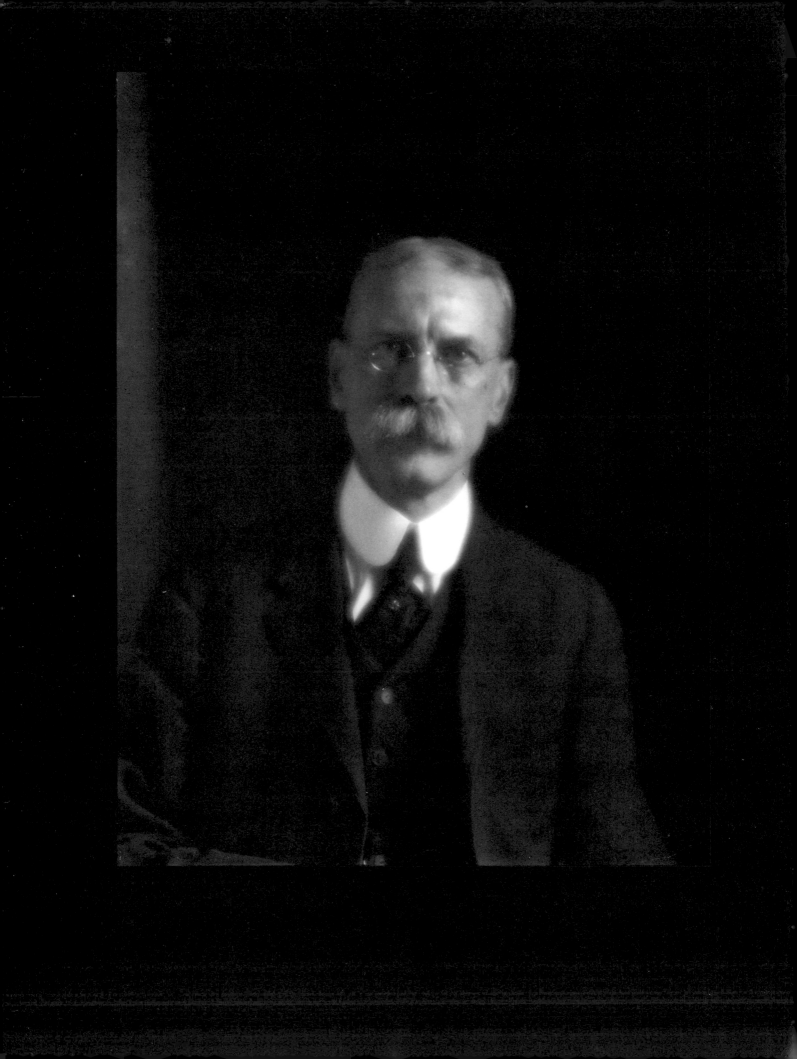

# An American Vision

## John G. Bullock and the Photo-Secession

TOM BECK
*Curator of Photography*

*Foreword by*
WILLIAM INNES HOMER

An exhibition created by the
Albin O. Kuhn Library & Gallery
William Dunlop, Coordinator of Exhibitions

APERTURE
in Association with

UNIVERSITY OF MARYLAND BALTIMORE COUNTY

Albin O. Kuhn Library & Gallery

1989

For Gina

and

For George R. Rinhart
who placed John G. Bullock's
work in public care for
all to discover

This exhibition was organized with the aid of a
grant from the National Endowment for the Arts.

First edition 1989

Aperture Foundation, Inc., publishes a periodical,
books, and portfolios of fine photography to
communicate with serious photographers and creative
people everywhere. A complete catalog is available by
writing the Aperture Foundation, Inc., 20 East 23
Street, New York, New York 10010

ISBN 0-89381-405-9

Printed in United States of America

*Frontispiece:* Plate 1. Self-Portrait, April 1914.

LIBRARY OF CONGRESS CATALOGING-IN-PUBLICATION DATA

Beck, Tom
    An American Vision : John G. Bullock and the Photo-Secession /
Tom Beck : foreword by William Innes Homer.
        p.    cm.
    "An exhibition created by the Albin O. Kuhn Library & Gallery.
    Bibliography: p.
    Includes index.
    1. Bullock, John G., 1854-1939—Exhibitions. 2. Photographers—
United States—Biography—Exhibitions. 3. Photography, Artistic—
Exhibitions. I. Bullock, John, G., 1854-1939. II. Albin O. Kuhn
Library and Gallery. III. Title.
TR140.B85B43 1989
779'.092'4—dc19
                                            88-36516
                                            CIP

# Contents

5

# *Foreword*

The mid-1970's witnessed a great renaissance of interest in photography—especially pictorial work—and it has continued to the present day. A host of books, articles, and museum exhibitions have celebrated the achievements of individual photographers as well as groups or schools practicing the art. Major figures such as Alfred Stieglitz have been explored thoroughly. But in the wake of these studies, scholars have also written about photographers who were not so well known: for example, Alvin Langdon Coburn, Gertrude Käsebier, Clarence White, and Eva Watson-Schütze. Examination of the work of such photographers shows that its quality is often extraordinarily high, at times rivaling or surpassing that of Stieglitz. Moreover, these individuals, who were members of the Photo-Secession, an elite photographic society founded by Stieglitz, worked diligently to further its aims and the larger goals of pictorialism in general.

John G. Bullock, a Philadelphia pictorialist who also belonged to the Photo-Secession, has never received the attention he deserves. Now, however, that situation has been rectified, thanks to Tom Beck's diligent efforts to shed new light on the man and his work. The exhibition and this catalogue present Bullock as a living entity, surveying his creative accomplishments from the beginning of his photographic career to its end. Beck has done a great deal of research into Bullock's intellectual and artistic milieu, unearthed essential information about his biography, and obtained a large collection of his negatives that epitomize his life's work. Moreover, for this exhibition, he has assembled an impressive group of vintage photographs by Bullock, many of them never seen before.

It is a pleasure to see the life and work of Bullock presented to the public in this way. He had a marvelous photographic vision and the technical skill to realize his dreams in tangible form. Starting in the naturalistic tradition favored by the Philadelphia pictorial photographers of the 1880's, he became a master of composition, forming his images with taste and irradiating them with crisp, clear sunlight.

Gradually he moved toward softer focus, with unclear forms, infusing his prints with subtle light and atmosphere. In this, he had fallen under the influence of the more painterly photographers of New York. But he never abandoned "straight" photography, preferring the optical verisimilitude associated with that branch of the pictorial movement.

Besides producing his own photographs, Bullock worked tirelessly on behalf of the pictorial movement. Based in Philadelphia and much involved with the Photographic Society of that city, he also maintained close ties with Stieglitz and his colleagues in New York. In both cities, in the 1890's, there was a drive toward excellence in pictorial photography, and individuals from both circles helped and supported their distant counterparts, individually and collectively. Stieglitz, for example, turned to the Photographic Society of Philadelphia as the medium for the first American photographic salon that truly embraced his ideals. In this effort, Bullock played a leading role; but Stieglitz, in turn, brought Bullock and several of his talented Philadelphia colleagues into the Photo-Secession when he founded it in New York in 1902.

Thus Bullock was, for a time, at the very center of photographic activity and innovation, playing both a creative and organizational role. The photographs he produced in the heyday of the pictorial movement reveal him as a skilled and sensitive photographer, ranking with the best in Philadelphia and often rivaling his Secessionist colleagues in New York.

After the decline of the Photo-Secession, around 1910, Bullock continued to photograph, but his work now seemed less affiliated with the artistic goals of the Secession. Instead, he became more personal, more private in his imagery, concentrating on family and home. But unlike so many pictorialists who flourished in the years 1895-1910 and then dropped out, he remained faithful to the promise of the medium, producing prints of value as much to himself as to others.

WILLIAM INNES HOMER
*H. Rodney Sharp Professor of Art History*
*University of Delaware*

# Preface

More than a century has passed since John G. Bullock began photography, yet his images have endured to be appreciated today for their originality, simplicity, atmosphere, and technical mastery. Moreover, they place us in touch with a quintessential American vision in art.

American subject-matter dominated Bullock's photography. Light, artifice, and symbolic meaning were important, too, but tended to be secondary to what was in front of the camera. When Bullock photographed a person or place, the image was intimately about that subject. Unlike most other Photo-Secessionists, whose images were more overtly symbolic and revealed little about the people and places depicted, Bullock often told a story about his subjects. He knew and understood rural subjects best despite his own lifelong urban and suburban residence. Perhaps because his family roots were in country life and farming, photographing rural America made him feel closer to something pure and elemental. His perceptions are presented to us through his carefully crafted images.

Craftsmanship came naturally to Bullock. As a child, he had printed and published his own newspaper. As an adult, his dexterity contributed greatly to his ability as a photographer. In addition, the sophisticated knowledge of chemistry he acquired through training to be a pharmacist prepared him well for photographic endeavors.

Bullock's earliest photographs were made with a small view camera using 4 x 5 inch Carbutt dry plates. The lenses he employed were designed for rapid exposures and reduced distortion, and included a Ross Rapid Rectilinear lens and a Grubb landscape lens. By 1886, he had a larger format camera which took 6½ x 8½ inch dry plates. Additional lenses with coverage for the larger plates were acquired during the next several years, including Dallmeyer (11 inch), Ross (22 inch), Wray (14 inch), and Cook (6 inch) lenses. He continued to use the smaller format, but most of his images were made with the larger camera. In 1911, he began using a roll film camera which made 3½ x 5¾ inch negatives.

Slightly later, he acquired another roll film camera which made 3¼ x 4⅛ inch negatives. The manageability of these small cameras relegated the larger ones to disuse. Needless to say, images made on roll film were less formal and even more intimate.

The earliest prints Bullock made were on albumen paper, the kind preferred by most photographers in the 1880's. He soon changed to platinum paper which gave a richer image. Thereafter, his exhibition prints were almost always noted as having been platinotypes. The brands of platinum paper Bullock was known to have used were manufactured by Willis & Clements and by Buchanan Bromley & Company. Platinum printing permitted great flexibility in the manipulation of the image, but Bullock only rarely made much alteration. On those occasions, he printed clouds into otherwise blank skies or changed the tonality of a localized area by using glycerine in the developing process. Most often when he altered the image, the changes were made by retouching the negative. Prints carefully made today from Bullock's negatives therefore reflect to a great degree his intentions.

The new prints from Bullock's negatives made to illustrate this catalogue and exhibition were produced by Alan Scherr, a photographer and master craftsman whose sensitivities to art, history, and Bullock's imagery are superlative. In making the new prints it was not intended that known original prints be imitated; especially since original prints by Bullock of most images are not known to exist. The purpose was rather to provide a representative selection from which Bullock's work might be studied further. Such tremendous care has been invested in making each new print that Bullock's abilities as a photographer come through virtually unchanged.

This project was made possible as a result of the magnanimous donation by George R. Rinhart of Bullock's negatives to the Photography Collections, Albin O. Kuhn Library & Gallery, University of Maryland Baltimore County. Mr. Rinhart's interest in preserving the negatives and promoting public notice of the imagery is a great contribution to photography.

Many people have contributed to the success of this project. Bullock family members were very hospitable and generous with advice and family history material. Richard H.D. Bullock and Sandra Leaf Bullock contributed greatly by sharing papers, memorabilia, diaries, family history, and genealogy. Elizabeth Guy Bullock shared documents, memorabilia, family history, and photographs. Watson and Jane Bullock shared reminiscences and photographs, and helped to identify images.

Enthusiastic and faithful support came from William Earle Williams of Haverford College. In addition, his suggestions of leads to follow and people to contact were a great help. Upon his recommendation, people were always willing to give their assistance. His advice on the manuscript was very helpful.

William Homer of the University of Delaware was also very helpful in providing leads and research advice. Everyone responded favorably knowing that he supported this project. His suggestions on the manuscript were exceedingly valuable especially because of his insight into the Photo-Secession.

Naomi Rosenblum of the Parsons School of Design gave excellent advice on the manuscript. Her broad and deep knowledge of history brought additional perspective to Bullock's life and work.

At each of the institutions where research was performed, gracious individuals generously gave their help. We are particularly grateful to: Diana Alten and Eva Walker Myer, Quaker Collection, Magill Library, Haverford College; Floss Genser, Arboretum Society, Haverford College; Kenneth Finkel and Susan Oyama, The Library Company of Philadelphia; Cheryl A. Leibold, Pennsylvania Academy of the Fine Arts; Gladys Brewer, Franklin Institute; Wesley L. Sollenberger, Historical Society of Chester County; Lizbeth Holloway and James Duffin, Germantown Historical Society; Marjorie Smink, Philadelphia College of Pharmacy and Science; Christa Sammons, Beineke Rare Book and Manuscript Library, Yale University; Rachel Stulhman, International Museum of Photography at George Eastman House; Maria Pellerano, Art Museum, Princeton University; Bernard Riley, Mary Ison, Leroy Bellamy, and Jerry Kerns, Prints and Photographs Division, Library of Congress; Martha Charoudi, Philadelphia Museum of Art; Grace Mayer, Edward Steichen Archive, Museum of Modern Art; and David King, Print and Picture Department, Philadelphia Free Library. Peter Bunnell of Princeton University especially helped to place Bullock's work in perspective.

Many of the staff in the Kuhn Library & Gallery provided support and assistance. We especially thank Emiko Ortega, Exhibitions Assistant; John Beck, Special Collections Assistant; Dick Vaughan, Assistant Technical Services Librarian; Linda Mayr, Bernadette Garner, Anna Keys, and Kathy Monteil, Accounting & Receiving Department; Joyce Tenney, Serials Librarian; Vicki Yanuario and Laura Weathers, Serials Department; Ruth Caldwell, Ruby Rustic, and Faye Thompson of the Director's Office; Larry Wilt, Associate Director, Collections and Access Services; Judith Sterling, Associate Director, Technical Services and Automated Systems; Timothy Pyatt, Special Collections Librarian; and the entire Reference Department staff, including Simmona Simmons, Carol Brueggemeier, Sarah Crest, Howard Curnoles, Diane Fishman, and Helen Williams. In addition, we wish to thank Clolita Williams, Shari Greene, and John Blecheisen, UMBC Procurement Department; Earl Kelly, Associate Director, Sponsored Programs; Joe School, UMBC Cartographic Lab; and Suzan Reed, Graphics Consultant. Research assistance was furnished by Anne Peterson and Janet Murray.

Billy Wilkinson, Director, Kuhn Library & Gallery, has our deepest appreciation for his strong support and commitment to this project and the Gallery programs. His assistance and guidance proved invaluable during the planning and execution of this project.

Editorial advice was provided by Jonathan LeBreton, Assistant Director, Kuhn Library & Gallery. His astuteness was extraordinary, not only in reading the manuscript, but also in enabling grant support to be obtained and administered.

Support from the Friends of the Albin O. Kuhn Library & Gallery is gratefully acknowledged.

We wish to thank Gerard A. Valerio for the elegance of the design of this volume.

TOM BECK
*Curator of Photography*

WILLIAM DUNLOP
*Coordinator of Exhibitions*

# *Illustrations*

FIGURES

Brackets [ ] indicate information supplied for clarity.

Figure 23. "The Embankment, London" by Alvin Langdon Coburn, 1906, gravure from *The Door in the Wall* by H.G. Wells (New York: Mitchell Kennerley, 1911).

Figure 24. "The Little Round Mirror" by Edward Steichen, gravure from *Camera Work* No. XVI, April 1906, Photography Collections, Albin O. Kuhn Library & Gallery.

Figure 25. "Hortensia" by Frank Eugene, gravure from *Camera Work* No. XXXI, July 1910, Photography Collections, Albin O. Kuhn Library & Gallery.

Figure 26. "East & West" by J. Craig Annan, gravure from *Camera Work* No. XXXII, October 1910, Photography Collections, Albin O. Kuhn Library & Gallery.

Figure 27. "Ninth Movement" by Gordon Craig, gravure from *Camera Work* No. XXXII, October 1910, Photography Collections, Albin O. Kuhn Library & Gallery.

Figure 28. "Photogravure of a Drawing" by Henri Matisse, gravure from *Camera Work* No. XXXII, October 1910, Photography Collections, Albin O. Kuhn Library & Gallery.

Figure 29. "Chew House" by John G. Bullock, 1913, Photography Collections, Albin O. Kuhn Library & Gallery.

Figure 30. "Benj. West's Birthplace, Swarthmore, Pa.," by John G. Bullock, 1884, Photography Collections, Albin O. Kuhn Library & Gallery.

# PLATES

Brackets [] indicate information supplied for clarity. Accession numbers follow each entry.

1. Self-Portrait, April 1914.
84.01.227
2. Storm, Cape Ann, August 1883.
84.01.001
3. Rages Ravine No. 1, June 1885.
84.01.41
4. Girl on Fence, Rockland, [Maine], July 16, 1885.
84.01.004
5. Beech Trees Near Pebble Beach, Mt. Kineo, [Maine], August 1885.
84.01.010
6. Camp Minerva, August 1885.
84.01.007a
7. Rock at Pebble Beach, [Mt.] Kineo, August 1885.
84.01.007
8. Old Swedes Church, Wilmington, [Delaware], December 17, 1885.
84.01.012
9. Mr. Jones' Family No. 2, July 26, 1886.
84.01.013
10. Water Cart No. 1, Near Pulaski, July 27, 1886.
84.01.014a
11. Her Wedding Journey, June 1888.
84.01.236
12. Re [Rebie] on Bridge Near So. Edgemont [sic], Massachusetts, June 1888.
84.01.034
13. Weaver's House, June 1888.
84.01.040a
14. To Keep the Memory of Orville Dewey 1794-1882, June 1888.
86.01.037

15. Falls, June 1888.
86.01.039
16. Road Through Woods, June 1888.
84.01.042
17. Big Elm, Sheffield, Massachusetts, June 1888.
84.01.026
18. Among the Berkshire, Road with Elm Tree Near Salisbury, Connecticut, June 1888.
84.01.024
19. J.G.B., Marjorie, Rebie, June 6, 1889.
84.01.045
20. Circus on the Beach, Sea Girt, July 1889.
84.01.043
21. Eastward As Far As the Eye Can See, August 1890.
84.01.047
22. Me Pussy Shrug Shoulders, May 1891.
84.01.057
23. [Tea Party, Marjorie Bullock and Friend], circa 1891.
84.01.432
24. Raymondskill Lower Fall with Bridal Veil, Pike County, [Pennsylvania], May 10-16, 1893.
84.01.068
25. Boy on Fence with Kettle #2, Pike County, May 10-16, 1893.
86.01.1673
26. J.G.B. in Road, Above Bushkill, Pike County, May 10-16, 1893.
84.01.064
27. Harrowing, Pike County, May 10-16, 1893.
84.01.066

75. The Coke Burner, June 1900.
84.01.252

76. The White Wall, Old Fort Mackinac Island, Michigan, July 1900.
84.01.189

77. Lake Craft, July 1900.
84.01.190

78. An Impression, Willow Tree Near Lincoln Drive, [Philadelphia], May 1901.
84.01.193

79. Marjorie with a Book, circa 1902.
86.01.1678

80. [John (?) with Companion at a Religious Retreat], circa 1902.
84.01.421

81. [Marjorie], circa 1902.
86.01.1669

82. House [Bullock's residence at 6439 Greene Street, Germantown], July 4, 1902.
84.01.196

83. [Marjorie in Garden], circa 1903.
84.01.306

84. Willows on Lincoln Drive, July 26, 1903.
84.01.209

85. Path to the Willows, Lincoln Drive, July 27, 1903.
84.01.210

86. Stubble Field, Water Gap, [Pennsylvania], July 1904.
84.01.212

87. [Boy Sitting on a Split-rail Fence], July 1904.
84.01.465

88. [Boys Fishing], circa 1904.
84.01.276

89. Richard H.D. Bullock, 1905.
84.01.356

90. Young Woman, circa 1905.
84.01.441

91. [J.G.B. and Richard], circa 1906.
84.01.359

92. Dr. William R. Bullock, September 1907.
84.01.219

93. [Marjorie], circa 1907.
84.01.454

94. [Marjorie with Cape], circa 1907.
84.01.453

95. [Marjorie in Hooded Cape], circa 1907.
84.01.452

96. J. Francke Rumsey, December 17, 1907.
84.01.218a

97. [Marjorie in Large Hat], circa 1908.
84.01.345

98. Richard in Long Overcoat, December 1909.
84.01.221

99. [Marjorie], circa 1909.
84.01.486

100. Frances [Marjorie's daughter] with Sunbonnet, September 1911.
86.01.245

101. R.H.D. Bullock, December 1911.
84.01.308

102. to 108.
Natives of Pocono, circa 1911.
86.01.202, 204, 205, 206, 224, 232, 309

109. Frances, February 1912.
86.03.447

110. Marjorie & Children, circa 1912.
86.03.367

111. [Rebie Bullock], circa 1916.
84.01.316

112. [Francke], circa 1916.
84.01.383

113. Richard H.D. Bullock, Age 15, December 1916.
84.01.368

114. [Path Through Woods], n.d.
84.01.394

115. [Ferns and Trees], n.d.
84.01.469

116. [Ferns and Birches], n.d.
84.01.418

117. [Cutting Wheat], n.d.
84.01.351

118. [Boy on Path], n.d.
84.01.417

119. [Brook], n.d.
84.01.457

120. [Field and Hills], n.d.
84.01.377

121. [Portrait of an Elderly Man], n.d.
84.01.424

122. [Elderly Man with Microscope and Flower], n.d.
84.01.396

123. Pocono Pines, circa 1922.
84.01.608

124. Car Wash, [Antoinette Bullock, Pocono Pines], 1935.
86.03.582

# An American Vision

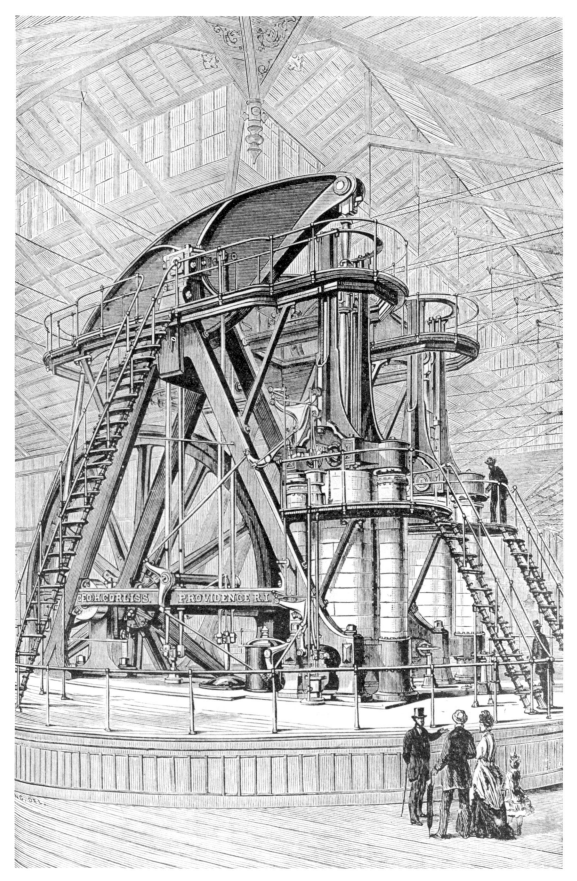

Figure 1. Corliss Engine, engraving from *The Centennial Exposition Described and Illustrated* by J.S. Ingram (Philadelphia: Hubbard Bros., 1876).

# The Circumstance of
# the Gilded Age

John G. Bullock, a future member of the Photo-Secession, wrote in 1875 that his contemporaries were "seeking but to add to their already great possessions, vainly grasping at the gilded bauble."[1] His judgment was consistent not only with his Quaker education, but also with other writers who labelled the last part of the nineteenth century and the beginning of the twentieth century the "Gilded Age." During this time, the population of the United States grew tremendously; nationalism intensified; vast fortunes were created; and a vision of a great civilization for America was born. The spirit of the European Renaissance is thought to have been recaptured in a distinctively American fashion.[2]

Material evidence that great changes were occurring could be found at the Centennial Exhibition at Philadelphia in 1876. The vigor of industrialization could be seen in the displays of heavy equipment, steam and electric power, and the American improvements in boilers, refrigeration, machine tools, railroading, and printing. The central focus of the Centennial, and indeed a national motif, was the Corliss stationary steam engine (fig. 1) which powered all the displays in Machinery Hall. So graceful was the Corliss behemoth that for some it possessed aesthetic qualities. Frederic Bertholdi, the sculptor who created another great symbol of the era, the Statue of Liberty, proclaimed: "The lines are so grand and beautiful, the play of movement so skillfully arranged, and the whole machine was so harmoniously constructed that it had the beauty and almost the grace of the human form."[3] In fact, it was typically observed that such diverse displays as machinery, horticulture, and utilitarian objects could be appreciated aesthetically. One visitor was twenty-two year-old George Eastman, who wrote to his mother:

*I intend to traverse every aisle, I have accomplished this in machinery hall & have got about half through the Main Building....The ingenuity that exhibitors have displayed in arranging such things as tacks candles soap hardware needles thread pipe & all such apparently interesting articles is something marvelous—and they command the attention of the observer even against his will.[4]*

Others who would have examined the displays with a fraction of Eastman's effort would have come away with a great new knowledge of an extraordinarily varied number of subjects.[5]

Yet doubts about the beauty and substance of what America might exhibit at the Centennial had delayed official Government endorsement for five years.[6] General Joseph R. Hawley, president of the Centennial Commission, explained: "When the Centennial Exhibition was projected, many Congressmen declared that we had nothing to show foreign nations. They were probably thinking of Raphaels or Praxiteles. Perhaps we had not such as these, but we had a nation to show."[7] America did not have an artistic heritage comparable to Raphael or Praxiteles; nonetheless, American art made a strong impression at the Centennial. Americans as well as Europeans discovered that the United States had an aesthetic history and tradition. A survey of American painting was included among the 3,256 paintings in the Centennial.[8] In the published reports on "Plastic and Graphic Art," John F. Weir, a painter, said: "No department of the International Exhibition attracted more general attention than that of the Fine Arts."[9] Weir further stated:

*The character of our art in general is decidedly varied, it is true, but it is quite possible to discriminate between that which is distinctly American and bears the unmistakable stamp of originality, and that which is either the work of artists of foreign birth residing in this country or of Americans residing abroad and adopting the manners of foreign schools. The distinction is clear enough, and one that is easily recognized.[10]*

Weir felt that American landscape painting was unsurpassed "by the contemporary art of any peo-

ple."[11] In an attempt to balance his obvious nationalism, Weir rated American genre painting less highly, but still described it as "original" (probably meaning that it was different from European schools). Tribute was also paid to the "older portrait-painters" whose work was exhibited at Philadelphia, and who served to "link the present with the past century." Work by Gilbert Stuart, Thomas Moran, Frederic Church, Eastman Johnson, John La Farge, and William Merritt Chase was seen at the Centennial.

Photography played a prominent role at the Centennial. Not only was every part of the exhibition recorded in photographs, but for the first time, there was a building constructed for the purpose of displaying photographs and photographic equipment. The Centennial photographic exhibitions, whether those in Photography Hall or those illustrating the innumerable other displays, were a reasonably good survey of the scientific, artistic, and commercial photography from the previous ten years. A visitor who would have carefully examined the photographs found throughout the Centennial would have gained a substantial knowledge of the range of techniques and styles of imagery being done at that time. Although Weir did not comment on the photographic displays, it was significant that photography was included in the category of "Plastic and Graphic Arts" along with painting, sculpture, etching, lithography, wood carving, stained glass, and medallions. Among the twenty-one judges of the prints in photographic competition was Dr. Hermann Vogel, the noted German photographer, photo-chemist, and subsequent teacher of Alfred Stieglitz.[12] Vogel was also founder of *Photographische Mittheilungen*, an early German photographic journal. The majority of the photographs submitted were judged by Vogel.[13]

The Centennial was unusual among international exhibitions in the nineteenth century. Unlike previous such exhibitions in London, Vienna, and Paris, the Centennial did not award first, second, and third prizes to entries in the competitions. Rather, at Philadelphia, judges awarded only a single bronze medal to commended entries with a citation stating the specific instance of the award. In photography, for example, Julia Margaret Cameron, the well-known English amateur was "commended for good taste and artistic composition of photographs."[14] Similarly, Carleton Watkins, the eminent American professional, was "commended for artistic excellence in landscape photographs."[15] Among many other photographers whose work was commended were Napoleon Sarony, William Kurtz, Frederick Gutekunst, and Henry Peach Robinson.[16]

One notable display in the "Chemicals, Pharmaceutical Preparations" class of the "Manufactures" department of the Centennial was by the firm of Bullock and Crenshaw, Philadelphia. The exhibit included "sugar coated pills; United States Pharmacopoeia and recipes of eminent physicians, accurately compounded, readily soluble, and strictly reliable in every particular."[17] An employee of Bullock and Crenshaw was John G. Bullock, then a twenty-one year-old student at the Philadelphia College of Pharmacy.[18] Bullock was a nephew to Charles Bullock who was in partnership with Edmund Crenshaw. The firm was entered in the competition, but initially did not receive an award. Upon appeal, the firm was "commended for superior workmanship, quality, and fitness for the purpose intended" for their sugar coated pills.[19]

The Centennial was a great national event which also marked the reemergence of Philadelphia on the national scene. Not since the events of the Revolutionary War era had so much attention been focused on the Quaker City.[20] Although the Centennial did not officially open until May 10th, the celebration actually began on New Year's Eve, December 31, 1875. Among the crowd of people packed together in the street was John G. Bullock, who had been anticipating the Centennial since at least 1872 when he made the first entry about the plans for the celebration in his diary.[21] The "river of human beings" which poured down Chestnut Street moving toward Independence Hall was a sight that Bullock usually saw only once a year. "You would think it was the fourth of July," he observed.[22] The New Year's crowds were impressive enough to him, but the throngs on the opening day of the Centennial were "beyond anything ever experienced before."[23]

Like nearly everyone else, Bullock was absolutely fascinated by the Centennial, and he returned day after day to systematically examine every display. He, too, was caught up in the nationalistic euphoria, but unlike most, he was not given to hyperbole about the event. His diary entries tended to be direct descriptions of what he saw. Like George Eastman, Bullock noted the attractiveness of the displays; even the unfinished ones were "already elegant." After

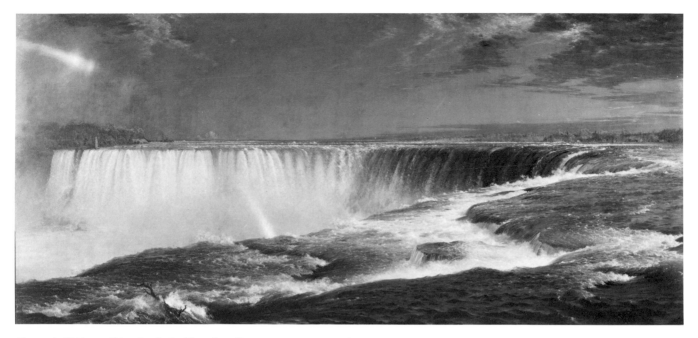

Figure 2. "Niagara" by Frederic Church, oil on canvas, 1857, in the Collection of The Corcoran Gallery of Art, Museum Purchase, Gallery Fund, 1876.

the Corliss engine, the paintings and photographs caught his attention, and he made special comment about visiting these displays:

> The Photographic Building next entices us, and we are duly rewarded. America far excels her foreign friends in portraits of every style, but England has most certainly some beautiful pictures of scenery. If our foreign brethren do not believe that America has the prettiest girls in the world, it is not the fault of the photographers of every quarter. The Main Art Gallery we did up pretty thoroughly. Many, many paintings of beauty and worth hang upon the walls, although there is much that is mediocre.[24]

Six years before he began photography, Bullock had already developed a keen eye for imagery in all media. For this reason, his comments upon visiting the Art Gallery at the Centennial carry more than casual significance.

Bullock was well aware that works of art could be analyzed and shown to have interrelationships. Just the year before, in 1875, he had demonstrated his understanding of art in an article he had written for a Haverford College publication:

> A work of art is not an isolated whole, but in viewing the productions of any one artist, we are struck with an almost family resemblance, some peculiarities of coloring or effects of light and shade observable in all, plainly declaring them to be the creations of one and the same mind. Critics can tell at a glance to which of the masters a certain work belongs. Nay, some even go so far as to predict the period of life at which it was executed. Still further, in the productions of a whole period or age can we trace a certain likeness, the causes of which must be sought for in the intellectual and social condition of the community in which they were produced.[25]

Although he did not record in his diary his specific analysis of the Centennial displays of paintings and photographs, his Haverford essay is quite revealing. Had Bullock commented on the exhibition, he might have reflected upon the contrast between traditional American paintings and the new imagery, work which later would become strongly identified with the Gilded Age. Traditional American painting (Hudson River School and Luminism) tended toward realism and indigenous subject-matter. Realism was the typical approach among older artists such as Frederic Church and Thomas Moran who were noted for their meticulously detailed landscape paintings. Church was famous for his accurate renderings of landscape panoramas and luminous natural skies. His painting "Niagara" (fig. 2) created an instant sensation when it was displayed in 1857 at a New York commercial gallery which required an admission charge just to view the great work. The young John G. Bullock noted in his diary that he had seen "Niagara,"[26] and later saw the equally lumi-

19

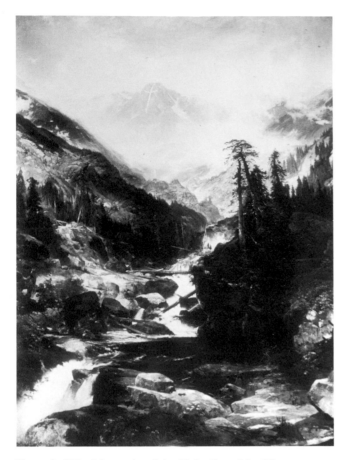

Figure 3. "The Mountain of the Holy Cross" by Thomas Moran, oil on canvas, 1875, Gene Autry Western Heritage Museum.

nous and precise painting "Chimborazo" by Church at the Centennial. Thomas Moran also was well recognized for his highly realistic paintings, so precise that they have been compared to photographs,[27] a quality likely to have been noticed by Bullock when, at the Centennial, he saw the painting "The Mountain of the Holy Cross" (fig. 3).

Church and Moran both had traveled and worked abroad, yet they were still viewed as quintessential American artists whose subject-matter was indigenous. Traditionally, American artists did not stray far from what they knew and understood. True to John F. Weir's observations about American artists being strongly identifiable, Church and Moran were genuinely American in their depictions of the landscape. Others, such as Eastman Johnson, also shared that distinctive identity. Even though he was trained in Europe, Johnson drew upon his rural American background to create genre paintings of country scenes. His indigenous tableaux were full of light

and people, and were naively optimistic. "Old Stage Coach" (fig. 4) by Johnson was characteristically nostalgic for farm life, a sentiment that would have appealed to John G. Bullock when he saw this painting at the Centennial, because he enjoyed country life and visits to farms.

Interestingly, the paintings that John La Farge and William Merritt Chase showed at the Centennial may also have appealed to Bullock. La Farge, in contrast to the boldness of Church and Moran, made delicate and more intimate paintings which moved viewers to contemplation rather than awe. "Bishop Berkeley's Rock, Newport" (fig. 5) by La Farge conveys some of the meditative quality that must have lured the philosopher to the Paradise Rocks of Rhode Island. William Merritt Chase's paintings also possessed a quiet beauty, but in a different mood. Chase's work was somber and strongly showed the influence of his training in Munich where dark tonality was the prevailing style. Even though "Keying Up—The Court Jester" (fig. 6), which he exhibited at the Centennial, may not be the best example of his work, it does show a tendency toward a more painterly style.

Paintings by Chase and La Farge displayed at the Centennial exemplified the progressive aesthetic direction then becoming evident in American painting. While it is not known exactly what Bullock derived from having seen paintings by these artists, it is worth observing that he was exposed to their work.

Bullock was also exposed to English landscape photographs at the Centennial and was moved to make particular note of them. Pre-eminent among the English exhibitors was Henry Peach Robinson, the photographer famous for his picturesque landscapes and combination prints.[28] Robinson's photographs and ideas were widely known in the United States through articles by and about him which had been appearing for more than a decade in *Humphrey's Journal of Photography* and *Philadelphia Photographer*.[29] His book, *Pictorial Effect in Photography*, published in 1869 (first American edition 1881), presented a unified theory of art in photography. The editor of *Philadelphia Photographer* once reflected about Robinson: "Doubtless there are hundreds of photographers in our country who have received their first inspiration in this direction [art photography] from Mr. Robinson's clear instructive writing."[30] Robinson had a profound understanding of

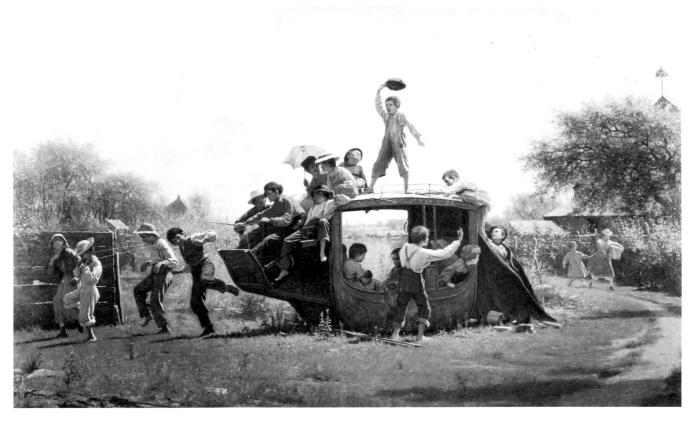

Figure 4. "The Old Stage Coach" by Eastman Johnson, oil on canvas, 1871, Milwaukee Art Museum, Layton Art Collection, Gift of Frederick Layton.

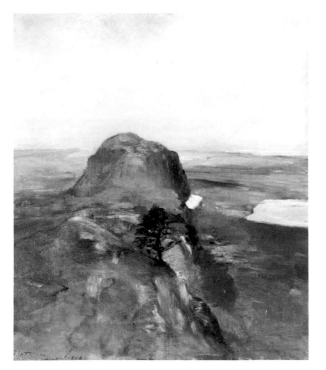

Figure 5. "Bishop Berkeley's Rock, Newport" by John La Farge, oil on canvas, 1868, Metropolitan Museum of Art, Gift of Frank Jewett Mather, Jr., 1949. (49.76)

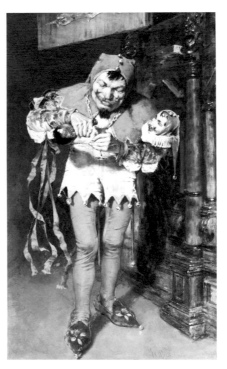

Figure 6. "Keying Up—The Court Jester" by William Merritt Chase, oil on canvas, 1875, The Pennsylvania Academy of the Fine Arts, Philadelphia, Gift of The Chapellier Galleries.

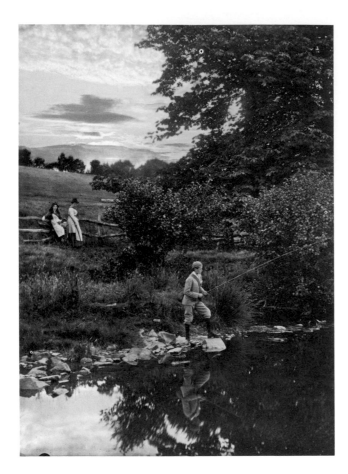

Figure 7. "At Sunset Leaps the Lusty Trout" by Henry Peach Robinson, platinum print, 1860, Gernsheim Collection, Harry Ransom Humanities Research Center, University of Texas at Austin.

the application of art principles to photography, and maintained: "The same laws which govern painters govern photographers."[31] For example, he believed that figures in a landscape photograph ought to be positioned similar to their placement in a painting. The figures should be "so right where they are placed, that we should have no supposition that it would be possible to place them anywhere else."[32] Robinson incorporated into his thinking and recommended to his readers art principles dating from the Renaissance and forward to his own time. His photographs were strongly reminiscent of paintings by artists he admired, such as Sir David Wilkie, the academician, who tightly composed his figures in bucolic settings.[33] Many photographers attempted to copy Robinson's style of integrating figures into a scene, but few succeeded in matching his allegorical intentions. The artistic qualities of Robinson's photography (fig. 7) undoubtedly appealed to John G.

Bullock, whose taste in imagery favored the pictorial. Bullock naturally would have been more impressed with English landscape photographs than with American landscape photographs.

The American landscape photographs in the Photography Building included those by Carleton Watkins (fig. 8), Thomas Houseworth, and Bradley & Rolufson.[34] Their photographs might best be described as scientific realism because of the analytical nature of the imagery and the great distance between the photographer and the subject. The images, which depict grand vistas of beautiful and rugged landscape shaped by geological upheaval, had much in common with photographs made for government-sponsored geological and topographical surveys of the West. Timothy O'Sullivan, William Bell, and William Henry Jackson (fig. 9) were among the survey photographers whose work was displayed in the United States Government Building at the Centennial. Their images were made primarily to fill the needs of scientific observation and tended to be richly designed, but devoid of the picto-

Figure 8. "Falls" by Carleton Watkins, albumen print, 1866, Photography Collections, Albin O. Kuhn Library & Gallery.

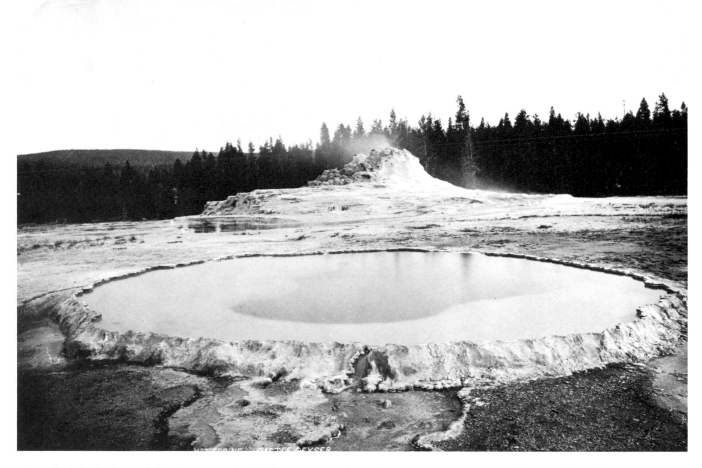

Figure 9. "Hot Spring and Castle Geyser" by William Henry Jackson, albumen print, circa 1871, Photography Collections, Albin O. Kuhn Library & Gallery.

rial sentiment that would have appealed to Bullock. Although the American landscape photographers made very beautiful images, none aspired to allegory like Robinson.

A keen observer at the Centennial, such as Bullock, might have noticed a transition in the aesthetics of American art. Painters like La Farge and Chase were rebelling against precise rendering in favor of more painterly and, especially in La Farge's case,

more overtly symbolic images. Photographers, on the other hand, still reveled in exact representation. During the Gilded Age, amateur photographers infused new energy into the medium and contributed to the development of an artistic vision similar to that manifested by American painters. Among those who would witness this transformation was Bullock, a person of refined taste soon to make his mark in photography.

[1] *The Haverfordian*, 1875, p.13. This article was unsigned, but on Bullock's personal copy his initials were handwritten at the end of the article.

[2] Several essays describe the era especially well, including Howard Mumford Jones, "The Renaissance and American Origins," *Ideas In America* (Cambridge, Massachusetts: Harvard University Press, 1945), pp. 140-151; and Richard Guy Wilson, Dianne H. Pilgrim, and Richard N. Murray, *The American Renaissance 1876-1917* (New York: The Brooklyn Museum, 1979).

[3] Robert M. Vogel, "Steam Power," *1876 A Centennial Exhibition*, ed. Robert C. Post (Washington, D.C.: The National Museum of History and Technology, 1976), p. 31.

[4] John Maass, preface, "The Centennial Success Story," *1876 A Centennial Exhibition*, ed. Robert C. Post (Washington, D.C.: The National Museum of History and Technology, 1976), p. 15.

[5] Even a casual visit today to the Arts and Industries Building of the Smithsonian Institution, where selected

Centennial displays have been reconstructed, cannot fail to provide one with a new knowledge and feel for the era.

[6] Maass, p.11.

[7] Maass, p. 22.

[8] Maass, p. 15.

[9] John F. Weir, "Group XXVII. Plastic and Graphic Art," *International Exhibition, 1876. Reports and Awards*, ed. Francis A. Walker, 8 vols. (Washington: Government Printing Office, 1880) vol. VII, p. 608.

[10] Weir, pp. 628-629.

[11] Weir, p. 629.

[12] Vogel's experiments in 1873 were aimed at equalizing the response of wet plate emulsions to different colors. His work was a step forward in the development of black and white panchromatic emulsions. Alfred Stieglitz studied with Vogel at the Polytechnicum in Berlin from 1883 to 1885. Stieglitz assisted in some of Vogel's experiments on the color sensitivity of emulsions. Vogel frequently wrote for American photographic journals such as the *Philadelphia Photographer*.

[13] Weir, p. 715. Exhibitors not receiving awards appealed for a second judging. Appeals in photography were judged by Coleman Sellers, a Philadelphia writer and member of the Photographic Society of Philadelphia (see Weir, p. 724).

[14] Weir, p. 685.

[15] Weir, p. 683.

[16] Sarony, Kurtz, and Gutekunst were pre-eminent American portrait photographers. Henry Peach Robinson was a famous English professional known for his art photographs.

[17] *International Exhibition. 1876 Official Catalogue.* (Philadelphia: John R. Nagle and Company, 1876), p. 102.

[18] A Committee of the Alumni Association, *Biographical Catalog of the Matriculates of Haverford College* (Philadelphia: The Alumni Association, 1922), p. 498.

[19] J.W. Mallet, "General Report of the Judges of Group III," *International Exhibition, 1876. Reports and Awards Groups III-VII*, ed. Francis A. Walker (Washington: Government Printing Office, 1880) vol. IV, p. 279.

[20] Nathaniel Burt and Wallace E. Davies, "The Iron Age, 1876-1905," *Philadelphia: A 300-Year History*, ed. Russell F. Weigley (New York: W.W. Norton & Company, 1982), p. 471.

[21] John G. Bullock, Diary, March 8, 1872. Bullock kept a diary from 1867 to 1882. I am most grateful to Richard H.D. Bullock, Jr., the grandson of John G. Bullock, for making the diary available.

[22] Bullock, January 1, 1876.

[23] Bullock, May 10, 1876.

[24] Bullock, June 15, 1876.

[25] *The Haverfordian*, 1875, p.13.

[26] Bullock, April 7, 1869.

[27] John Wilmerding, *American Art* (New York: Penguin Books, 1976), p. 128.

[28] Robinson (1830-1901) made combination prints of several negatives printed on a single piece of photographic paper. The resulting image was more "artistic" in his view.

[29] *Humphrey's Journal of Photography and the Allied Arts and Sciences* was published under various names from 1850 to 1870. The *Philadelphia Photographer* was published under that name from 1864 to 1888. Robinson began photography in the early 1850's and started publishing articles on the subject later in the decade.

[30] "Our Picture," *Philadelphia Photographer*, XIX (April 1882), p. 97.

[31] Margaret Harker, *The Linked Ring* (London: Heineman, 1979), p. 16.

[32] Henry Peach Robinson, *Pictorial Effect in Photography* (London: Piper and Carter, 1869; Pawlet, Vermont: Helios, 1971), p. 50.

[33] Sir David Wilkie (1829-1916) was a member of the Royal Academy and Painter to the King. Wilkie was noted for his genre and landscape paintings.

[34] Carleton Watkins (1829-1916) was the renowned pioneering Western landscape photographer who was noted for his mammoth plate views of Yosemite Valley. Thomas Houseworth (1829-1915) was a publisher and award winning photographer of Yosemite. Bradley & Rolufson was a photography and publishing firm (in operation 1863-circa 1880) noted for Western landscape views.

# Intellectual and Spiritual Influences

John Griscom Bullock was born into a distinguished orthodox Quaker family on September 27, 1854 in Wilmington, Delaware. Close to his immediate family, he was also very aware of his long family history. For six generations in America, family members had been successful farmers, educators, and chemists, many of whom had been prominent members of the Society of Friends (Quakers). Quaker thought and the accomplishments of his relatives powerfully influenced Bullock's life.

John Griscom (1774-1852), great-uncle to John G. Bullock, had an indirect influence on him. Griscom was a prominent educator and chemist who attended country schools and the Friends Academy in Philadelphia. Self-taught in chemistry, he became famous as one of the earliest teachers of chemistry in America. While operating a Quaker boys' school in New York between 1807 and 1831, he also lectured at Columbia College and Rutgers Medical School. He was well acquainted with European chemical literature, and during a trip to Europe in 1818 and 1819, he met some of the leading scientists there. Griscom's book, *Year in Europe* (1823), recounted the trip and gave impressions of European education. Later, he served as editor of the *Journal of the Franklin Institute*, and at the time of his death, he was superintendent of the Burlington, New Jersey school system.[35] Griscom exemplified the traditional Quaker educator by his emphasis on concrete and utilitarian learning rather than "airy knowledge."[36] He passed along to his nephews, William Rockhill Bullock and Charles Griscom Bullock (John G. Bullock's father and uncle respectively) an orientation toward scientific truth and an interest in chemistry.[37]

Although John Griscom was a pioneer in the teaching of chemistry, he is best remembered for delivering the classic condemnation of Shakespeare by a Quaker. So strong was the Quaker commitment to a particular concept of truth that Griscom and many other Friends of his time could not tolerate theatre. They believed that stage performance falsely personated the character of others.[38] When invited to attend a lecture on Shakespeare, John Griscom responded:

> *J. Griscom returns his sincere thanks for the kindness which prompted the invitation to attend a lecture..."upon Shakespeare." In the spirit of reciprocated comity he would beg leave to remark, that if the lecture is to be given for the purpose of demonstrating that the morals of mankind would be benefited by the entire extermination of the writings of the great British dramatist, he would be more inclined to attend it. That there may be many noble thoughts, many humane sentiments, many profound and correct exhibitions of human nature, which may be culled, as the bee gathers sweet from poisonous plants, from these writings, he would not deny. But that, taken in their totality, they demoralize society to a great extent is an opinion, whether right or wrong, he has long entertained.[39]*

Shakespeare's plays would have been particularly objectionable to Friends because of the frequent bawdiness and dissimulating characters in the plays. Traditional Quakerism, moreover, regarded the arts in general as vain and valueless strivings. Paintings, whether portraits or landscapes, were considered idolatry and utterly at variance with Quaker principles. Portraits normally were viewed as indulgences, but occasionally the most representational portraits might be found in the Quaker home. Later, opposition to portraiture was weakened by photography, because portrait photographs were considered more truthful. In 1862, a writer in the *British Friend* deemed even photography to foster vanity,[40] but by the end of the century, Quaker opposition to the arts was softening. An eminent Friend stated in 1895: "Fine arts, these at their greatest always con-

tain some revelation of the Spirit of God . . . Friends may witness to the glory of God and advance that glory by that service."[41]

Notable Quaker artists were very few in number, even at the end of the nineteenth century. Young Friends tended to be encouraged toward more scientific professions such as medicine and pharmacy, the pursuits chosen by William and Charles Bullock respectively. The brothers had been influenced not only by their uncle, but also by their parents, John (1785-1847) and Rachael Griscom Bullock (1784-1842), who operated the Bullock Boarding School for Boys in Wilmington. John Bullock had attended Westtown Boarding School, a Quaker institution located in Chester County, Pennsylvania, and taught mathematics there and elsewhere before founding the Bullock School in 1821.[42] William and Charles Bullock began their education at the Bullock School.

William Bullock (1824-1914) was, in many ways, the ideal Quaker father who balanced his practice as a highly regarded physician with civic involvement, Quaker meeting, and time for his family.[43] William Bullock attended the Bullock School, then entered Haverford College, a Quaker influenced school, in 1839. In 1842, he left Haverford to study medicine at the University of Pennsylvania. After receiving his M.D. degree, he studied further in Paris where he witnessed violent street fighting during the Revolution of 1848. Ironically, valuable medical experience was gained by Bullock, a Quaker pacifist, in treating gunshot wounds and performing amputations during the revolution.[44]

Dr. Bullock returned to America in 1850 and married Elizabeth Ann Emlen, the daughter of a prominent Quaker physician. After practicing medicine for a brief time in Philadelphia, he moved back to Wilmington, having purchased a home at Ninth and Tatnall Streets, a fashionable section of town. The neighborhood streets were lined with sugar maple and horse chestnut trees. The Bullock home had gardens in the rear where fruit trees bloomed in the spring. Mary Emlen "Mamie" Bullock (1851-1909) and her younger brother John G. Bullock played in this idyllic setting.

Public benefit was a constant concern to Dr. Bullock. Throughout the Civil War, he served as a surgeon at the Tilton Hospital established by the United States government on land leased from the Bullock family at Tatnall and West Streets. He was also visiting physician at the county almshouse and participated in the successful drive to construct a new building for the Wilmington Institute and Library where he frequently lectured on chemistry and electricity. He served for many years on the public school board, including several years as president. A founder of the Delaware Hospital, he remained on staff until his retirement in 1905. He also was a member of the Freedman's Aid Society and was very interested in the education of blacks.[45] Dr. Bullock's outstanding accomplishments were rivaled only by his brother Charles.

Charles Bullock (1826-1900), had an obvious affection for his nephew, John G. Bullock, and strongly influenced his career. "Uncle Charlie" encouraged his nephew's childhood interest in science by giving him "a splendid little microscope,"[46] and later proved to be his great mentor. Charles Bullock entered the sophomore class at Haverford College in 1841, but left in 1842 and began an apprenticeship in pharmacy in 1844 with the firm of Smith and Hodgson. Daniel B. Smith, partner in the pharmacy and a teacher at Haverford, earlier had been a student of John Griscom. Charles Bullock graduated from the Philadelphia College of Pharmacy in 1847, and continued to work for Smith and Hodgson. In 1849, he formed a partnership with Edmund A. Crenshaw, his friend and former fellow apprentice, and bought out Smith and Hodgson. Like their predecessors, Bullock and Crenshaw retailed medicines to the public as well as wholesaling pharmaceuticals and apparatus all over the United States. They also manufactured a number of medicinal preparations.[47]

In addition to his business, Charles Bullock held positions of successively greater importance with the Philadelphia College of Pharmacy between 1849 and 1900. After becoming a partner in the firm of Bullock and Crenshaw, he was invited to be a member of the College; that is, he was on an advisory board of the school. By 1874, he was first vice-president, and in 1885, he became president, a position he held until his death. His administration of the College was "marked by much physical and educational progress," and he was described by his colleagues as "an important and enlightened figure."[48] Like his brother William, Charles Bullock was involved in a variety of professional and civic activities. He joined the American Pharmaceutical Association in 1857 and was promptly elected its

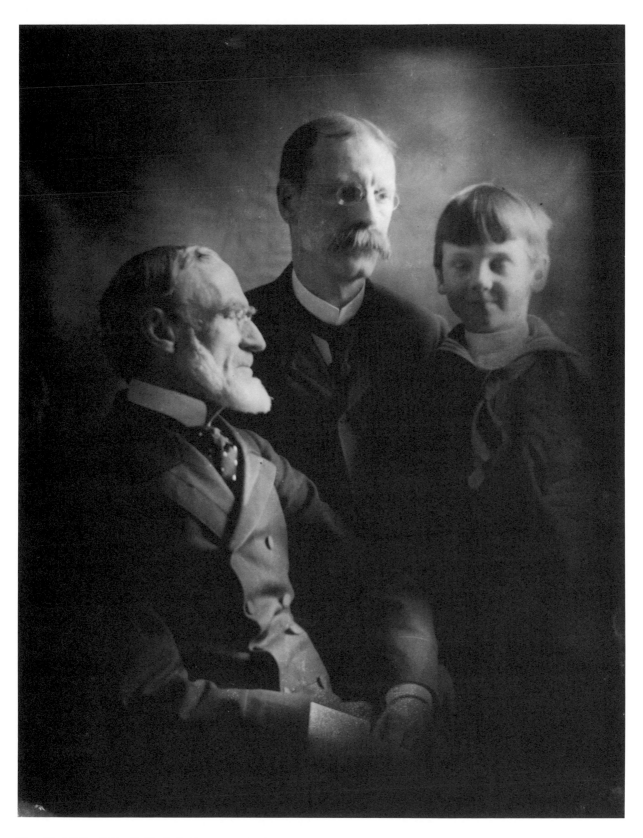

Plate 74. J.G.B., W.R. Bullock (left), J.E. Bullock, 1900.

recording secretary. At the meeting of the Association in 1876 at Philadelphia, he was elected president. Like his Uncle John Griscom, he was active in the affairs of the Franklin Institute, ultimately rising to its presidency.[49]

The young John G. Bullock made special note in his diary of frequent visits to Uncle Charles' pharmacy. Bullock and his father would make the trip from Wilmington by train to attend the Quakers' Philadelphia Yearly Meeting, to buy clothes, or simply to get a haircut. Each trip would be capped off by a visit with "Uncle Charlie," who undoubtedly had a kind word for his nephew.

Father and son shared many other trips together as well, such as visiting patients at the county almshouse, or going to the Du Pont estate where members of the Eugene Du Pont family required periodic medical treatment. On other occasions, they toured boat yards, railroad car shops, and printing plants. Printing proved to be a special interest of the younger Bullock.

A few months after his twelfth birthday, Bullock purchased a small printing press. Previously, he had published a handwritten newspaper called the *City Journal*, which was circulated in the Bullock household. Beginning in March, 1867, the newspaper was handset in type and printed for a slightly wider distribution.[50] The five by seven inch folded format allowed enough space for three or four short articles on such topics as "Water," "The Country," "The Progress of America," "Perseverance," or "A Visit to the Atlantic." The carefully written prose reveals a precise and curious young mind with the scientific bent characteristic of his father, uncle, and great uncle. The little newspaper continued about two years, but Bullock's curiosity and scientific outlook stayed with him for life.

The well crafted *City Journal* attracted other printing jobs for Bullock from local merchants and from the Kappa Gamma Society, the debating and rhetoric club of Mr. Reynolds' School which he attended. He printed the Society's programs for public meetings which generally included: a declamation; the reading of an essay; a dialogue among several students; the enactment of several scenes from a Shakespeare play; and music by a parlor orchestra. Not only did he print the programs, but he also participated. In presentations of scenes from *The Merchant of Venice*, he played the roles of Salarino or Nerissa. Although John Griscom was a strong influence on his great-nephew, John G. Bullock (and many Quakers of his generation) did not share Griscom's views on Shakespeare.

At thirteen, Bullock read his first public essay, "The Art of Printing," before a meeting of the Kappa Gamma Society. The essay was a short history of the development of the printing press from ancient China to the Philadelphia *Public Ledger*. With care similar to the craftsmanship which characterized his printing, Bullock researched his subject and pointed out some of the major innovations in printing presses. He proudly concluded his essay by citing the Bullock printing press, which printed two sides of a page simultaneously and was in use at the *Public Ledger*. The manufacturers of the press were likely his relatives. Together with his diary, subsequent essays which Bullock read before the Kappa Gamma Society over the next several years reveal considerable insightful analysis of world affairs.

Participation in the debates sponsored by the Kappa Gamma Society broadened his intellect. Topics included: "That emulation is a wholesome stimulation to education" (he debated with the negative but the debate was decided with the affirmative); "That military chiefs should be the chief rulers of a free people" (decision not cited); or "That the reign of George III was beneficial to England" (decision not cited). The intellectual demands made on Bullock by the debates and other activities of his schoolboy days were unrelenting, but he relished the stimulation.

On September 13, 1871, Bullock took the grueling entrance exams for Haverford College, then an elite center of orthodox Quaker education. From 9:30 A.M. until 4:30 P.M. that day, he sat for English composition, grammar, geography, United States history, arithmetic, geometry, Latin, and Greek exams. He complained of a headache that night. The next day, he took exams in Cicero, Virgil, and Xenophon, and with a note of surprise, he exclaimed, "I am successful," as he was admitted not to the freshman class, but to the sophomore class.[51]

College life required adaptation for John G. Bullock. Initially, he complained about Haverford's regimentation and, like almost every student anywhere before or since, disliked the food. He was often compelled to study late into the night, but the effort paid off. When the first grades came out in November, Bullock was ranked first in his class.

He quickly became involved in campus activities

by joining a literary society called the "Grasshoppers" and publishing a brief newspaper for the group at the end of the academic year.[52] *The Grasshopper*, as it was appropriately named, disseminated graduation speeches, bits of news, and satiric observations upon the academic year.[52] In 1874, the title of the newspaper changed to *'O Tettic*, which was "published by the Grasshoppers of Haverford College." The reason for the change was stated by Bullock in an editorial: "Our former title . . . which we bore to indicate the society of which the paper is the organ, we have laid aside lest it should convey to those unacquainted with it an idea of greater levity than we wish to maintain."[53] Amusingly, the new title was simply the Greek for "the grasshopper."[54] The editors went their merry, tongue-in-cheek way giving loaded meaning to their writing.[55] Bullock and his peers tended to be serious, but were not without a sense of humor.

A more serious literary effort was *The Bud*, a handwritten journal of which Bullock became one of four editors in 1872.[56] The journal primarily recorded the orations given before the Everett Society, one of several competing literary groups on campus. The activities of the society transpired in secret sessions, but the nature of the meetings hardly seems now to have required such privacy.[57] Pseudonyms such as "Hermas" or "Epizootic," the two used by Bullock, were the only identifications of the authors in *The Bud*, although the editors were named on the title page.[58] Between 1872 and 1873, Bullock published four articles in *The Bud*, all of which had the same utilitarian quality as his writings in the *City Journal*, his childhood newspaper. The subjects were: the manufacturing of rail cars, the building of ships, disease in horses, and the need for more contributions to the journal.[59] The last article has particular interest because it reveals the competitive side of Bullock's character. *The Bud* was locked in an intense rivalry with *The Gem*, published by the Athenaeum Society, each trying to outproduce the other.[60]

The curriculum of Haverford College between 1871 and 1874, during Bullock's time there, was strongly oriented toward classical and religious studies.[61] Ten to twelve subjects were studied each semester, which included the core curriculum of Scripture, Latin, and Greek. Bullock's sophomore studies encompassed Homer, Livy, the New Testament (in English), surveying, chemistry, English,

and ethics. The text for his ethics class was *A View of the Evidences of Christianity* (1794) by William Paley who argued the existence of God was proven by the design apparent in nature. Use of that text typified the conservative Haverford approach: Darwin's theories, published in 1871, were not taught until much later. The junior studies combined French, rhetoric, logic (the Aristotelian system), political science, and elocution with the core curriculum. His courses included Sophocles, Thucydides, Cicero, Horace, English literature, Herschel's descriptive astronomy, and human anatomy and physiology. Finally, senior studies included Demosthenes, practical astronomy (observatory), Pliny's letters, Plautus, German, philology, psychology, Christian doctrines (the text was *Observations on the Distinguishing Views and Practices of the Society of Friends* [1824] by Joseph Gurney, the liberal orthodox Quaker writer), natural and revealed religion, and modern history. In short, Bullock received a reasonably well-rounded classical education with a heavy religious emphasis.

One of the most challenging of Bullock's professors was Pliny E. Chase, a Griscom family cousin, who also arrived at Haverford in 1871. Chase was reputed to know seven or eight languages perfectly and could read in an additional one hundred and twenty three languages and dialects. He was a mathematical genius able to perform complicated calculations without writing anything down. Although he taught logic, Chase was also revered by students as a spiritual guide. Rufus Jones, the eminent Quaker philosopher and historian, saw Chase as a "central creative figure" at Haverford.[62] An emphasis of Chase's class was the detection of fallacies, a quality that Bullock surely carried into his later endeavors.[63]

Strict adherence to logic generally characterized Bullock's writings, and his junior and senior orations were exceptionally fine examples of his technique. In "Fuel and Force," his junior oration delivered January 29, 1873, he eloquently synthesized diverse ideas around the theme that the sun is the source of all energy. He supported his theme by a series of derivations of processes traceable back to the sun. Photography was cited in support of one contention:

*That the origin of chemical affinity is in the sun's rays we have plainly illustrated in the arts of photography and bleaching; chemical affinity is that force which tends to unite dissimilar bodies, and is associated with the consumption of fuel; it is the same action which takes place in the galvanic*

*battery, in the growth of a plant, or under the boiler of a steam engine.*[64]

He concluded that all physical and, to some degree, intellectual actions of human beings derive from the sun. Even as a young man, the affects of light had a special interest to this future photographer.

His senior oration entitled "Worlds Idols" dealt with hero worship among different peoples. Bullock artfully explained how heroes could be found where ordinarily not expected:

*As different eras in human progress have been characterized by a varying idol worship, so do the diverse classes of our present race, according to a mental standard, bow to the soldier, quack, sensational scribbler, and solid reasoner; a royal birth casts a colored light over some, but there are more true heroes amid the toiling sons of America than in all the courts of the crowned heads of Europe.*[65]

His sentiments, perhaps, help explain a predilection later for vernacular American subject-matter in imagery.

Aesthetic matters were clearly on Bullock's mind in very practical ways during his senior year at Haverford. The buttonwood trees along the avenue into campus from Lancaster Pike were noticeably failing, and in his role as class president, Bullock was instrumental in having new trees planted to beautify the campus. The effort was not insignificant since permission was required not only from the administration, but also from the alumni, and Bullock had to organize a fund-raising campaign.[66] These complications arose most likely because the management of the college at that time was split—and not too cleanly—between the Board of Managers and the academic administration. Thus, permission for this project was required from both authorities, while without Bullock's active organizing efforts it might not have been done at all.

As valedictorian of the Class of 1874, John G. Bullock truly believed that: "Parting is a sad, sad task, it is the knife which severs us from the happy past, which cuts the golden links of friendship; but the sense of a good work done, of a duty fulfilled mitigates, in part, the pain."[67] These words described Bullock's own circumstances as he graduated from Haverford College. He had been academically, intellectually, and socially successful at school. He was first in his class, president of his class, editor of a literary magazine, president of two literary societies, founder of the school newspaper, and a player of intramural cricket. Most of all, he was a loyal Haverfordian about to become an active alumnus.

Immediately upon graduation, John G. Bullock was nominated for the executive committee of the Haverford Alumni. His commitment to alumni affairs was substantial considering that he was busy working and later attending the Philadelphia College of Pharmacy.[68] The reverence which Bullock had for his alma mater explains in part his willingness to make the effort, as he described in his diary:

*Next Wednesday college opens, it seems indeed strange that I do not return of course I do not wish to now as my work there is done. But I would not exchange my Haverford experience for any worldly gifts. I am more satisfied for having gone to Haverford than had I attended any other college in the country.*[69]

Another evidence of his loyalty and activism was his service on the committee to organize a major reunion of Haverford alumni in1876. The reunion coincided with the Centennial, a time which was already especially busy for him.[70]

Yet another demonstration of his energy on behalf of Haverford was the founding in 1878 of *The Quaker Alumnus*, a journal devoted to educational, intellectual, and alumni matters relating to those who had graduated from the various Quaker educational institutions. The concept behind the journal was to increase the attention paid to "higher education, accurate scholarship, and general culture" by members of the Society of Friends.[71] Bullock's motivation in seeking to publish the new journal was revealed by his diary:

*Ned Allinson came up this evening to talk over the quarterly journal which we propose to publish on behalf of the Society of Friends but most particularly as the organ of the Haverford Alumni. Think we shall call it the "Quaker Alumnus."*[72]

The journal was well written and rich in intellectual material, but lasted only a year before changing its name to *Alumnus*, which continued until July 1880.

During his senior year at Haverford, Bullock speculated on what life as an alumnus would be like. He prophesized about his friends, then said that "I shall be high in some business firm and respected at least."[73] Without specific expectations, he was remarkably accurate in his prediction.

Three weeks after graduation, he received a letter from his father telling of a position offered by Uncle

Charles. In his diary, John G. Bullock reacted to the news:

*Uncle has a place ready for me in his store which is good news to me. I intend to work very hard and hold none but the first place; learn the whole business and then take up some specialty so many of which are in the broad field of chemistry as yet undeveloped.*[74]

Within the week, he began a self-directed study of botany, a subject especially vital to pharmacists in 1874. His spirits were further uplifted by plans to tell Miss Annie Lawrence of his feelings for her. Annie Lawrence and John G. Bullock met at a social gathering held by one of his Haverford classmates. Annie lived on Long Island, but frequently visited relatives and friends in Philadelphia. Bullock was captivated by her gentle nature and pleasing disposition. They saw each other at group gatherings, but only rarely were off by themselves, such as walking on the beach together while vacationing with family and friends at Atlantic City. Most likely, Bullock was her first love, as she was for him. He spoke to Annie's parents about his relationship with her and was warmly received by them. His friends roundly congratulated him and offered hopes for future happiness. Yet their relationship broke down, perhaps because distance permitted only infrequent visits. In May 1875, Bullock wrote a woeful entry in his diary specifying only that: "I cannot but believe that she acts according to what she feels she should do, but, oh it is a cruel thrust."[75] It took a very long time before he recovered from the pain of this failed relationship. He did not marry until 1888, thirteen years later.

Following the lead of his Uncle Charles, John G. Bullock became a pharmacist. Given his family history, education, and the enjoyment he had derived since childhood from visits to Bullock and Crenshaw, it was not surprising that he began working there in the fall of 1874. Although he was a graduate of Haverford with training in chemistry, his first job was unpacking and shelving glassware. After he achieved thorough familiarity with the stock of glassware and chemicals, he was permitted to work in sales. Meanwhile, in the spring of 1875, he entered the Philadelphia College of Pharmacy to study toward a degree in the field and receive Pennsylvania State certification as a pharmacist. The discipline of pharmacy was becoming more stringent, and at that time required a thorough knowledge of botany, chemistry, toxicology, pharmacology, and the theory and practice of pharmacy. The requirements for the degree also included: a four year apprenticeship, a thesis paper, qualifying examinations at the completion of the apprenticeship, and the written recommendation of the faculty. Bullock commented from time to time in his diary about being overwhelmed at the burden of his studies and was impatient with the lengthy study in fulfilling all the requirements for the degree of Ph.G. (Graduate in Pharmacy), which he received in 1879.

A source of broader scientific information for him was the Franklin Institute of the State of Pennsylvania, for the Promotion of the Mechanic Arts. He had been accompanying his Uncle Charles to Institute-sponsored events since 1874. On October 11, 1876, John G. Bullock was certified for membership in the Franklin Institute,[76] the pre-eminent American institution devoted to the sciences and mechanic arts at the time.[77] Among the numerous lectures he attended at the Institute over the next several years were those on such topics as the Centennial, light, color, sound, Edison's phonograph, and the telephone. The lecture on January 18, 1882, stood out particularly and received special comment in his diary:

*Attend monthly meeting of the Franklin Institute. Carbutt shows some beautiful photographic slides taken by Mr. Browne on Carbutt's dry plates, most of them instantaneously. The dry plate process is a grand improvement in photography enabling many to take it up as amateurs who did not come to do so under the old troublesome system.*[78]

Bullock had attended one of several lectures by John Carbutt, a Philadelphian promoting and demonstrating new photographic plates. Carbutt was a photographer and manufacturer of photographic equipment and materials, who, like many others, had seen the need to improve upon the process of making photographic negatives.

For many years, photographers were limited by having to coat wet emulsion just prior to exposure onto glass plates and develop the images immediately afterwards. If the emulsion dried out, it would become impervious to developer. Images were best made in a studio with controlled lighting and a full darkroom nearby. Field work was difficult and required carrying along a dark tent and all the necessary chemicals. Dr. Richard L. Maddox, a British

amateur photographer, experimented with dry emulsions and in 1871 published his formula for gelatine dry plates. His concept was successful, but the sensitivity of the emulsion was inferior to the wet plate. Refinement was needed to make gelatine dry plates practical. Throughout the 1870's various researchers in America and Europe worked on the problem. Toward the end of the decade only small quantities of improved dry plates were available. Carbutt seized the opportunity and, after making his own refinements, manufactured and sold nationwide his "Keystone Rapid Gelatine Plates" beginning in 1879.[79]

First-hand knowledge of Carbutt's dry plates motivated Bullock to learn more about the process. The next day, he called upon John C. Browne, the amateur photographer whose images had been shown by Carbutt at the Franklin Institute. Bullock recorded his visit with Browne:

*Spend the evening very pleasantly with Mr. Jno. C. Browne who shows us his beautiful collection of photographs and imparts what he can on the subject of amateur photography. He has found pleasure in it for 30 years and is one of the first in the ranks of amateurs.*[80]

The next week, Bullock noted in his diary that he had purchased "a photographers outfit."[81] This was to be his last diary entry. Photography became his passion, and apparently replaced his need to keep a diary. Little did he know at that moment that his new pursuit would lead him to center stage in the struggle to establish photography as art in America.

[35]Clark A. Elliott, *Biographical Dictionary of American Science: The Seventeenth Through the Nineteenth Centuries* (Westport, Connecticut: Greenwood Press, 1979), pp. 110-111. Another good source of information on John Griscom is *Reports on European Education* by John Griscom, Victor Cousin, and Calvin E. Stowe, ed. Edgar W. Knight (New York: McGraw-Hill, 1930).

[36]Margaret H. Bacon, *The Quiet Rebels: The Story of the Quakers in America* (New York: Basic Books, 1969), pp. 152-153.

[37]Committee on Historical Volume, *The First Century of the Philadelphia College of Pharmacy 1821-1921* (Philadelphia: Philadelphia College of Pharmacy and Science, 1922), p. 363, specifically notes the relationship between John Griscom and Charles Griscom Bullock, but does not mention William Rockhill Bullock. In all likelihood Griscom had a similar influence on both brothers.

[38]Frederick J. Nicholson, *Quakers and the Arts* (London: Friends Home Service Committee, 1968), p. 43.

[39]Bacon, p. 168.

[40]Nicholson, p. 53.

[41]Nicholson, p. 96, cites a paper by the Quaker historian, William Charles Braithwaite, "Has Quakerism a Message to the World Today?" which was delivered at the Yearly Meeting in Manchester, England, in 1895.

[42]Clarence Russell Moll, "A History of Pennsylvania Military College—1821-1954," diss., New York University, 1954, pp. 18-26. Courtesy of Sandra Leaf Bullock. The Bullock School remained a select boys' school for about fourteen years after John Bullock's death. During the Civil War, military instruction was introduced at the secondary and the college levels and dominated the curriculum until after World War II. Today, the school is coeducational, has a full curriculum in the arts and sciences, and is known as Widener University.

[43]Sandra Leaf Bullock, wife of Richard H.D. Bullock, Jr., was very generous in sharing her research on Bullock family history. She has my sincerest thanks for her help.

[44]"Memoir of William R. Bullock, M.D.," n.d., p. 2. Courtesy of Sandra Leaf Bullock.

[45]"Memoir," p. 3. Although he rarely wrote for publication, Dr. Bullock translated a major work on obstetrics from the French.

[46]John G. Bullock, Diary, May 11, 1868. Bullock enthusiastically wrote that "Uncle Charlie sends me a splendid little microscope."

[47]Committee on Historical Volume, p. 363.

[48]Committee on Historical Volume, p. 176.

[49]Committee on Historical Volume, p. 363. He also held memberships in the American Philosophical Society and the Academy of Natural Sciences.

[50]Copies of the newspaper do not have the year printed on them, but comparing various issues to diary entries revealed that handwritten copies were begun in the Fall of 1866. The first typeset issue was March 11 [1867] which included the note: "With this number we present to our subscribers the first one in print; the former ones being written, which was a great labor for the editor, but now since a printing press has been bought, a great number of copies can be issued in an hour." The last known issue of the paper appeared April 9, 1868. Elizabeth Guy Bullock, widow of Bullock's son John Emlen Bullock, and Sandra Leaf Bullock very generously made copies of the newspaper available.

[51]Bullock, September 14, 1871.

[52]A Committee of the Alumni Association, *Biographical Catalog of the Matriculates of Haverford College* (Philadelphia: The Alumni Association, 1922), p. 164. The annual *Grasshopper* was a forerunner of the college newspaper, *The Haverfordian*.

[53]"Editorial," *'O Tettic*, 1874, p. 4. This editorial was not signed in the printed copy, but was initialed "JGB" in Bullock's personal copy.

[54]Dr. Carolyn G. Koehler, Chairperson of the Ancient Studies Department, University of Maryland Baltimore County, kindly provided the translation from the Greek.

[55] The editors were Bullock, Edward P. Allinson, and Francis B. Gummere, later Professor of English and German at Haverford, 1887-1919.

[56] *The Bud*, The Quaker Collection, Magill Library, Haverford College. The editors were Bullock, Allinson, Henry Haines, and Miles White, Jr.

[57] Isaac Sharpless, *The Story of a Small College* (Philadelphia: The John C. Winston Company, 1918), p. 82.

[58] Bullock's articles were identified by his style and his handwriting.

[59] The editors were John G. Bullock, Edward P. Allinson, Henry Haines, and Miles White, Jr.

[60] Rufus M. Jones, *Haverford College: A History and an Interpretation* (New York: Macmillan, 1933), pp. 55-56.

[61] Information about the Haverford College curriculum for 1871-1874 was gathered from Bullock's handwritten class schedule made available by Sandra Leaf Bullock and from college catalogues from the Quaker Collection, Haverford College Library.

[62] Jones, pp. 44-48. See also John F. Gummere, "The Early Years," *The Spirit and the Intellect: Haverford College*, Gregory Kannerstein, ed. (Haverford: Haverford College, 1983), p. 13.

[63] *A Catalogue of the Officers and Students of Haverford College for the Academic Year 1871-1872* (Philadelphia: Haverford Corporation, 1872), p. 39. Courtesy of the Quaker Collection, Magill Library, Haverford College.

[64] John G. Bullock, "Fuel and Force," Junior Oration, Haverford College, January 29, 1873. Courtesy of Elizabeth Guy Bullock.

[65] John G. Bullock, "World's Idols," Senior Oration, Haverford College, May 1, 1874. Courtesy of Elizabeth Guy Bullock.

[66] The project of planting the trees largely resulted from Bullock's personal effort. He did most of the planning and leg work himself, including handsetting type and printing a solicitation for funds from student organizations and the Haverford Alumni. Originally, Meehan's Nursery of Germantown recommended tulip oaks which were planted on March 26, 1874, a cold and windy day, but these trees were replaced a week later with English oaks.

[67] *'O Tettic*, 1874, p. 1.

[68] Bullock became a life member of the Alumni Association of Haverford College May 15, 1875.

[69] Bullock, Diary, August 29, 1874.

[70] Bullock's name appears as a committee member on a form letter, dated June 12, 1876, inviting alumni to the reunion on the evening of commencement day, June 28, 1876. Courtesy of Richard and Sandra Bullock.

[71] *The Quaker Alumnus*, Vol. 1, No. 1 (July, 1878), p. 8.

[72] Bullock, Diary, March 29, 1878.

[73] Bullock, Diary, March 4, 1874.

[74] Bullock, Diary, July 18, 1874.

[75] Bullock, Diary, May 16, 1875.

[76] Bullock's certificate of membership in the Franklin Institute was generously made available by Elizabeth Guy Bullock.

[77] Bruce Sinclair, *Philadelphia's Philosopher Mechanics* (Baltimore: The Johns Hopkins University Press, 1974), p. ix.

[78] Bullock, Diary, January 18, 1882.

[79] William Brey, *John Carbutt on the Frontiers of Photography* (Cherry Hill, New Jersey: Willowdale Press, 1984), pp. 107-122.

[80] Bullock, Diary, January 19, 1882.

[81] Bullock, Diary, January 25, 1882.

Plate 11. Her Wedding Journey, June 1888.

# John G. Bullock:
# An American Vision

John G. Bullock came of age a generation after the discovery of photography. More than twenty years had passed since the public learned of the new medium in 1839. However, new processes were constantly being devised, and photography was perpetually new to an American public with seemingly boundless enthusiasm for images.

During his teens, Bullock had noted in his diary the occasions when his photograph was taken. He alternately visited Maybin's and Garrett's studios in Wilmington about twice a year for portrait sittings. Joseph A. Maybin evidently noticed the boy's interest in photography and invited Bullock on a photographic outing in the fall of 1870.[82] The occasion merited description in Bullock's diary:

> Go up the Reading at 11 AM with Mr. Maybin to take views, got off at Centre Station & first take a tressle [sic] bridge 2 views, then walking ¾ mile take another very high tressle [sic], & two views of a very deep cut for the RR. Take tea at Mr. Swaynes. Have a very nice time indeed. Reach home about 9 PM.[83]

That winter, Bullock was attending a local stereopticon presentation, images projected from glass positives, and was pleasantly surprised to see one of the images made during his excursion with Maybin: "One picture was that which Mr. Maybin took up the Reading RR in which I was sitting on the track."[84] Stereopticon presentations were both entertaining and educational spectacles in the nineteenth century, and John G. Bullock attended several with themes such as scenes along the railroad and Yosemite Valley. In 1878, an especially interesting presentation was held at the annual reception of "the amateur photographers" which Bullock attended.[85] He was impressed by the beauty of some of the images and the stop-action quality of others.

Until 1882, photography remained for Bullock a submerged interest which surfaced only when stimulated by a portrait sitting, a stereopticon presentation, or an exhibition. When he realized how easily photographs could be made with gelatine dry plates, however, he was motivated to action. Within three weeks of Carbutt's January 18th lecture, Bullock began learning the dry plate process from John C. Browne[86] and attended his first monthly meeting of the Photographic Society of Philadelphia on February 1st.[87] Browne proposed Bullock for membership in the Society at the April 5th meeting,[88] and the group voted unanimous approval at the May 3rd meeting.[89]

John Coates Browne (1838–1918) was both a teacher and a guide to John G. Bullock.[90] Not only did Browne share his technical expertise with Bullock, but he also passed along twenty years of experience in photography and the Photographic Society of Philadelphia. Browne was a founding member of the Society in 1862 and its first recording secretary.[91] He held various other offices at different times and was president from 1870 to 1877.[92] In the early years especially, Society meetings were technically oriented, a stance that reflected the uncertainties of the wet-plate process and the need for photographers to share information. Browne was an enthusiastic participant who later became known for his technical capability with dry plates. In fact, in 1881, Carbutt named his fastest dry plates "J.C.B." in honor of Browne.[93]

*The Philadelphia Photographer*, one of the most important national journals on photography, published in the April 1882 issue a short paper, "Gelatine Dry-Plates," by Browne. The paper, which had been read at the March meeting of the Society,[94] advised beginners not to use the fastest plates, but to use the slowest ones. Precise exposures were not required, and the plates could be used conveniently outdoors where a novice would not have to struggle with artificial lighting. Browne continued:

Figure 10. "On Wilmington & Phila. Pike at Shellpot" by John G. Bullock, albumen print, circa 1883, on loan from George R. Rinhart.

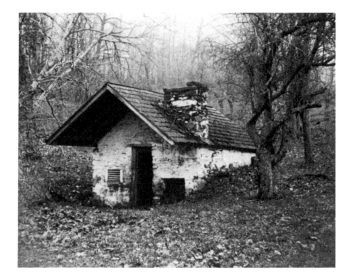

Figure 11. "Old Spring House, Mill Creek" by John C. Browne, 1882, courtesy of The Library Company of Philadelphia.

*We will now suppose that the operator has purchased a proper outfit, and is ready for an excursion into the country, having a landscape lens and gelatine dry plates . . . In selecting a point of view, be particular never to allow the sun's rays to touch the lens, but arrange the camera so that the sun will be behind it...use a small stop, selecting a subject that is evenly illuminated. . . .[95]*

Browne further advised that accurate notes be kept of all exposures. A record should be made of the type of lens, the amount of exposure, the aperture, and the condition of the light. He said: "By carefully observing these rules, rapid progress will be made, and the beginner will soon learn to time correctly." Not only did Bullock hear Browne present the paper at the Society,[96] but he genuinely took the advice to heart.

Early images by Bullock were all made outdoors and were recordings of his excursions into the countryside. These clear, sharp photographs seem to have been made with a short-focus landscape lens employing a small aperture. Subjects were evenly lighted, and to avoid lens flare, the sun was normally behind the camera. "On Wilmington & Phila. Pike at Shellpot," 1883 (fig. 10), exemplifies Bullock's early work and shows several similarities to "Old Spring House, Mill Creek," 1882 (fig. 11), a typical image by Browne. Both photographers generally achieved dimensionality and realism in their images of architecture by approaching their subjects from a slight angle, showing the front and side of a building. Also, both tended to center their subjects and include an even area of space around the top, bottom, and sides, an arrangement which later facilitated cropping if desired. Finally, Browne and Bullock both enjoyed "an excursion into the countryside" to photograph rural or vernacular subject-matter.

Within a year of producing his first photographs, Bullock had demonstrated marked ability as a photographer. Although his imagery was more oriented toward making records than works of art, many of his photographs (such as figs. 12, 13, and 14) were quite beautiful. The early work anticipated his future artistic images and in one instance prefigured slightly a later work by Alfred Stieglitz (1864-1946): Bullock's untitled photograph of the ferryboat "Baltic" (fig. 15) could be compared to Stieglitz's "The Ferry Boat," 1911 (fig. 16). Stieglitz's image is far superior, but the young John G. Bullock was already thinking along lines that would later appeal to Stieglitz.

Neither urban nor nautical subject-matter attracted John G. Bullock as much as the countryside. Perhaps inspired by an abandoned prospect of a journey to rural North Carolina with the Photographic Society of Philadelphia,[97] Bullock joined in another North Carolina journey with family and friends to the Blue Ridge Mountains in July, 1884. An amusing record of the trip titled *Jolts and Scrambles or "We Uns and Our Doin's"* was written by the eleven members of the party, each having taken turns in rotation re-

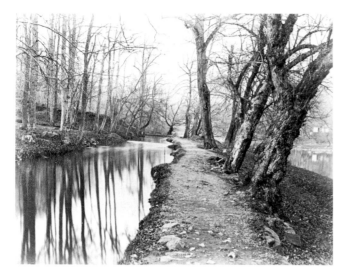

Figure 12. [Tree-lined Creek] by John G. Bullock, albumen print, circa 1883, on loan from George R. Rinhart.

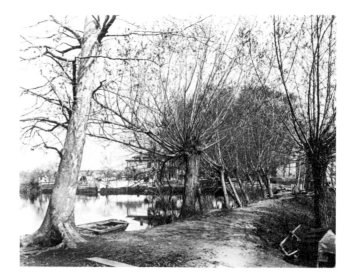

Figure 13. [Trees at Water's Edge] by John G. Bullock, albumen print, circa 1883, on loan from George R. Rinhart.

porting the day's events. The initial entry for Thursday, July 17, 1884 set the tone for the book:

*On this cool, summer evening, a short time before six o'clock, there assembled at the Broad Street Station, Philadelphia, the party of distinguished explorers, artists and scientists who had been selected from among the learned people of the United States to make explorations and discoveries in the, as yet, almost unvisited wilds of North Carolina.*[98]

The account told of riding in wagons and on horseback through the rugged and beautiful landscape. The group debarked from the train at Marion, North Carolina, having gathered on the train along the way at the stops in Philadelphia, Wilmington, and Washington, D.C. The ultimate destination was Ashland, although side trips to Black Mountain and Hickory Nut Gap were made. Vivid descriptions of the places and events along the route were dutifully recorded, including Bullock's experience, amusing only in retrospect, ascending Mt. Mitchell on horseback and camping out in heavy rain.

Thirteen of John G. Bullock's photographs were tipped into the book, generally in strategic relation to the text.[99] These carefully and artfully made images have a consistency characteristic of Bullock's mature photographs. The unity between text and image (see fig. 17), and the uniform style of the writing throughout suggests that Bullock was the editor. Considering his editorial experience, it was likely he who supplied the stimulus for publication. Most im-

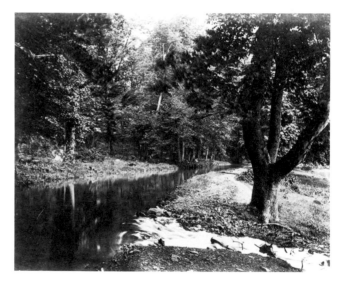

Figure 14. [Creek and Woods] by John G. Bullock, albumen print, circa 1883, on loan from George R. Rinhart.

portantly, the book demonstrated that after two years of serious photographic endeavor, Bullock had established his own style of vernacular imagery as well as a pattern of photographing during extended summer journeys.

Since childhood, Bullock's summer vacations, lasting several weeks at a time, were spent at the seashore or in the country. As an adult, it was natural for him to devote a substantial portion of his vacation time to his pleasure—photography. He was never interested in traveling abroad, although he certainly could have done so. Rather, he chose to go

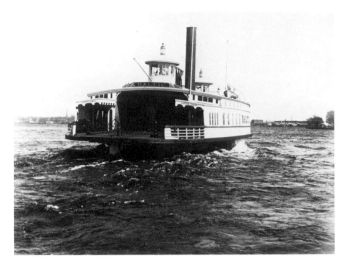

Figure 15. [Ferryboat "Baltic"] by John G. Bullock, albumen print, circa 1883, on loan from George R. Rinhart.

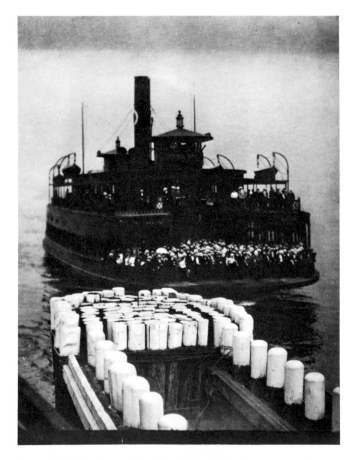

Figure 16. "The Ferry Boat" by Alfred Stieglitz, gravure from *Camera Work* No. XXXVI, October 1911, Photography Collections, Albin O. Kuhn Library & Gallery.

to Gloucester, Massachusetts (1883); Ashland, North Carolina (1884); Moosehead Lake, Maine (1885); Pulaski, Virginia (1886); and Sheffield, Massachusetts (1888), and many other destinations in the United States. Rural American life fascinated him and became one of the prime subjects for his photography. "Watercart No. 1, Near Pulaski," 1886 (plate no. 10) typifies his approach to his subject-matter. He chose a characteristic rural activity and photographed the participants from the most attractive view. Like the earlier architectural subjects, there was more than ample space around the center of attention in the photograph, and highlights stressed the activity portrayed. Harmonious tonality enhanced the feeling of an idyllic and pastoral life where humans, animals, and nature co-existed in harmony.[100]

Bullock often idealized the people in his rural images. The farmer in "Harrowing" (plate no. 27), for example, is a hearty upstanding individual who holds dominion over the good earth. The young woman in "Where Are You Going My Pretty Maid" (plate no. 53) is a model of robust good health and beauty. Although life moves at the pace of the horse-drawn wagon (see plate no. 18) rather than the speeding locomotive, the people are honest, hardworking souls who are to be admired for being attuned to the rhythms of nature. Bullock felt close to these people, because he was descended from farmers and his relatives were still farming lands in southern New Jersey which had been in the family for generations. Moreover, Bullock's photographs seem to echo the words of his Haverford senior oration: "There are more true heroes amid the toiling sons of America than in all the courts of the crowned heads of Europe."

Bullock was thoroughly enamored with rural life, and found in Rebecca "Rebie" Malin Downing (1865-1945) a kindred spirit with whom to share trips to the countryside. Following their marriage on June 5, 1888 (see fig. 18),[101] they spent their honeymoon in rural western Massachusetts. During the trip, Bullock made several especially fine images of his wife. "Her Wedding Journey" (plate no. 11) and "Re on Bridge Near So. Edgemont [sic], Mass." (plate no. 12) depict her as a country woman at ease in wooded surroundings.

As Bullock became more successful with his camera, he grew more active in the Photographic Society of Philadelphia. In the Fall of 1884, he was

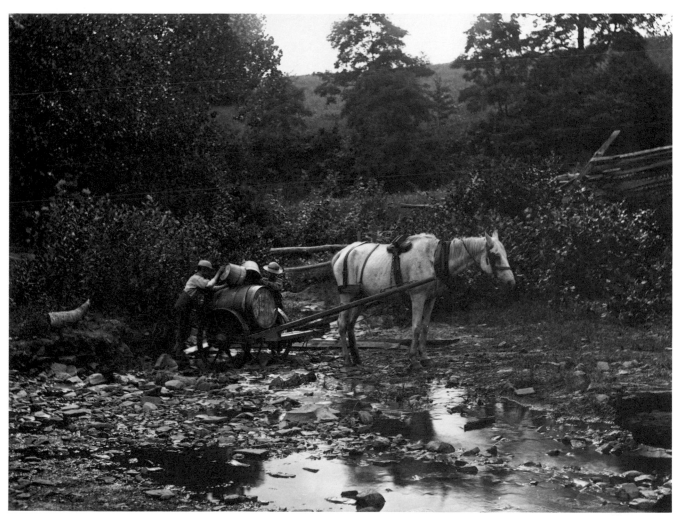

Plate 10. Water Cart No. 1, Near Pulaski, July 27, 1886.

elected vice-president, and upon showing some lantern slides at that meeting, he was one of several who "received the approbation of the members."[102] His newfound activism in the Society focused particularly upon displays and exhibitions of photographs. He was the motivator of the International Exhibition of Photography sponsored by the Society and held at the Pennsylvania Academy of Fine Arts (PAFA) in January 1886.[103] The exhibition presented images by 114 photographers, sixteen of whom were from foreign countries. A total of 1,752 photographs were exhibited in three large galleries of the PAFA. The *Philadelphia Photographer* described the event:

> *It was more than a simple exhibition of pictures for the amusement of curious visitors: it was instructive as well as pleasurable; refining as well as entertaining; an object lesson, which told of the wonderful jumps which the art has*

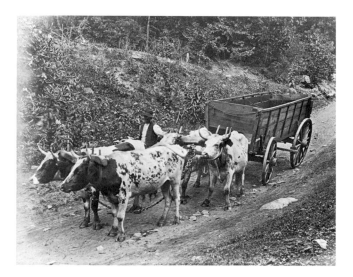

Figure 17. "Ox Team, [North Carolina]" by John G. Bullock, 1884, Photography Collections, Albin O. Kuhn Library & Gallery.

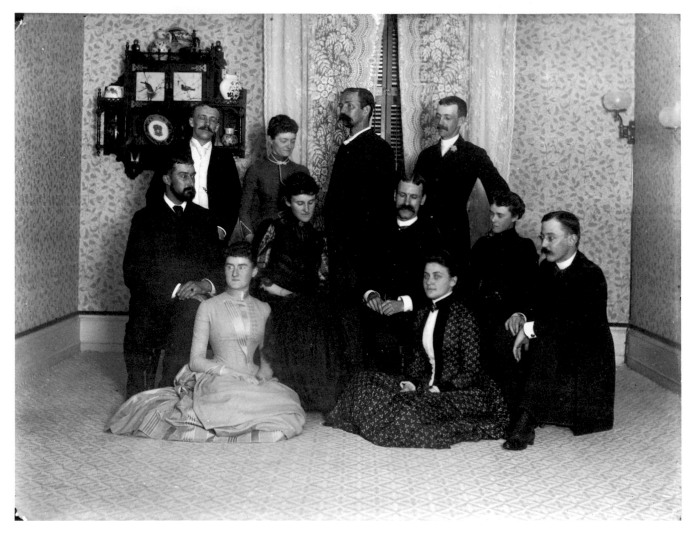

Figure 18. "Wedding Group" by John G. Bullock, 1888, Photography Collections, Albin O. Kuhn Library & Gallery.

*made the past three years. . . . The great praise is due to the hanging committee, Messrs. Robert S. Redfield, John G. Bullock, and C.R. Pancoast, for the admirable manner in which they performed a most difficult and somewhat thankless task.*[104]

Unanimously favorable reviews appeared in the prominent journals of the time. One review declared: "In numbers and quality the contributions exceed any previously held exhibition in this country; in fact, no Exhibition that could properly be termed a general one has ever been attempted, so far as the record shows. . . ."[105] Enthusiasm caused the writer to forget the Centennial, but no one was going to contest the judgment. The PAFA exhibition set the stage for grander future presentations such as the Joint Exhibitions and the Philadelphia Salons.

Exhibitions were a natural outlet for Bullock's attention. Like the majority of serious amateur photographers everywhere, he put tremendous effort and care into making his photographs, but what then? If the photographs were shared only with family and the small circle of members of the Society, then the appreciation of the images was relatively limited. But if the photographs were shown to a larger audience, the prospects of wider appreciation and discourse became possible. Whether Bullock articulated this logic is not known, but as his imagery became stronger, he exhibited his photographs more and more.

Amateur photographers of Bullock's time were ardently devoted to their pursuit. They were true lovers of photography as the term "amateur" implies from its Latin root *amare*, to love. The real amateur

should not be confused with those who casually made images and sent them off (after 1888) to Eastman Kodak Company for processing. Nor should they be confused with professional photographers who did not have the same artistic commitment and who had to produce a consistent and reliable product for a paying public.[106] Profit such as that realized by professionals did not motivate amateurs. Occasionally, amateur photographers sold photographs from a show, but such sales were infrequent (even for Bullock) and not the reason for making pictures. Self-satisfaction, recognition, and medals won in competition were all reasons why amateurs pursued photography.

Bullock was an especially good example of the dedicated amateur photographer who derived great satisfaction from making and exhibiting images. Photography was a creative outlet which permitted him to explore and render his vision, and exhibitions were a source of recognition for his capabilities. Prints and slides entered into competitions frequently won praise as well as prizes. For example, his work admitted to the Boston Salon in 1885 was described along with that of others as deserving "the highest praise for their many and varied excellences."[107] Just a few months later, a lantern slide singled out of a Photographic Society of Philadelphia competition by the *Philadelphia Photographer* was praised as "remarkable for its combination of vigor of design, and softness of atmosphere effect . . . It was highly artistic in conception."[108] In 1886, Bullock's photographs in the International Exhibition of Photography at PAFA won a diploma. His work was so remarkable that in 1892 he was selected one of a dozen photographers who were declared "Leading Amateurs in Photography" by Clarence B. Moore in an article for *Cosmopolitan* magazine.[109] Also cited were future Photo-Secessionists, Robert S. Redfield and Alfred Stieglitz. Bullock and Redfield were lauded by Moore for making the 1886 PAFA exhibition a success which has "done so much to advance amateur photography." Moore stated that Bullock "is a busy man and has exhibited rarely, though the results . . . lead to a different inference." The inference Moore had in mind was that in five years, Bullock had received seven major awards, medals, and honors.

The primary hindrance to greater recognition for Bullock was his responsibility for running Bullock and Crenshaw. As Uncle Charles became more in-

Figure 19. "Moosehead from Mt. Kineo" by John G. Bullock, 1885, Photography Collections, Albin O. Kuhn Library & Gallery.

volved in outside activities, John G. Bullock was required to give more attention to the business. Nonetheless, Bullock was also able to make some significant contributions as an exhibiting photographer.

Like many of the best amateur photographers, Bullock sent his work to various competitive exhibitions in America and abroad. Juries of photographers reviewed the work for admission and awards. It was an honor to be admitted to the show, and an even greater honor to receive a medal or diploma. At the 1890 Newcastle-upon-Tyne, England, exhibition, for example, Bullock received not one, but two medals for his landscapes, including one in the general category of landscape (see fig. 19). Although he had exhibited work abroad before, these medals significantly increased Bullock's stature as an international award winning photographer. Interestingly, the nine photographs exhibited were some of his most vernacular American work, including "Water-

cart No. 1, Near Pulaski," (plate no. 10). Bullock's American vision had captured the attention not only of American critics and judges, but also foreign ones as well.

John G. Bullock's love of rural American subject-matter had motivated him to make photographs which aspired to the status of art. In his hands as in the hands of a growing number of pictorially ori-ented photographers, the photograph became a medium of self-expression with similarities to paintings in a variety of styles. From his position as a recognized leader among amateur photographers, Bullock was poised for a role of even greater leadership in raising the standards by which photographs were judged and in winning acceptance for photographs into art museums.

[82] William Culp Darrah, *Stereo Views: A History of Stereographs in America and Their Collection* (Gettysburg: Times and News Publishing Co., 1964), p. 213. Maybin was a professional photographer who made stereographs, stereopticon views, and portraits during the era of the 1860's and 1870's.

[83] John G. Bullock, Diary, October 18, 1870.

[84] Bullock, Diary, January 20, 1871.

[85] Bullock, Diary, January 23, 1878. It is not known which group of "amateur photographers" Bullock visited that evening.

[86] Clarence B. Moore, "Leading Amateurs in Photography," *Cosmopolitan*, 12 (February 1892), p. 428.

[87] "Minutes Photographic Society of Philadelphia April 18, 1878—," mss., Sipley Collection, International Museum of Photography at George Eastman House, Rochester, February 1, 1882.

[88] "Minutes," April 5, 1882.

[89] "Minutes," May 3, 1882.

[90] Moore, p. 428.

[91] John C. Browne, *History of the Photographic Society of Philadelphia* (Philadelphia: Photographic Society of Philadelphia, 1884), p. 8.

[92] Browne, pp. 8-24.

[93] Mary Panzer, *Philadelphia Naturalistic Photography 1865-1906* (New Haven: Yale University Art Gallery, 1982), p. 36.

[94] John C. Browne, "Gelatine Dry-Plates," *The Philadelphia Photographer*, XIX (April 1882), pp. 107-110. A footnote informed readers that this paper had been presented at the meeting.

[95] *The Philadelphia Photographer*, April 1882, p. 108.

[96] The "Minutes" show that Bullock attended the meeting which was held on March 1, 1882.

[97] *The Philadelphia Photographer*, XXI (July 1884), p. 209.

[98] *Jolts and Scrambles or "We Uns and Our Doin's"* (Philadelphia: Privately Printed, 1884), p. 5.

[99] The information supplied here is based upon the copy held by the University of North Carolina, Chapel Hill. Two other copies of this rare volume are known to exist. One is at the International Museum of Photography at George Eastman House, and the other was offered at the Phillips Auction, N.Y., Sale No. 331 on December 3, 1980. These three copies of the book vary in the number of pages and the number and type of illustrations.

[100] Panzer, p. 7.

[101] Rebecca Downing was a Hicksite Quaker who received a Bachelor of Literature from Swarthmore College. The wedding took place at the bride's family home in Philadelphia, and among the wedding party were Charles Pancoast and William A. Bullock (a cousin), two members of the Photographic Society of Philadelphia. John G. and Rebecca Bullock joined the Protestant Episcopal Church upon marriage. He became a member of the vestry of St. Peter's Church in Germantown, and later attended the Church of the Holy Trinity in West Chester, Pa. A family story says that there was reaction among orthodox Quakers against Bullock marrying a Hicksite Quaker, so Bullock and his bride became Episcopalians. Also, Bullock became less involved with Haverford College alumni affairs.

[102] *The Photographic Times and American Photographer*, XIV (November 1884), pp. 612-613.

[103] *The Philadelphia Photographer*, XXII (February 1885), p. 49. See also *The Photographic Times and American Photographer*, XV (January 23, 1885), p. 46. The exhibition opened January 11 and continued until January 16, 1886.

[104] *The Philadelphia Photographer*, XXIII (February 6, 1886), p. 82.

[105] "The Philadelphia Exhibition," *The Photographic Times and American Photographer*, XVI (January 22, 1886), p. 48.

[106] Robert A. Stebbins, *Amateurs: On the Margin Between Work and Leisure* (Beverly Hills and London: Sage Publications, 1979), pp. 19-44. The definition of a modern amateur is discussed by Stebbins, but there is much that is applicable to the nineteenth century.

[107] *Philadelphia Photographer*, January 1885, p. 25.

[108] *Philadelphia Photographer*, March 1885, p. 89.

[109] Moore, pp. 421-433.

# The Spirit of
# Secessionism in Philadelphia

The Photographic Society of Philadelphia (PSP) was founded in 1862 by a group of amateur photographers. They recognized the benefits of exchanging information and providing mutual support for each other. Among the founding members were powerful men of science such as Coleman Sellers, Fairman Rogers, and Frederic Graff.[110] Sellers was an engineer and inventor who designed locomotives, hand tools, and interchangeable parts for machine shafting. He proposed the use of glycerine to keep wet-plate negatives moist, and he patented an apparatus for exhibiting stereographs of moving objects.[111] Sellers was a life-long member of the PSP who served as corresponding secretary and president during the 1860's.

Like Sellers, Rogers was an engineer, but one whose career was spent in teaching. He lectured on mechanics at the Franklin Institute before becoming professor of civil engineering at the University of Pennsylvania. Rogers was a founding member of the National Academy of Sciences and the manager of the Pennsylvania Academy of the Fine Arts for many years.[112] Although he did not hold office in the PSP, he shared responsibility for organizing the first meeting and remained an active member throughout his life.

Life-long commitment to the PSP was also characteristic of Frederic Graff, an engineer recognized for his expertise on municipal water systems. After serving as chief engineer of the Philadelphia system for fifteen years, he designed water pumps and consulted on water supply for numerous cities. In addition, he conceived the idea for Fairmount Park, and was a founder of the Zoological Society and Gardens of Philadelphia. He was founding vice-president of the PSP and served as president at different times. Graff, like Sellers and Rogers, was influential in Philadelphia life and in providing the direction of the PSP for many years.[113]

Discussions at the early meetings of the PSP established photographic science and technique as primary concerns of the group. Among the subjects which captured the attention of members were: the merits of different lenses; the advantages of albumen printing; and variations in the chemistry of different processes.[114] Occasionally, fine prints were brought to meetings for viewing, but comments about these photographs tended to be about technical qualities rather than aesthetics. The advent of commercially available dry plates brought a new generation and diversity of members streaming into the PSP in the 1880's.[115] The relative ease of using dry plates contributed to an increased interest in photography and the rise in PSP membership. Discussions continued to focus on craft and technique, but in time, as the interests of the newer members diverged from those of older members, exhibitions received more attention in meetings.

Exhibitions had been a part of the activities of the PSP since the early years. Annual competitions with awards for the best landscape or portrait were special events for the members.[116] However, no previous Society exhibition could compare in size or scope to the International Exhibition of Photography held at the Pennsylvania Academy of the Fine Arts (PAFA) in 1886. In a single extraordinary effort, all previous PSP exhibitions were eclipsed.

So successful was the International Exhibition, that the Society was prepared to sponsor more large scale exhibitions. A "fair balance of profit to the credit of the Society" was reported by the Exhibition Committee, but the amount of work required to gain that profit must have left the Committee a little reluctant to make such an effort every year.[117] After talk among the members, the Committee recommended that the Boston Camera Club, the Society of Amateur Photographers of New York, and the PSP combine their efforts and jointly sponsor an annual exhibition which would rotate among the

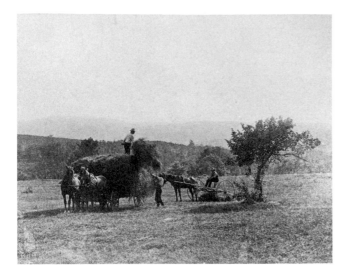

Figure 20. [Haying] by Robert S. Redfield, platinum print, circa 1899, The Library Company of Philadelphia.

three cities. Only once every three years would each group have to host the combined exhibition.

This recommendation was a brilliant stroke. The jointly held exhibitions would not interfere with annual members exhibitions of each group and would capture public attention better than exhibitions sponsored separately. Theoretically, prizes won at the new combined exhibitions would be more prestigious, since the best work from the whole country would be attracted to the new and enlarged competition. To gain the concurrence of the PSP, John G. Bullock offered the following motion:

> *Resolved, That the Photographic Society of Philadelphia hereby agrees to hold a general exhibition of photographs once in three years only, provided that the Society of Amateur Photographers of New York and the Boston Society of Amateur Photographers will make a similar agreement, with the object in view to unite our interests and improve our exhibitions thereby.*[118]

Bullock's role in motivating this grand scheme is not clear, but the framing of the idea was well in keeping with his earlier organizational efforts on behalf of Haverford and the PSP. It was characteristic of Bullock to see a need and then deduce a way to resolve the situation.

Letters communicating the resolution and rationale for the combined exhibitions were sent to New York and Boston. The responses were unanimously favorable, and the date and location of the First Joint Exhibition only remained to be negotiated.[119] On a

motion by John C. Browne, a committee of Bullock, Robert S. Redfield, and Charles R. Pancoast was appointed to arrange and carry out the plan. After some hedging by the Society of Amateur Photographers of New York, the exhibition was arranged for New York and was held for one week at the Ortgies Gallery (Broadway near Fourteenth Street) beginning March 26, 1887.[120]

The First Joint Exhibition included more than 1000 photographs judged by a five-person panel composed of both amateur and professional photographers.[121] Medals were not given, but diplomas were awarded in fifteen categories to twenty-four people. Among the prominent photographers to receive diplomas was the English photographer Peter Henry Emerson. A reviewer for *The Photographic Times and American Photographer*, however, was not overwhelmed by Emerson's photographs, sharply criticizing "Gathering Water Lilies," saying that the water in the picture "was as solid as the boat." John G. Bullock, who received a diploma for "best technical excellence with much artistic feeling in choice of subject,"[122] fared better, but on this occasion as well as others, Bullock shared honors with Robert S. Redfield:

> *It would be hard to recognize the work of Mr. Bullock . . . and Mr. Redfield apart; for their tastes seem to be very nearly the same in the kind of subjects selected and the method of treatment; not that either repeats the other; but the same general results apply to the work of both; than which neither could have higher praise . . . and that makes it [Bullock's work] extremely good.*[123]

Redfield (1849-1923) was born into a Quaker family of distinguished scientists.[124] He had studied photography in 1866 with Constant Guillou, the first president of the PSP, but only became seriously involved after dry plates became readily available.[125] Perhaps it was preordained that Bullock's and Redfield's photographic activities would be parallel, since both were proposed and approved for membership in the PSP at the same meetings,[126] and both served as officers of the PSP until 1901. Moreover, they had in common an appreciation for rural landscape imagery.

The beautiful scenery of eastern Pennsylvania served as subject matter for Bullock, Redfield, and other PSP members.[127] Bullock was especially attracted to the Delaware Water Gap area (plate no. 86), Raymondskill (plate no. 24), and the

Plate 71. Loading Hay, July 1899.

Wissahickon Valley (plate nos. 84 and 85). The similarity between Bullock's and Redfield's photographs included, but was not limited to, subject matter. In photographs of hay gathering (compare fig. 20 and plate 71) each conceived his image as a view of the men and the countryside. They often conceptualized their photographs in the same way, so their styles in photographing such subjects as fields with split-rail fences and marshy landscapes were frequently alike.

There were strong stylistic similarities among PSP members for several reasons. The older generation of photographers served as role models and often teachers for the younger generation and passed along preferences in subject matter and approach.

Exhibitions and discussions of members' work would have invited exchanges of visual concepts. In addition, camera outings would have encouraged influence among participants. One such outing was memorialized in a photograph labelled "The Bullock Group" by Louise Deshong Woodbridge (fig. 21). The photograph depicted Redfield, Henry Troth, and, of course, John G. Bullock.

Like Woodbridge, other PSP members looked to Bullock as a natural leader. He was respected by the membership of the group and was continuously elected vice-president from 1884 until 1889. In 1890, on the motion of John C. Browne, Bullock was unanimously elected president following the death of president Frederic Graff.[128] Bullock was re-

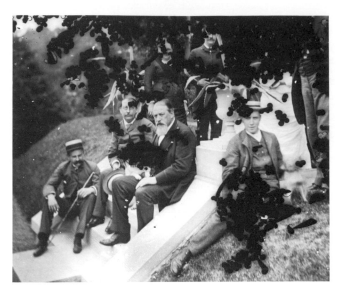

Figure 21. "The Bullock Group" by Louise Deshong Woodbridge, circa 1890, courtesy of the Delaware County Historical Society.

elected for another year, but then retired from that post, probably because of increased family and business pressures.

Bullock's two years as president of the PSP were a time of change and reorganization. He was the first of the younger generation (those who joined after the advent of dry plates) to become president. While he was well-schooled in the traditions of the PSP, his vision for photography was not limited by past experience. The PSP had grown considerably over the years to reach nearly 200 members.[129] During Bullock's presidency, a board of directors was created to manage business affairs and the organization relocated to a larger space in a more centrally located building, 10 South Eighth Street. The new board of directors improved the governance of the organization by facilitating discussion of administrative detail not easily accomplished at large general meetings. This change was reported in *The American Amateur Photographer* as "a step in the right direction."[130] The new location received similar approval, since the meeting and exhibition spaces were expanded.

The demands of leading the PSP did not deter Bullock from participating in exhibitions. Besides showing work at Newcastle-upon-Tyne (1890), he submitted work to the Calcutta Salon (1890), the PSP Competition (1891), the Liverpool Salon (1891), and the Fourth Joint Exhibition (New York,

1891). In addition, Bullock showed prints in one of the most significant exhibitions of the era, the 1891 "Ausstellung Künstlerischer Photographien," commonly called the Vienna Salon. This exhibition was the first international competition with the primary aim of presenting only the finest work from around the world, and it was rigorously judged by a panel of eleven painters and draughtsmen who selected 600 photographs by 160 image makers.[131] Forty American photographers sent photographs to the exhibition, but work by only ten was accepted.[132] Bullock had two photographs admitted and received a grand diploma. Another member of the elite group of Americans admitted to the exhibition was Alfred Stieglitz.

To Stieglitz, the Vienna Salon represented an ideal toward which American exhibitions were slowly progressing. The Fifth and Sixth Joint Exhibitions, held in Boston (1892) and Philadelphia (1893) respectively, contributed to that progress.[133] In Boston, for example, awards were no longer given by category, which previously necessitated in some instances giving awards among few entries and little competition.[134] Bullock showed six landscapes and received a diploma "which he well deserved."[135] Included among his entries was "Eastward As Far As the Eye Can See" (plate no. 21), one of his finest images.

The Sixth Joint Exhibition, presented in Philadelphia at the PAFA, was hailed by Alfred Stieglitz as "without doubt, the finest exhibition of photographs ever held in the United States, and probably was but once excelled in any country. I refer to the memorable exhibition at Vienna."[136] Stieglitz, who had recently accepted a position as a contributing editor at *The American Amateur Photographer*, was very complimentary toward the exhibition, because "a competent Board of Judges" of five painters and photographers had admitted only high quality work. However, the majority of the medals at the Sixth Joint Exhibition were awarded to photographers from England, a fact which caused Stieglitz to complain:

*The work shown by Englishmen is proof positive that we Americans are "not in it" with them when art photography is in question. Where are our Davisons, Gregers, Cembranos, Robinsons, Sutcliffes, Gibsons, Sawyers, Gales? . . . Still the present exhibition goes to show that we are progressing . . . .[137]*

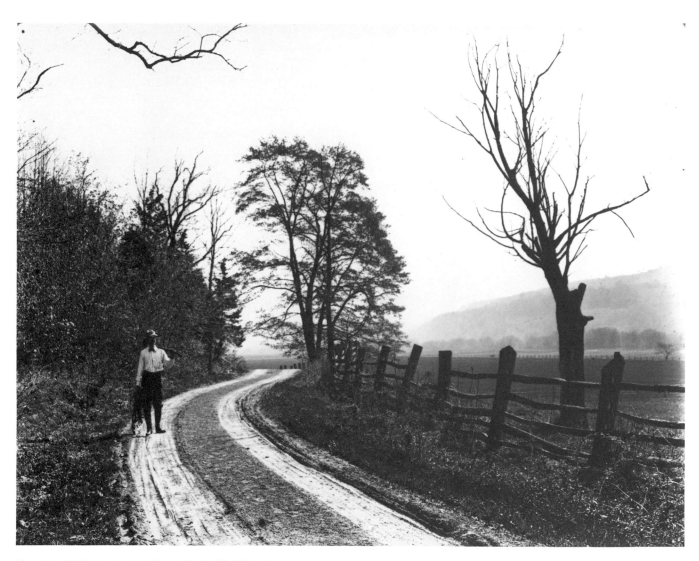

Plate 26. J.G.B. in Road, Above Bushkill, Pike County, May 10-16, 1893.

Stieglitz' praises for American photographers were most strongly directed toward Robert Redfield, whom he described as "one of the most talented of American photographers. He has an eye for the picturesque and a perfect knowledge of photographic manipulation."[138] Redfield was also praised by Stieglitz for having performed the "lion's share" of the exertion in managing the exhibition and working "for the cause of the improvement of art photography."[139]

Bullock did not fare so well. Stieglitz described him as a "mainstay" of the PSP who "has shown to better advantage in previous exhibitions. Some of his pictures . . . are too heavy in the shadows."[140] This comment was far from the condemnation sometimes employed by Stieglitz on work by other

photographers: "Technically good, pictorially rotten."[141] Although Bullock's pictures were admitted to the exhibition, the judges also must have had reservations, since he received no awards—even though John C. Browne was one of the judges.

The Seventh Joint Exhibition at New York in 1894 brought Bullock no greater fortunes. Once again his photographs were accepted into the exhibition (including plate nos. 25, 26, and 27), but received no awards. Stieglitz' review, which made passing mention of Bullock, said the work was "quite meritorious, but contained too many blacks."[142] There is some irony in this comment, considering Stieglitz' own work later would have predominantly black tones. Stieglitz believed that the exhibition was a failure. Although there was

some good work on display, he felt the judges had discredited themselves by taking only four hours to review 700 photographs![143]

The Joint Exhibitions came to an end after seven grand efforts. Boston was scheduled for the next one, but the Boston Camera Club voted to withdraw from the agreement under which the rotation had been occurring. The reason given was the tremendous amount of time required to make a success.[144] Joseph Keiley, a New York amateur photographer and friend of Alfred Stieglitz, believed differently:

> These began well, but in time, with the majority, their larger purpose was sub-ordinated to the desire for medal and riband, or place-winning. It soon became evident to the few who, understandingly, were striving for the advancement of photography as a picture-making medium, that the Joint Exhibitions had gotten into a rut that made future progress, through their assistance, impossible. The Exhibitions had ceased not alone to forward the movement, but were creating a condition and unsound standards that held back those who urged on, and were ignoring their warnings, were rapidly degenerating the whole movement.[145]

The passing of the Joint Exhibitions was not mourned. As early as 1893, the PSP Exhibition Committee had placed on the record some of the deficiencies of the Joint Exhibitions. The Committee, which included Bullock, Redfield, Edmund Stirling, Charles Pancoast, and Charles Mitchell, reported:

> There appears to be a strong feeling among those who have watched the progress of photographic exhibitions that the main interest centres more and more each year in the artistic side of photography. This is a gratifying acknowledgement of the claims of pictorial photography to rank as an art. Your committee having this fact in view and also feeling that now there is no lack of good material are disposed to recommend that at future exhibitions a rigid system of selection be instituted, only pictures of decided artistic merit being admitted and hung. The admission of a picture in itself would be an honor independent of any further awards it may be expedient to offer. While an exhibition so conducted would include a much smaller number of pictures, the average quality would be of a higher grade and the interest and value of the exhibition would be increased accordingly. An exhibition of this character, the work being selected by a careful and competent jury, would tend to greatly elevate the standing of art in the community, and would attract attention as an exhibition of pictures and not as a show of mere 'photographs.'[146]

The Committee had hopes for greater shows to come, as did Alfred Stieglitz, who proposed in 1895: "An Annual Photographic Salon, to be run upon strictest lines. Abolish medals and all prizes; acceptance and hanging of a picture should be the honor."[147] A consensus was forming about the kind of exhibition which would best represent artistic photography, but no immediate sponsor had yet come forth, not even the Society of Amateur Photographers, Stieglitz' own affiliation.

Between 1895 and 1898, Bullock exhibited less than before. Besides taking part in two shows in 1895 and one in 1897, the only other public display of his work consisted of lantern slide presentations. It was not uncommon in years previous to this period for him to participate in four or more exhibitions in a year. Yet Bullock's actual production of images increased at the same time his number of exhibitions decreased, at least as evidenced by the relative number of surviving negatives.[148] Most of the images he made at this time depicted his children: Marjorie (1889-1979), John E. (1891-1970), and Franck R. (1895-?) Bullock. His youngest child, Richard H.D. Bullock (1901-1975), was born later and also served as a frequent subject for his father's images. Photographs of the children were submitted to numerous exhibitions in the years following 1898, including the Philadelphia Salons, which marked a renewed commitment to exhibitions for Bullock.

In 1895, representatives of the PAFA contacted Robert Redfield,[149] then president of the PSP, to seek joint sponsorship of a Philadelphia Photographic Salon of "pictures . . . as may give distinct evidence of individual artistic feeling and execution."[150] Photography had become fashionable, and the managers of the PAFA were seeking to attract large audiences like those drawn to the earlier photography exhibitions. At the outset, Redfield recognized there would be problems.[151] The PSP was an organization which had managed for years to hold together a loose alliance of disparate interests in photography. The group had among its ranks those interested in scientific, technical, commercial, personal, and artistic photography. There were serious amateurs and professionals, as well as hobbyists, and those who simply enjoyed socializing. The exhibition sought by PAFA would exclude the comprehensive interests of the PSP in favor of artistic photography alone.

Redfield wrote to Stieglitz seeking advice and the loan of catalogues which might serve as models for the Salon catalogue. The letter bubbled with enthusiasm for the Salon:

> As the first suggestion to hold such an exhibition was made to us by the Academy Management we consider that photography as a fine art has received a great compliment and it gives us an opportunity to get up an exhibition purely on artistic lines which I feel is hardly practical for a Society devoted to the general development of photography to hold by itself. At least the general support of its members would hardly be given to such an exhibition.[152]

Both Redfield and Stieglitz saw the Salon as an opportunity to achieve the as yet elusive, true international exhibition of art photography. By March, a PSP committee consisting of Bullock, Redfield, and George Vaux, Jr., had most of the details of the exhibition worked out with the PAFA officers, including a guarantee fund from PSP members to insure the PAFA against financial loss. Twenty PSP members, including Bullock, contributed equally to make a total of $150.[153] Broadsides sent out to solicit photographers to submit work for judging gave the following information:

> No pictures will be accepted which have already been shown in Philadelphia at any exhibition open to the general public. No special awards are offered, and no charge will be made to exhibitors. Each exhibitor will be furnished with a certificate of the acceptance of his work.[154]

The jury of selection, announced in the broadside, consisted of painters William Merritt Chase and Robert Vonnoh, illustrator and amateur photographer Alice Barber Stephens, and photographers Redfield and Stieglitz.

Stieglitz' influence on photography had grown tremendously in the 1890's and could be felt even more in Philadelphia by his membership on the Salon jury. As an editor of *The American Amateur Photographer*, and later as the editor of *Camera Notes*, Stieglitz had become a powerful voice in favor of the artistic refinement of photography. His photographs had been internationally exhibited and had received many awards. He was something of a celebrity by the time of the Philadelphia Photographic Salon,[155] and that status further contributed to his influence. When Stieglitz spoke, most people listened.

John G. Bullock and Robert Redfield, organizers of the Salon, were associates of Stieglitz even at that time, because Stieglitz knew and respected them, and had reproduced their photographs in *Camera Notes*.[156] This personal contact enhanced Stieglitz' influence on the Salon even further, especially considering that Chase and Vonnoh were too busy to come to the judging sessions, leaving the task to Redfield, Stephens, and Stieglitz.[157]

The Salon was extraordinarily popular with the public and the press. Over 13,000 people visited the show, which opened on October 24 and closed on November 18 after a one week extension.[158] A banner headline citing "Choice Photographs From The Academy Exhibition" in the second section of *The Philadelphia Press* trumpeted public approval. Half the page was filled with reproductions of photographs in the exhibition.[159] An accompanying review quoted William Merritt Chase as saying that Gertrude Käsebier's portrait of a "Mother and Child" was as fine as any that Van Dyke painted.[160]

The exhibition comprised 259 photographs selected from more than 1500 entries.[161] Bullock was one of ninety-one photographers chosen to be in the exhibition, but he was represented by only one print.[162] Most important, however, was that work by Bullock and other future Photo-Secessionists were brought together for the first time. Clarence White, Gertrude Käsebier, Eva Lawrence Watson (later Watson-Schütze), Redfield, and Bullock all showed in the Salon.

The Philadelphia Photographic Salon was so successful that both the PSP and PAFA were favorably disposed toward another Salon in 1899. On the initiative of the PSP this time, the two organizations agreed to sponsor the Second Philadelphia Photographic Salon on the same terms. Representatives of the two institutions from the year before did not change. The guarantee fund, to which fifteen PSP members contributed including Bullock, was once again established.[163] The jury of five photographers included F. Holland Day, Henry Troth, and three future members of the Photo-Secession: Käsebier, White, and Frances B. Johnston.

The results of the Second Salon were not dramatically different from the First. There were slightly more people in attendance (17,000) and more photographs in the show (350). The exhibition was held October 22 to November 19, about the same length of time as the First Salon. John G. Bullock was again represented, only this time he had two photographs in the show. Since the Salon was not a new idea, as in

the year before, there was less excitement among the critics. Nonetheless, everyone seemed satisfied, particularly the PAFA, as recorded by its annual report: "The success gained by this and the preceding Salon has given Philadelphia a leading place in this field."[164] The direction of leadership, however, was about to be severely criticized.

The Third Philadelphia Photographic Salon in 1900 seemed to proceed as had the other two. Again, the jury consisted only of photographers, including Stieglitz, Käsebier, Frank Eugene, and Eva Watson, all future members of the Photo-Secession. They selected a significantly smaller number of photographs (118) to which were added almost as many unjuried prints (86) to make up the show of 204 photographs. The unjuried prints were those by the judges and those by foreign photographers who were invited to send work. The foreigners otherwise would not risk the expense of sending prints which might be rejected by the jury.

Critics immediately reacted unfavorably to the exhibition. Some like Charles L. Mitchell, a member of the PSP and earlier proponent of the Joint Exhibitions, felt that half of the pictures in the Salon "could never have been submitted to a jury at all,"[165] a blunt attack upon the large number of invitational prints. He also singled out individuals, such as Bullock, for committing the sin of joining the "New School" of photography.[166] Mitchell and his followers condemned the Salon for being "impressionistic," that is, for having employed selective depth-of-field and soft focus. Charles Pancoast, a PSP member who had served on Joint Exhibition committees, aired his opposition to the "New School" to a newspaper reporter. Impressionism to Pancoast was a passing fad: "It has been tried abroad and proved to be only a fad with no artistic merit."[167] Only "Old School" pure photography, which generally meant sharply focused and retouched images, appealed to adversaries of the Salon. The "Old School" photographers preferred traditional exhibitions which mixed architectural, landscape, genre, scientific, and decorative photography together.[168] For Mitchell, the Third Philadelphia Salon had "too many impressions . . . too few realities."[169]

The photographs by John G. Bullock which drew fire from Mitchell were "Tree Study" and "The Coke-Burner" (plate no. 75).[170] While it is not known to which tree photograph the former title refers, it might well be one like those Bullock made just after the Third Salon (plate nos. 78 and 84). Mitchell considered "Tree Study" far inferior to the beautiful compositions with which Mr. Bullock used formerly to grace the exhibition of the Photographic Society of Philadelphia."[171] "The Coke-Burner" was rated only slightly better by Mitchell: "It is quite effective, but it does not seem necessary to treat so small a print in so broad a style."[172] The meaning of this statement is vague, but it likely related to Mitchell's opposition to the "New School."[173]

Having publicly declared his views, Mitchell had polarized PSP members and set the stage for confrontation. Edmund Stirling, newspaper writer and member of the PSP Salon Committee, kept Stieglitz informed of the unfolding events in a lively series of letters. Even before Mitchell published his criticisms, Stirling anticipated confrontation:

*We are likely to have a fight on our hands this fall in our own Society—that is some of the discontented ones are talking very loud, & one of them, Dr. C.L. Mitchell has written two very insulting letters to Redfield on the subject of the "experiments & failures of a lot of cranks" which we have chosen for our Wall Displays [at the PSP], & he threatens to disrupt the Society if we don't be "Catholic in our methods" & suppress all interest in anything but what he calls "pure photography," . . . John Bullock is our wise counsellor at present and I hope we shall not get into an undignified squabble. We are pretty strong and so far the advantage is with us.[174]*

It was characteristic of Bullock to work quietly and rationally to resolve difficulties, but he was wise enough to know when a fight was necessary.

The opening battles were won by proponents of the "New School." Mitchell introduced two motions at the November 1900 meeting of the PSP which were brought up for consideration at the December meeting. The first motion concerned exhibiting at the PSP the work rejected from the Salon of 1900. The second motion sought to sever the relationship between the PSP and its own Salon Committee! Both motions were defeated.[175] Moreover, at the February 1901 PSP meeting, resolutions were adopted which thanked the PAFA for past cooperation and authorized PSP President Redfield to appoint a committee to arrange yet another Salon.[176]

But Robert Redfield announced in February that he had decided a year before not to seek re-election as president. Nominations presented at the March meeting showed S. Hudson Chapman of the "Old

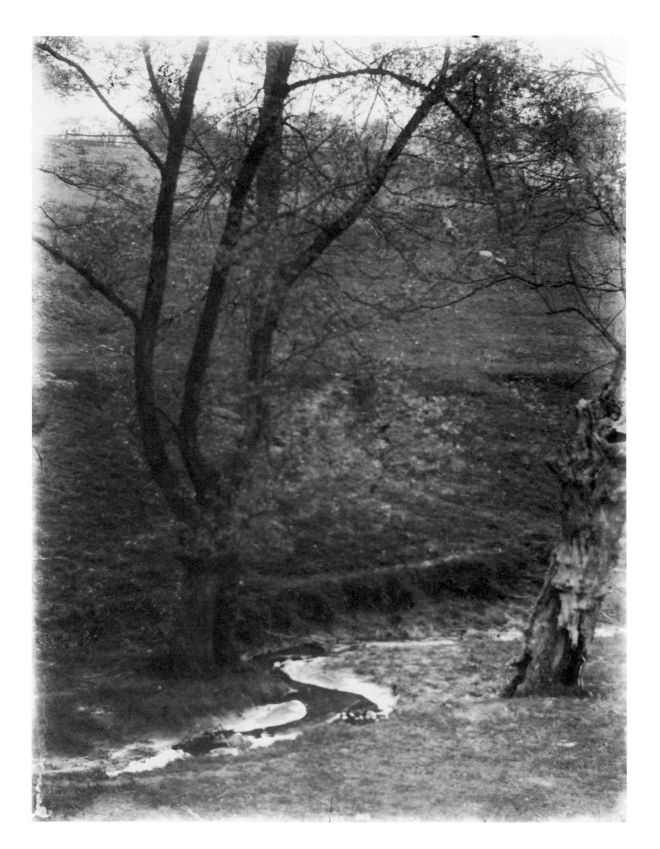

Plate 78. An Impression, Willow Tree Near Lincoln Drive, [Philadelphia], May 1901.

School" running against George Vaux, Jr., of the "New School." Bullock and Redfield accepted nomination to the board of directors. The balloting at the annual meeting in April resulted in a victory for Chapman and the "Old School," although Bullock and Redfield were elected to the board.[177] Stirling reported the results the next day in a letter to Stieglitz:

> I've been waiting from day to day before writing you, in the hope that I'd some news for you. And I have, but not what I hoped! We are beaten in the election last night by 4 votes out of 78 or 79. It was a case of misplaced confidence. The other fellow was so impossible some of our friends did not take it seriously while the Mitchell party marshalled all the kickers, the fellows who stopped work 5 or 10 years ago and expect the Society to do the same, and some of the younger members who, I suppose, jumped at the chance to join in a kick. . . . Of course Bullock, Redfield and I will resign and leave the matter open, as we cannot go to the Academy as matters rest now.[178]

Stirling announced the expectation that he, Bullock, and Redfield would resign from the Salon Committee, since the change in PSP leadership would preclude negotiations with the PAFA for another Salon without reaffirmation from the new leadership. Desiring to appoint his own committee,[179] Chapman accepted their resignations. When Chapman had difficulty assembling a creditable committee, he approached Bullock about rejoining, but Bullock declined, saying that Chapman's election was based upon hostility to the Salon Committee of 1900 and what it represented.[180]

The Fourth Philadelphia Photographic Salon in 1901 was finally held and declared a success in the newspapers, even though many of the most prominent American and European photographers did not participate. The PAFA afterwards declined to support another Salon. Bullock and his "New School" colleagues remained in the PSP for the moment, although he and Redfield resigned from the board of directors.[181] The PSP held discussions about sponsoring a fifth Salon, but realized that without the support of the PAFA, too large a guarantee fund would be required.[182] A resolution was passed which called for a Salon in some future time when the PAFA might have a change of heart, a hope which never materialized.

As a result of the strong differences which erupted in the PSP, the "New School" photographers gradually left the group. Stieglitz, who had been elected an honorary member in 1900, resigned in 1902. Käsebier, who had joined in 1901, also resigned in 1902. The resignations of Bullock, Redfield and Stirling were accepted at the December meeting that same year.[183] As the year came to a close, so did a chapter in photographic history, at least for Philadelphia. The departures of important members from the PSP amounted to a secession of the most prominent art photographers that organization had ever known. The interests of these art photographers shortly would be shifted to New York, where Stieglitz was prepared to unite those who had suffered similar difficulties throughout America.

[110]John C. Browne, *History of the Photographic Society of Philadelphia* (Philadelphia: Photographic Society of Philadelphia, 1884), pp. 6-7.

[111]"Sellers, Coleman," *The National Cyclopedia of American Biography* (New York: James T. White & Company, 1909; Ann Arbor: University Microfilms, 1967), vol. XI, p. 53.

[112]"Rogers, Fairman," *The National Cyclopedia of American Biography*, vol. XI, p. 60.

[113]"Graff, Frederic," *The National Cyclopedia of American Biography*, vol. IX, p. 514.

[114]Browne, pp. 1-36.

[115]Browne, p. 33.

[116]Anne B. Fehr and William Innes Homer, "The Photographic Society of Philadelphia and the Salon Movement," in Homer, William Innes, *Pictorial Photography in Philadelphia: The Pennsylvania Academy's Salons 1898-1901* (Philadelphia: Pennsylvania Academy of the Fine Arts, 1984), p. 5.

[117]*The Photographic Times and American Photographer*, XVI (March 26, 1886), p. 173.

[118]*The Photographic Times and American Photographer*, XVI (March 26, 1886), p. 173.

[119]*The Photographic Times and American Photographer*, XVI (May 21, 1886), p. 279. See also the account of the meeting of the Society of Amateur Photographers of New York in *The Photographic Times*, XVI (May 14, 1886), p. 265.

[120]*The Photographic Times and American Photographer*, XVII (January 28, 1887), p. 48.

[121] The judges included the professional photographers James D. Smillie and George G. Rockwood and the amateur photographers E. Wood Perry, Jr., C.Y. Turner, and George C. Cox.

[122] *The Photographic Times and American Photographer*, XVII (April 8, 1887), p. 163.

[123] *The Photographic Times and American Photographer*, XVII (April 15, 1887), p. 198.

[124] Mary Panzer, *Philadelphia Naturalistic Photography 1865-1906* (New Haven: Yale University Art Gallery, 1982), p. 41.

[125] Panzer, p. 41.

[126] "Minutes Photographic Society of Philadelphia April 18, 1878—," mss., Sipley Collection, International Museum of Photography at George Eastman House, Rochester, April 5, 1882 and May 3, 1882.

[127] Panzer, p. 10.

[128] *The Photographic Times and American Photographer* XX (May 1890), p. 229.

[129] The number of members was estimated based upon 1884 and 1897 membership lists.

[130] *The American Amateur Photographer* III (March 1891), p. 116.

[131] Weston J. Naef, *The Collection of Alfred Stieglitz: Fifty Pioneers of Modern Photography* (New York: The Metropolitan Museum of Art / The Viking Press, 1978), p. 22.

[132] *The American Amateur Photographer* III (July 1891), pp. 268-269. The ten accepted American photographers were: James L. Breese, Alfred Stieglitz, Mary Martin, Harry Reid, John E. Dumont, George B. Wood, Mrs. N. Gray Bartlett, H. McMichael, George A. Nelson, and Bullock.

[133] Alfred Stieglitz, "The Joint Exhibition at Philadelphia," *The American Amateur Photographer* V (May 1893), p. 201.

[134] Catherine Weed Barnes, "The Boston Fifth Annual Joint Exhibition," *The American Amateur Photographer* IV (June 1892), p. 259.

[135] Barnes, p. 262.

[136] Stieglitz, "The Joint Exhibition at Philadelphia," p. 201.

[137] Stieglitz, "The Joint Exhibition at Philadelphia," p. 201.

[138] Stieglitz, "The Joint Exhibition at Philadelphia," p. 206.

[139] Stieglitz, "The Joint Exhibition at Philadelphia," p. 206.

[140] Alfred Stieglitz, "The Joint Exhibition at Philadelphia," *The American Amateur Photographer* V (June 1893), p. 252.

[141] Naef, p. 27.

[142] Alfred Stieglitz, "The Seventh Annual Joint Exhibition," *The American Amateur Photographer* VI (May 1894), p. 218.

[143] Stieglitz, "The Seventh Annual Joint Exhibition," p. 218.

[144] *The American Amateur Photographer* VII (January 1895), p. 26.

[145] Fehr and Homer, p. 8.

[146] Joseph T. Keiley, "The Decline and Fall of the Philadelphia Salon," *Camera Notes* V (April 1902), p. 281.

[147] Fehr and Homer, p. 8.

[148] There are thirty surviving negatives from 1891-1894, as compared to 135 negatives from 1895-1898.

[149] Robert S. Redfield, letter to Alfred Stieglitz, 18 February 1898, The Yale Collection of American Literature, Beineke Rare Book and Manuscript Library, Yale University.

[150] "Philadelphia Photographic Salon," catalogue, Archives of Pennsylvania Academy of the Fine Arts, 1898, p. 5.

[151] Panzer, p. 13.

[152] Redfield, February 18, 1898.

[153] "Guarantee Fund," mss., Philadelphia Photographic Salon Scrapbook, Sipley Collection, International Museum of Photography at George Eastman House, Rochester, 1898.

[154] "The Philadelphia Salon," broadside, 1898, Archives of Pennsylvania Academy of the Fine Arts.

[155] Marguerite J. McLaughry and William Innes Homer, "Stieglitz and the Philadelphia Photographic Salons," in Homer, William Innes, *Pictorial Photography in Philadelphia: The Pennsylvania Academy's Salons 1898-1901* (Philadelphia: Pennsylvania Academy of the Fine Arts, 1984), p. 12.

[156] McLaughry and Homer, p. 12. Bullock's photograph "The White Wall" was reproduced in *Camera Notes* V (April 1902), p. 275. Redfield's work was reproduced in *Camera Notes* IV (January 1901), p. 131; IV (April 1901), p. 245; and V (April 1902), p. 265.

[157] McLaughry and Homer, p. 12.

[158] McLaughry and Homer, p. 13.

[159] "Choice Photographs From The Academy Exhibition," *The Philadelphia Press*, November 13, 1898, Second Part, p. 17.

[160] Harrydele Hallmark, "Possibilities of the Camera," *The Philadelphia Press*, November 13, 1898, Second Part, p. 22.

[161] McLaughry and Homer, p. 12.

[162] The photograph in the exhibition was titled "Lines in Pleasant Places." It has not been possible to determine to which image that title refers. Bullock often labeled his negatives with informational titles different from the ones he used in exhibitions.

[163] "Guarantee Fund," Philadelphia Photographic Salon Scrapbook, Sipley Collection, International Museum of Photography at George Eastman House, Rochester, 1899.

[164] *Pennsylvania Academy of the Fine Arts. Ninety-Third Annual Report* (Philadelphia: Pennsylvania Academy of the Fine Arts, 1900), p. 13.

[165] McLaughry and Homer, p. 17.

[166] McLaughry and Homer, p. 19.

[167] "Photographers Denounce the Academy's Recent Display of Freakish Pictures," *Philadelphia Evening Item* 54 (November 19, 1900), p. 1.

[168] McLaughry and Homer, p. 19.

[169] McLaughry and Homer, p. 19.

[170] "The Third Philadelphia Salon," catalogue, Archives of the Pennsylvania Academy of the Fine Arts, 1900, p. 10.

[171] Charles L. Mitchell, "The Third Philadelphia Salon," *The American Amateur Photographer* V (December 1900), p. 565.

[172] Mitchell, p. 565.

[173] The version of "The Coke-Burner" that Mitchell saw in the Salon was probably cropped so that only the left one-third of the image was represented, similar to a print of this photograph held in the Quaker Collection of Magill Library, Haverford College.

[174] Edmund Stirling, letter to Alfred Stieglitz, July 28, 1900, The Yale Collection of American Literature, Beineke Rare Book and Manuscript Library, Yale University.

[175] *Journal of the Photographic Society of Philadelphia* VII (December 1900 - January 1901), p. 2.

[176] *Journal of the Photographic Society of Philadelphia* VII (February 1901), p. 17.

[177] *Journal of the Photographic Society of Philadelphia* VII (March and April 1901), p. 29.

[178] Edmund Stirling, letter to Alfred Stieglitz, April 11, 1901, The Yale Collection of American Literature, Beineke Rare Book and Manuscript Library, Yale University.

[179] Edmund Stirling, letter to Alfred Stieglitz, April 16, 1901, The Yale Collection of American Literature, Beineke Rare Book and Manuscript Library, Yale University.

[180] Edmund Stirling, letter to Alfred Stieglitz, April 19, 1901, The Yale Collection of American Literature, Beineke Rare Book and Manuscript Library, Yale University.

[181] *Journal of the Photographic Society of Philadelphia* VIII (March-April 1902), p. 9.

[182] *Journal of the Photographic Society of Philadelphia* VIII (May-June 1902), p. 21.

[183] *Journal of the Photographic Society of Philadelphia* VIII (October-November-December 1902), p. 31.

# Bullock, Stieglitz,
# and the Photo-Secession

The conflicts which resulted in conservatives reasserting authority over the Photographic Society of Philadelphia (PSP) were similar to those which took place in the Camera Club of New York.[184] *Camera Notes*, the Club's official journal edited by Alfred Stieglitz, became the focus of battles between the Old School and the New School.

In 1897, Alfred Stieglitz had proposed that the Club's newsletter could be converted at low cost to an illustrated quarterly with influence and readership well beyond the organization. By combining a small subsidy from the Club with advertising revenues, the new journal could be offered without charge to Club members and for profit to outsiders. The content of the journal would include Club activities and "everything connected with the progress and elevation of photography."[185] Stieglitz' proposal was not only accepted, but also he was given nearly complete editorial freedom.

During the next five years, Stieglitz and a group of close associates carefully selected photographs and articles for publication and made the quarterly journal highly prized among an international following.[186] From time to time conservative members of the Club expressed objections to the New School dominance over the *Camera Notes*, but support continued. In an effort to provide balanced coverage, Stieglitz duly published remarks by opponents. In one instance, a Club member was particularly sharp in his comments:

*A growing and very dangerous Tarantism has inoculated the club, and it appears that nothing is artistic which is not outré, nothing beautiful which not bizarre, nothing worthy of attention which is not preposterous, nothing serious unless untranslatable. Photography has no legitimate field except impressionism and sensationalism. . . . This fad . . . will soon pass away and we will recognize that a photograph to be artistic need not be hideous.*[187]

An organized attack was mounted in 1900, and opponents wrested away control of reporting Club activities.[188] In 1901, opponents forced Stieglitz to gain permission to print reviews of Club members' exhibitions.[189] Stieglitz finally had had enough, and he notified the trustees of the Club that he was resigning as editor at the completion of the July 1902 issue.[190] With a new editor and format, the journal lasted only three issues. Stieglitz hardly had time to notice, since, even before his departure from *Camera Notes*, he was already involved in founding new publications and the Photo-Secession. In essence, Stieglitz and the New School had gained independence by seceding from the restraints of the Camera Club of New York.

In launching the Photo-Secession, Stieglitz gathered together those photographers, such as John G. Bullock, with whom he had favorable personal and aesthetic associations over the years. The first known contact between Bullock and Stieglitz had occurred in January 1891, just four months after Stieglitz returned from nearly nine years of continuous residence abroad.[191] Stieglitz included Bullock's photographs among those he sent to the landmark 1891 Vienna Salon.[192] Promoting the Vienna Salon must have been Stieglitz' earliest such effort on behalf of American photographers. He was not yet even a member of the Society of Amateur Photographers of New York.[193]

Exhibitions were the primary reasons Bullock and Stieglitz had intermittent contacts throughout the 1890's. The most sustained interaction occurred as a result of Stieglitz' involvment with the Philadelphia Salons. During that time the salutation on Bullock's letters to Stieglitz changed from "Dear Mr. Stieglitz" to "My dear Stieglitz." The content of the letters concerned the conflicts within the PSP over the Salons. A topic of one letter in 1901 was S. Hudson Chapman's attempts to assemble a Salon

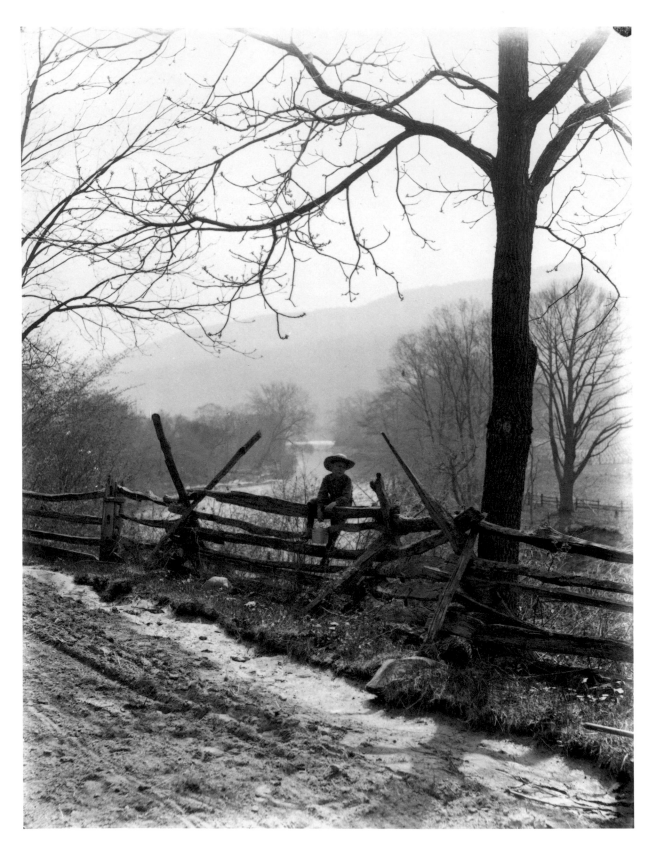

Plate 25.  Boy on Fence with Kettle #2, Pike County, May 10-16, 1893.

jury. Bullock took a dim view of the jurors who were finally selected. In a letter to Stieglitz, he described one of the jurors as:

*the old type of photographer versed in the manipulation of photography but he is most emphatically opposed to the "new school." He is an old friend of mine with whom I am intimate and we have had many, many verbal fights over the subject. So now you know about what the character of the jury is.*[194]

Bullock went on in the letter to tell Stieglitz about a paper by Chapman on art photography delivered at a PSP meeting, and added sarcastically: "I wish you could have heard it; you would like to have it for the [Camera] Notes???"

Chapman was not among those included in *Camera Notes*, but Bullock was. A short review of a three-person exhibition with Redfield and Stirling at the Camera Club of New York appeared in the January 1902 issue. Interestingly, this brief notice called attention to the differences rather than the similarities among the three:

*[the exhibition] is particularly interesting as showing the individuality of three different workers in photographic art. Were any demonstration needed that it is possible for a photographer to impress upon his work the stamp of his own temperament it would be furnished by these prints.*[195]

Bullock showed thirty-three prints as a general survey of his work; writing to Stieglitz: "I let them go as representing in a way the changes which come over us with time and newer ideas."[196]

Bullock was next included in *Camera Notes* when his photograph "The White Wall" (plate no. 76) was published in the April 1902 issue.[197] This image was much more daring than his previous work. A comparison with the earlier photograph, "Boy on Fence With Kettle #2," made in May 1893 (plate no. 25), shows that Bullock was attempting to change his style. The earlier image is basically frontal like most of Bullock's work, with space defined by compositional lines and atmospheric effect. It is typically picturesque in keeping with Bullock's style of vernacular photography. By contrast, the later image is oblique to the subject and makes more dramatic use of diagonal lines. Shapes are much more important than earlier. Perhaps because it seemed that Bullock was trying to be more modern, "The White Wall" particularly appealed to Stieglitz, who selected it on several occasions for exhibitions.[198]

Stieglitz must have recognized that Bullock's abil-

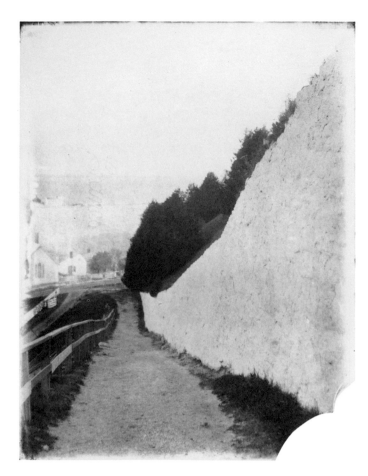

Plate 76. The White Wall, Old Fort Mackinac Island, Michigan, July 1900.

ity to change and evolve contributed vitality to the work and was an example for others. Stieglitz was sympathetic to Bullock, who was frustrated by the conflicts with the reactionary Old School photographers. Bullock particularly felt the sting of the conflicts and said so to Stieglitz:

*By this time you will have heard from Stirling of the unhandsome treatment we received last night at the Society. I have served as President, Vice-President and member of the Board of Directors for a longer continuous period than any other member of the Society and I feel the stab pretty keenly. . . . I don't know but that we can be of more use to the "cause" and to our own pleasure, outside the Society than in it.*[199]

There was solace to be found in talking to Stieglitz, because he understood the problems Bullock and his friends were having. In return, Bullock felt it necessary to thank Stieglitz by expressing his gratitude for Stieglitz' harsh criticisms of the Philadelphia Salons: "I thought at the close of the first salon that you were

57

a little 'hard' on us, but I believed afterward that your criticisms were mostly just, and certainly prevented our feeling too much elated or self-confident after our first attempt."[200]

The need for Bullock and his friends to seek mutual support outside established organizations was yet another manifestation of a pattern which had begun abroad in 1892. That year, members of the Photographic Society of Great Britain walked out of a meeting as a result of a dispute over the rigid interpretation of exhibition rules. Henry Peach Robinson, George Davison, Alfred Maskell, and other art photographers were upset not only about the interpretation of the rules, but also about the great attention paid to technique in the proceedings of the organization. They subsequently resigned and established the Linked Ring, a new group devoted to art photography. One of the activities of the new group was their own annual, juried exhibition, the London Salon. Bullock exhibited several times in the Salon along with Stieglitz, who was a member of the Linked Ring.

Bullock respected and trusted Stieglitz tremendously. The trust was required of those who would be the founders of the Photo-Secession. Stieglitz needed to be able to act in what he felt was the best interest of the group without fear of disenchantment. Moreover, Stieglitz wanted a loyal following as he was faced with competition from F. Holland Day (1864-1933) for the leadership of American artistic photography. Day, like Stieglitz, was from an affluent background and could afford to pursue almost any interest he desired. He chose photography, and, in time, the Boston Camera Club became the means for him to promote his ideas about artistic photography.[201] In 1900, Day assembled an exhibition of nearly 300 artistic American photographs and sought Stieglitz' collaboration in presenting the show in New York. When Stieglitz would not cooperate, Day endeavored to take the exhibition to London under the title "New American School of Photography" with the support of the Linked Ring. Stieglitz sent a telegram advising refusal of the show.[202] Upon learning that the Linked Ring would not support his project, Day simply offered the exhibition to the rival Royal Photographic Society (formerly called the Photographic Society of Great Britain) which was quite willing to provide sponsorship. The exhibition was a stunning success. Bullock and other Stieglitz associates were among those whose work was included in the show. Thereafter, Stieglitz strived harder to consolidate his own leadership of American photography and establish an organization devoted to art photography in New York.[203]

Stieglitz' first action on behalf of the Photo-Secession was to organize entirely under his own direction an exhibition in New York.[204] The search for a suitable gallery resulted in an invitation from the managing director of the National Arts Club at 37 West Thirty-Fourth Street.[205] The exhibition included 162 pictures by some of the best known pictorial photographers of the time, such as Käsebier, White, Edward Steichen, and Bullock. Stieglitz had selected his two favorite Bullock images to be shown: "The Coke-Burner" and "The White Wall" (plate nos. 75 and 76).[206] When the National Arts Club exhibition opened on March 5, 1902, it was the first time many of the exhibitors heard the name "Photo-Secession." Gertrude Käsebier was one who asked Stieglitz about it, as he recounted later:

*"What's this Photo-Secession? Am I a Photo-Secessionist?" My answer was, "Do you feel you are?"*
*"I do."*
*"Well, that's all there is to it," I said.*[207]

Not all of those who inquired received a positive response, despite being included in the exhibition. Half of those who exhibited at the National Arts Club were members of the Photo-Secession, Stieglitz claimed.[208]

This first exhibition "arranged by the Photo-Secession" closed on March 24 and was a great success. The Photo-Secession had been established but needed to be better defined.[209] It was, therefore, a matter of drawing upon the advice of the "members" and setting out the purposes of the group. Various drafts of plans were circulated, and in responding to Stieglitz about one plan, Edmund Stirling reported that he and Bullock had reviewed it together and concurred that there should be two classes of membership.[210] A small journal issued in December in the name of the group conveyed the finished statement:

*The object of the Photo-Secession is:*
*To advance photography as applied to pictorial expression;*
*To draw together those Americans practicing or otherwise interested in art, and*
*To hold from time to time, at varying places, exhibitions not necessarily limited to the productions of the Photo-Secession or to American work.*[211]

The organization was to consist of a council made up of a director (Stieglitz) and twelve founders (who were also called fellows) who would manage activities until 1905.[212] Then, five additional fellows would join the Council and share in decision making. Fellows were entitled to exhibit two new pictures in all Photo-Secession exhibitions without submission to a jury. They would also vote on applicants to the second category of membership, the associates, those who would be members but would have to submit their work to be juried. "Interest in the aims of the organization" was the only stated requirement to be an associate.[213] Bullock was one of the founders and fellows of the Photo-Secession. The nature of his participation in Council activities is not known, since no minutes of meetings have come to light. Council actions were reported from time to time in Photo-Secession publications. For example, the Council decided not to endorse either of two rival 1903 exhibitions in London[214] but, at the same time, enthusiastically accepted the invitation to exhibit as a group at the 1903 Chicago Salon.[215] Slightly later, an exhibition surveying sixty years of pictorial photography sponsored by the Photo-Secession was approved by the Council.[216] Perhaps the most important actions by the Council were approval of more than seventy new members between 1902 and 1909.[217] The first list of proposed associates was assembled after Stieglitz solicited recommendations from various founders.[218] Most often, Council decisions, especially about membership, were made through exchanges of letters.

The looseness of the organization might suggest that the Photo-Secession lacked cohesiveness, but, especially in the early days, only the opposite was true. Commitment to the "cause" of promoting art photography bound the far-flung members together. They shared Stieglitz' belief that photography was an art equal to painting and sculpture, and it was worthy of being shown and collected by museums. Moreover, the Photo-Secessionists were at odds with those willing to compromise on artistic standards. Frequent letters among members and occasional visits between some of them helped maintain contact. The New York members held informal dinners once a month at Mouquin's Restaurant.[219] The first such dinner was attended by several Philadelphia members, a practice which surely continued. Philadelphia members also met occasionally at the home of George Vaux, Jr., in suburban Philadelphia.[220] Vaux had joined the Photo-Secession as an associate in 1902.[221]

Perhaps the most important link among Photo-Secessionists was *Camera Work*, the journal founded by Stieglitz in 1902.[222] Stieglitz insisted that the new journal was "an independent magazine devoted to the furtherance of modern photography,"[223] but the ideas he wished to promote were those of the Photo-Secession, and the subscribers he solicited first were the members of the group. Bullock immediately subscribed and offered to seek other subscribers:

*Nothing could give me greater pleasure than to send you enclosed subscription to the new "Work." All success to it! If you have a few extra circulars and subscription blanks please mail them to me as there are some persons to whom I would give them & I hope become subscribers.[224]*

The model for *Camera Work* was *Camera Notes*, but unlike the earlier journal the new one made fewer compromises in quality. There were no reports of camera club activities in *Camera Work*, and only the most select images were reproduced. In short, *Camera Work* propagated the ideas espoused by Stieglitz and the members of the Photo-Secession.

The strongest promotion of the Photo-Secession was through exhibitions. General Luigi Palma di Cesnola, director of the Metropolitan Museum of Art and American Commissioner to the Esposizione Internazionale di Arte Decorativa Moderna in Turin, asked that the Camera Club of New York prepare an American display of artistic photography for the 1902 Turin Exposition.[225] The committee appointed to assemble the photographs consisted of Stieglitz, Joseph Keiley, and Charles Berg, but Stieglitz quickly became dominant.[226] Work by thirty photographers, mostly Photo-Secessionists, was selected. Bullock was represented by one image, "The Coke-Burner" (plate no. 75) and received one of the nineteen awards given to Americans. King Victor Emmanuel III also bestowed upon the whole American display a special award which became the subject of some confusion. The award was mistakenly given to the Camera Club of New York, since the original request was made of that body. Stieglitz corrected the error, saying that the show was from the "Photo-Secession."[227] General di Cesnola eventually untangled the confusion.[228]

Exhibition invitations poured in as a result of the favorable publicity from the initial exhibitions of the

Photo-Secession.[229] Bullock was represented in many of the shows, including: the Salon of the Colorado Camera Club, Denver, 1903; the Cleveland Camera Club Salon, 1903; the San Francisco Salon, 1903; the Hamburg Jubilee Exhibition, 1903; Cercle de L'Art Photographique,"L'Effort," Brussels, 1903; the Photo-Club de Paris Salon, 1903; the St. Petersburg (Russia) International Photographic Exhibition, 1903; the Chicago Salon, 1903; the International Art Exhibition, Bradford, England, 1904; the First International Photographic Salon, The Hague, 1904; the Pittsburgh Salon, 1904; and the Corcoran Gallery of Art, Washington, D.C., 1904, to name only two years of exhibitions. In short, Bullock's work appeared in more exhibitions in two years than in the previous four years put together. Bullock seemed to be at the height of his photographic powers at the same time that the Photo-Secession was at its height.

Recognition for Bullock and his work did not diminish as the Photo-Secession proceeded, but more vigorous photographers overshadowed him. As always, Bullock's photographs were appreciated for their picturesqueness. He had an eye for beautiful scenery which he potently translated into fine prints. He continued to idealize his subjects which gave his work an uplifting quality. There were no rainy days or emotionally upsetting moments to be found in his imagery. Instead, he reveled in American vernacular subject matter such as country roads and split-rail fences. Country life so appealed to Bullock that most of his photographs depicted landscapes or farm scenes. He also enjoyed making portraits and was especially strong in characterization of his subjects. Like other Photo-Secessionists, Bullock made portraits of people he cared for or admired—mostly family members and friends—rendering them with elegance and charm. However, all of the qualities of Bullock's photographs were not enough to captivate the critics as in the early days. Younger photographers, who worked full time at making images, produced work which aspired to metaphorical meaning. Clarence White and Eva Watson-Schütze, for example, not only made portraits, but also commented on great themes like motherhood. The vigor of their work derived from working and exhibiting more; their images led viewers to new understandings in a way that Bullock's images did not. It was understandable, therefore, that Käsebier, Steichen, Alvin Langdon Coburn, White, Watson-Schütze,

and Stieglitz received more awards and attention. In time, their shadows grew as they rose higher yet, and he was obscured all the more. Bullock's responsibility for running Bullock and Crenshaw had increased over the years as his uncle became more involved in the affairs of the Philadelphia College of Pharmacy. Time devoted to photography was especially restricted after his uncle's death in 1900. Although he sold the business in 1902 to George D. Feidt & Company,[230] Bullock apparently remained at work for the firm until retirement in 1907.[231] During those years, he continued limitedly to photograph and exhibit.

Among Bullock's later exhibitions, three were especially noteworthy: the "Exhibition of Members' Work" inaugurating the Little Galleries of the Photo-Secession, "An Exhibition of Photographs Arranged by the Photo-Secession" at the PAFA, and the "International Exhibition of Pictorial Photography" at the Albright Art Gallery in Buffalo. The members' exhibition, held from November 25, 1905 to January 4, 1906, was a most important step for the Photo-Secession.[232] This single event transformed the Photo-Secession from a mental construct in the minds of the members into a concrete organization. Before the opening of the Little Galleries, the group existed primarily through exhibitions, personal associations, and the writings in *Camera Work*. Afterwards, the Photo-Secession was tangible with a headquarters and gallery spaces. The change came about because Alfred Stieglitz wanted a place in New York to show work by the members, and because Edward Steichen was, in the words of art historian William Homer, "eager to demonstrate the progress pictorial photography had made."[233] Steichen convinced Stieglitz that rooms at 291 Fifth Avenue could be converted into galleries for the Photo-Secession. One particular show that Stieglitz wanted to present was an all-inclusive survey of pictorial photography. But the Little Galleries were literally too small, and he was forced to wait for another opportunity to do that exhibition. Instead, Stieglitz presented a series of shows devoted to contemporary camera workers beginning with the members of the Photo-Secession.

The "Exhibition of Members' Work" included one hundred prints representing forty photographers, about half of the image makers in the group.[234] (Not all the members were photographers, some were critics, editors, etc.) Bullock

showed a recent image called "Stubble Field" (plate no. 87) which depicted the edge of a freshly cut wheat field lined with trees. This photograph possesses greater subtlety than most of Bullock's previous work and shows that he was continuing in his attempt to change his style. Unlike his earlier images, there is no single dominating center of attention in this photograph. One is not needed. "Stubble Field" was hung in the smallest of the three rooms which made up the tastefully arranged Little Galleries.[235] Steichen had designed the interiors of the three rooms so that the walls were sectioned into fabric-covered panels. Bullock's photograph had been tightly, but not uncomfortably, grouped with three other small images (fig. 22).

The next show which included Bullock's work was "An Exhibition of Photographs Arranged by the Photo-Secession" held April 30 to May 26, 1906 at the PAFA. John Trask, Director of the PAFA, had visited the Little Galleries of the Photo-Secession and was convinced that a photography exhibition should be included in the series of international art exhibitions being presented at the PAFA.[236] Stieglitz, Steichen, and Keiley assembled the exhibition and traveled to Philadelphia to hang the 132 pictures which, the catalogue stated, would "summarize in a broad way the trend of that international movement of which the Photo-Secession is the organized exponent, a protest against the conventional conception of what constitutes Pictorial Photography."[237] This exhibition surely represented to Bullock a triumph over the provincialism of the Photographic Society of Philadelphia and a consolation to Bullock's stinging departure from that group.

Bullock's last major exhibition during his lifetime was as a participant in the "International Exhibition of Pictorial Photography" at the Albright Art Gallery in 1910. The director of that Gallery had sought the support of the Photo-Pictorialists of Buffalo and the Photo-Secession in preparing an exhibition of work from those two groups, along with photographers invited from abroad and American photographers who would submit work to a jury.[238] When the Photo-Pictorialists decided that Stieglitz was being allowed too much influence over the show, they refused to participate.[239] As usual, among those Stieglitz invited to exhibit was John G. Bullock. The forward to the catalogue said:

*The aim of this exhibition is to sum up the development and progress of photography as a means of pictorial*

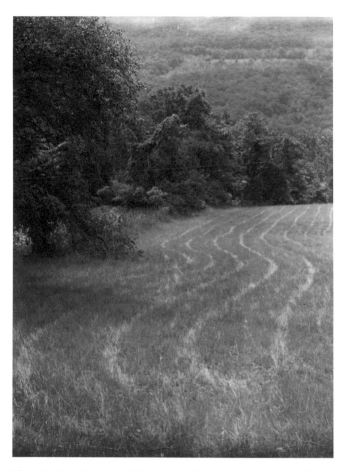

Plate 86. Stubble Field, Water Gap, [Pennsylvania], July 1904.

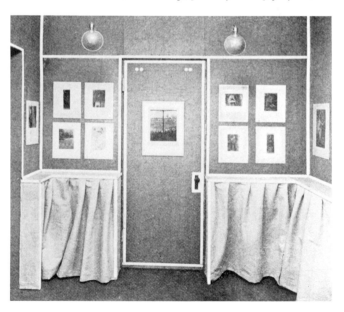

Figure 22. [Installation of the "Exhibition of Members' Work" at the Little Galleries of the Photo-Secession] by Edward Steichen, halftone from *Camera Work* No. XXIV, April 1906, Photography Collections, Albin O. Kuhn Library & Gallery. "Stubble Field" by Bullock is the lower left-hand image to the left of the door.

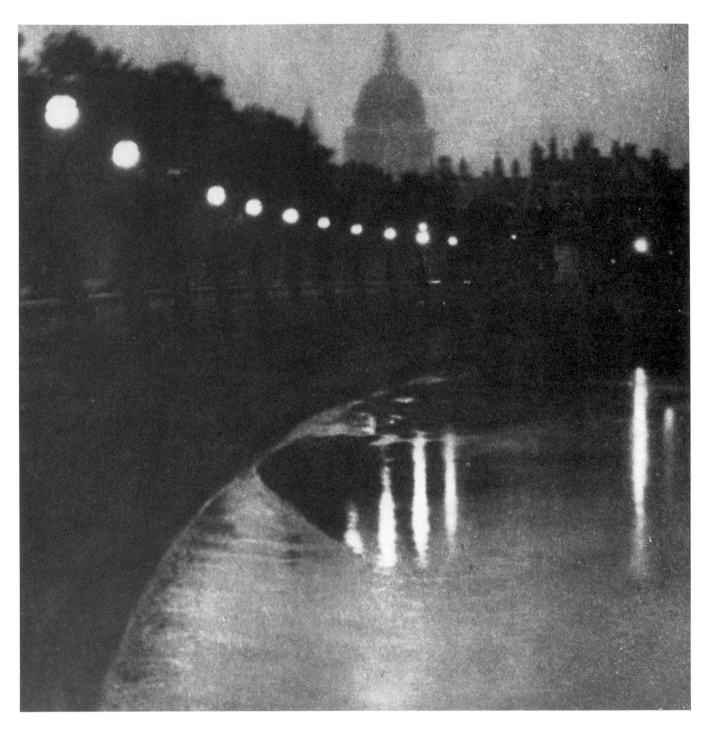

Figure 23. "The Embankment, London" by Alvin Langdon Coburn, 1906, gravure from *The Door in the Wall* by H.G. Wells (New York: Mitchell Kennerley, 1911).

A general statement more descriptive of Bullock's contribution to the exhibition could not be better written. Certainly, Bullock had attained international recognition, and he had contributed to the development and progress of photography. Moreover, his images marked a special stage in the history of the development of pictorial photography. Bullock showed three prints made in 1901, including "The White Wall" (plate no. 76), a landscape, and a beach scene. Compared to Coburn or Steichen, Bullock was no longer part of the avant-garde of pictorial photography. Bullock's images represented a kind of bridge between traditional pictorial photography and the newest work by Coburn and Steichen (figs. 23 and 24).

After the Albright Art Gallery show, Bullock, like most other members, lost touch with the Photo-Secession. The group never formally disbanded; it just withered away.[241] There were no more grand exhibitions sponsored by Stieglitz, who had become more involved in promoting the understanding of European and American modern art.[242] The war over the artistic merit of pictorial photography, which brought Bullock and Stieglitz together, was largely won. Major museums had exhibited photographs and accepted them into their collections. Bullock also was changing his direction and embarking on new projects.

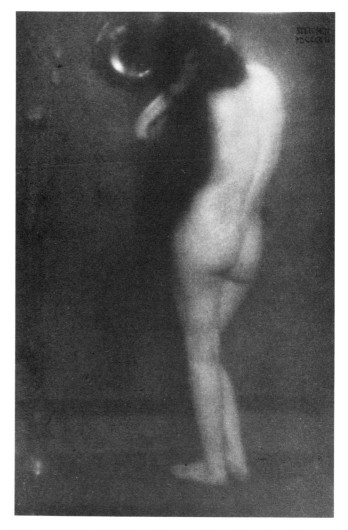

Figure 24. "The Little Round Mirror" by Edward Steichen, gravure from *Camera Work* No. XVI, April 1906, Photography Collections, Albin O. Kuhn Library & Gallery.

[184]William Innes Homer, *Alfred Stieglitz and the Photo-Secession* (Boston: Little, Brown and Company, 1983), p. 49. Alfred Stieglitz originally joined the Society of Amateur Photographers of New York in 1891. When that organization and the rival New York Camera Club both suffered declining vigor, a merger, which created the Camera Club of New York, was facilitated by Stieglitz in 1896.

[185]Sue Davidson Lowe, *Stieglitz: A Memoir/Biography* (New York: Farrar, Straus, Giroux, 1983), p. 108.

[186]Lowe, p. 108.

[187]Daniel K. Young, "The Other Side—A Communication," *Camera Notes* II (October 1898), pp. 46-49.

[188]Lowe, p. 113.

[189]Lowe, p. 113.

[190]Lowe, p. 115.

[191]Lowe, pp. 380-381.

[192]John G. Bullock, exhibition list, circa 1904, Richard and Sandra Bullock.

[193]Lowe, p. 382.

[194]John G. Bullock, letter to Alfred Stieglitz, June 13, 1901, The Yale Collection of American Literature, Beineke Rare Book and Manuscript Library, Yale University.

[195]*Camera Notes* V (January 1902), p. 227.

[196]John G. Bullock, letter to Alfred Stieglitz, Septem-

ber 27, 1901, The Yale Collection of American Literature, Beineke Rare Book and Manuscript Library, Yale University. A listing of the thirty-three prints has not come to light.

[197] *Camera Notes* V (April 1902), p. 275.

[198] Stieglitz sent "The White Wall" to the 1901 London salon, and the print was rejected by the jury. He once again sent the picture in 1902, and it was accepted. The image was also included in the first exhibition of the Photo-Secession.

[199] John G. Bullock, letter to Alfred Stieglitz, February 13, 1902, The Yale Collection of American Literature, Beineke Rare Book and Manuscript Library, Yale University.

[200] John G. Bullock, letter to Alfred Stieglitz, January 5, 1902, The Yale Collection of American Literature, Beineke Rare Book and Manuscript Library, Yale University.

[201] Homer, p. 40. Day was born in Norwood, Massachusetts and was educated at a private school in Boston. Like Stieglitz, he began photography in the mid-1880's and quickly became recognized as an exhibiting photographer.

[202] Homer, p. 41.

[203] Homer, p. 42.

[204] Robert Doty, *Photo-Secession: Photography as Fine Art* (Rochester: George Eastman House, 1960), p. 26.

[205] "Exhibition of Pictorial Photography at the National Arts Club," *American Amateur Photographer* XVI (April 1902), p. 171.

[206] *Camera Notes* VI (July 1902), p. 40.

[207] Homer, p. 54.

[208] Homer, p. 53.

[209] Homer, pp. 55-56.

[210] Edmund Stirling, letter to Alfred Stieglitz, July 18, 1902, The Yale Collection of American Literature, Beineke Rare Book and Manuscript Library, Yale University.

[211] *The Photo-Secession* 1 (December 1902), no pagination.

[212] The original fellows were Bullock, Eugene, Käsebier, Redfield, Stirling, Watson-Schütze, White, William B. Dyer, Steichen, Dallett Fuguet, Joseph T. Keiley, and John F. Strauss.

[213] *The Photo-Secession* 1 (December 1902), no pagination.

[214] *The Photo-Secession* 3 (October 1903), no pagination.

[215] *The Photo-Secession* 3 (October 1903), no pagination.

[216] Doty, p. 38.

[217] *The Photo-Secession* 1-7 (December 1902-June 1909), no pagination.

[218] Edmund Stirling, letter to Alfred Stieglitz, December 17, 1902, The Yale Collection of American Literature, Beineke Rare Book and Manuscript Library, Yale University.

[219] *The Photo-Secession* 2 (April 1903), no pagination.

[220] Edmund Stirling, letter to Alfred Stieglitz, December 15, 1902, The Yale Collection of American Literature, Beineke Rare Book and Manuscript Library, Yale University.

[221] *The Photo-Secession* 3 (April 1903), no pagination.

[222] Homer, p. 111.

[223] Homer, p. 111.

[224] John G. Bullock, letter to Alfred Stieglitz, August 28, 1902, The Yale Collection of American Literature, Beineke Rare Book and Manuscript Library, Yale University.

[225] *Camera Work* 1 (January 1903), p. 60.

[226] Homer, p. 114.

[227] Homer, p. 114.

[228] *Camera Work* 1 (January 1903), pp. 60-61.

[229] Homer, p. 114.

[230] *Gopsill's Philadelphia City Directory for 1902* (Philadelphia: James Gopsill's Sons, 1902).

[231] This conclusion is based upon an unidentified obituary, dated December 15, 1939, found at the Historical Society of Chester County.

[232] "Editorial," *Camera Work* 14 (April 1906), p. 17.

[233] Homer, p. 118.

[234] "Editorial," *Camera Work* 14 (April 1906), p. 17.

[235] "The Little Galleries of the Photo-Secession," *Camera Work* 14 (April 1906), pp. 41-43.

[236] William Innes Homer, *Pictorial Photography in Philadelphia: The Pennsylvania Academy's Salons 1898-1901* (Philadelphia: Pennsylvania Academy of the Fine Arts, 1984), p. 28.

[237] Homer, *Pictorial Photography . . .* , pp. 28-29.

[238] Homer, *Alfred Stieglitz . . .* , pp. 144-154.

[239] Homer, *Alfred Stieglitz . . .* , p. 145.

[240] "The Exhibition at the Albright Gallery—Some Facts, Figures, and Notes," *Camera Work* 33 (January 1911), p. 61.

[241] Homer, *Alfred Stieglitz . . .* , p. 148.

[242] Homer, *Alfred Stieglitz . . .* , p. 147.

# Beyond
# Pictorial Photography

As the Albright Art Gallery exhibition receded into memory, Bullock endeavored to keep the spirit of the Photo-Secession alive for himself through correspondence with Stieglitz. In November 1910, Bullock wrote to Stieglitz to praise and criticize recent issues of *Camera Work*. He lauded the publication of photographs by Frank Eugene and J. Craig Annan (figs. 25 and 26) and was receptive to Gordon Craig's drawing "Ninth Movement" (fig. 27). But Matisse's drawings of nudes (fig. 28) did not please him: "I suppose that I am not quite ready yet to appreciate the Matisse drawings." Another of his criticisms was much harsher:

> You have known me always to be a sincere friend of Camera Work, almost one of its foster parents, so you will take me kindly when I tell you that for your sake and for the sake of the high tone of Camera Work I do not like the article "Puritanism &c." It suggests to me immorality and unGodliness and leaves a very unpleasant memory in my mind after closing the book....I am not making this a public declaration but say it to you quietly as a friend interested in you and what the journal stands for.[243]

Bullock was reacting to an article by Sadakichi Hartmann which chastised Puritanism in American culture. Hartmann wrote: "What monsters of intolerance and fanaticism the old Puritans must have been. I believe St. Gaudens was too much of a Puritan himself to have revealed to us in his statue (at the City Hall Square, Philadelphia) the true significance of their harsh principles of Christian gravity and zeal."[244] Bullock's comment revealed that he was still strongly oriented toward his Quaker background, with its origins in Puritanism, despite having left the Society of Friends more than twenty years before. Stieglitz's response to Bullock, if there was one, is not known.

Bullock wrote to Stieglitz again in the fall of 1916 attempting to understand the images appearing in *Camera Work*. The tone of the letter expressed both curiosity and disapproval:

> I fear that your own taste and criticism has so much advanced beyond that of some of us old fellows that we will not have the chance of seeing a good many things which we would think pretty good. I fear that you think that a thing must be novel as well as good art to be worth while. Wouldnt a Rembrandt be worthwhile reproducing today if the old master should resurrect and paint it in New York? Therefore would not people support Camera Work if it reproduces what you judge good art depicted in a photograph? I think so.... Not having been very well for a quite long period I did not get over to N. Y. and so have not been to 291, but I keep interested in it, even if it is not all photographic.[245]

Bullock mentioned also that a package of his photographs was on the way for Stieglitz to see.

It took Stieglitz more than four months to reply to Bullock:

> I do not know whether my tastes in criticism have advanced as much as you think. I never did anything which didn't <u>add</u> something to what had gone before. That was understood by few. That's the scientific way of doing things. It is not a question of novelty. I am not interested in novelty. I am interested in development. In growth. If Rembrandt were alive today he certainly would not paint at all the way [the] Rembrandt you know exists. The spirit would be the same. But the pictures entirely different. As far as the support given by people to Camera Work is concerned, I have never taken that into consideration. Camera Work is creative. Undoubtedly you know what creative means.[246]

The tone of Stieglitz' letter was bitter and unpleasant. He expressed concern for Bullock's health, then went on to comment that few of the members of the Photo-Secession had grown: "Many are still doing pictures. But none quite as good as the early fresh ones." The mention of "pictures" likely referred to the kind of pictorial photographs which had been evolving over the last twenty years. The remark was intended as criticism of the Photo-Secessionists for not having moved on to less sentimental imagery.

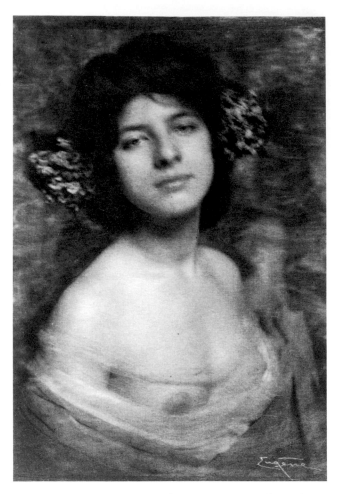

Figure 25. "Hortensia" by Frank Eugene, gravure from *Camera Work* No. XXXI, July 1910, Photography Collections, Albin O. Kuhn Library & Gallery.

Stieglitz basically liked the photographs Bullock had sent him but commented: "I am conscious primarily of photographs, and not of the thing you felt.... It is the intensity of feeling *expressed* which lives. It is not the technique. Technique is a dead thing, no matter how masterly it may be in itself." Judging from the titles of the photographs ("Farm Bell" and "Valley Green") mentioned in Stieglitz' letter, Bullock must have sent him characteristically vernacular images which would not have excited Stieglitz. Bullock had done other work which surely would have interested Stieglitz more.

About 1911, Bullock started using a roll-film camera to make what might best be called quick sketches of people. Absent from these images (plate nos. 100, 102-108) was the pictorial sentimentality characteristic of his earlier photographs. Although the new work was carefully crafted, Bullock was

less formal and his approach in most instances more intensely involved with the subjects. Nearly all of the images showed on top and bottom the rounded arc of the edge of the lens, indicating that the lens did not cover the full format of the film. Far from having made a mistake, Bullock deliberately used such a lens for expressive purposes. He intended that attention be more readily focused on certain attributes of the subjects. Prints of these images have not come to light, suggesting that the prints were simply lost or that Bullock may never have printed them. Perhaps, he considered the images not "artistic" enough to show to Stieglitz.

Subjects of Bullock's new photographs were, as before, family members. Having settled into retirement, he was able to spend more time with his family and acquired a cabin in the Pocono Mountains of Pennsylvania for family retreats. Here he made photographs of his grandchildren and other subjects (plate nos. 109, 110, and 112).

Figure 26. "East & West" by J. Craig Annan, gravure from *Camera Work* No. XXXII, October 1910, Photography Collections, Albin O. Kuhn Library & Gallery.

Figure 27. "Ninth Movement" by Gordon Craig, gravure from *Camera Work* No. XXXII, October 1910, Photography Collections, Albin O. Kuhn Library & Gallery.

During this same time (1911-1915), Bullock embarked on a new photographic project in Germantown where his suburban Philadelphia home was located. He made photographs of historic buildings to be used in illustrating a new edition of *The Guide Book to Historic Germantown* by Charles F. Jenkins.[247] His Germantown project, as might be expected, went far beyond the requirements of Jenkins' book. Bullock made a careful and meticulous photographic survey of the surviving colonial-era buildings. A good example of the effort he invested in the project is his image of "Chew House" (fig. 29). Not only did he photograph the house, but also recorded a brief history of it in a notebook. He wrote that the house was "in the world at large the best known Germantown house," and was "the centre of action in the Revolutionary War battle of Germantown."[248] British troops barricaded themselves in the house and held out against a Continental Army platoon until additional British troops came to their

rescue. Bullock made about 130 lantern slides from his Germantown negatives and gave illustrated lectures.[249] Indeed, Bullock had been interested in local history for many years, and had periodically photographed historic sites around the region, including Benjamin West's birthplace (fig. 30) in Swarthmore, Pennsylvania; the "Phila. Flag House" (1898, plate no. 62), also known as Betsy Ross House; and other Colonial homes. He still approached architectural imagery the same way as he had learned from John C. Browne in 1882. This direct approach was ideal for studying the historical subjects depicted.

Obviously, Bullock's involvement in local history was not a passing interest. When he moved in 1923 to West Chester, a charming town twenty miles west of Philadelphia, he quickly became interested in local history there. In January 1924, he and his wife were elected to membership in the Chester County Historical Society,[250] the organization to which he devoted most of his time for the rest of his

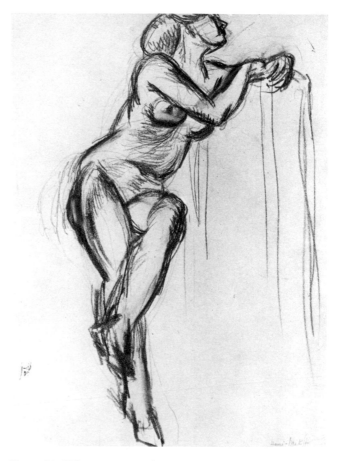

Figure 28. "Photogravure of a Drawing" by Henri Matisse, gravure from *Camera Work* No. XXXII, October 1910, Photography Collections, Albin O. Kuhn Library & Gallery.

Plate 61.  Phil. Flag House, Spring 1898.

life. Photography, in turn, became secondary to his participation in Society activities. He was elected to the Council of the Society in 1925 and served on the "Committee on Historical Markers," which arranged that year for the Pennsylvania Historical Commission to place a marker along "The Great Trail" of the Susquehanna Indians in Chester County.[251] Bullock initiated various other projects during his service on the committee, such as having Fayette Street in West Chester correctly marked as "LaFayette Street" and placing a marker at the site of "The Manor of Steyning" in southern Chester County, land given by William Penn to his daughter. Later, Bullock was elected corresponding secretary, a role which led him to initiate negotiations to unite the various activities of the Society in Memorial Hall, the present location of the organization.[252]

One of Bullock's major contributions to the Society was his nearly seven years service as a curator between 1929 and 1936.[253] Among his accomplishments were: preserving fragile historical papers, convincing the Society to catalogue its large holding of historical manuscripts, and preventing county officials from routinely destroying documents without Society review. While serving as a curator, Bullock continued as corresponding secretary, and in that role, he often hosted board meetings at his home. He retired from the secretary's position in 1937 but remained on the board until his death on December 14, 1939.

John G. Bullock never gave up photography, but there is no evidence that he made images after 1935 when he was eighty-one years old. That year, as always, he photographed family members vacationing at the cabin in the Poconos (plate no. 124). The images he made then, although not among his strongest, showed no dramatic change in his style. His only other photographic activity was an exhibition a few years later in West Chester. A clipping from a local newspaper found at the Chester County Historical Society refers to an exhibition of Bullock's photographs in 1938.[254]

Perhaps Bullock's life in photography reveals once again that the more photography changes, the more it stays the same. At the turn of the century, artist-photographers redefined the nature of the medium, and in the 1980's redefinition has been occurring once again. The Photo-Secessionists, including Bullock, looked deeper into themselves,

Figure 29. "Chew House" by John G. Bullock, 1913, Photography Collections, Albin O. Kuhn Library & Gallery.

Figure 30. "Benj. West's Birthplace, Swarthmore, Pa.," by John G. Bullock, 1884, Photography Collections, Albin O. Kuhn Library & Gallery.

searching for a new vocabulary in photography with which to express personal experience.

In the end, Stieglitz was disappointed with the Photo-Secessionists because, as he indicated to Bullock, most could not make the next step beyond pictorial photography into what we now call modernism. Bullock tried to find a new approach to his own photography but did not succeed. Perhaps all the traditional aesthetics he had assimilated early in his life from viewing genre paintings and photographs were too firmly ingrained for him to substantially alter his imagery.

69

When he began photography, Bullock was strongly influenced by John C. Browne whose style of photography was the imitation of nature. Bullock worked in the countryside according to Browne's instructions and quickly succeeded at making award winning pictures. His finely crafted photographs, aptitude for aesthetics, and belief in the merits of artistic photography qualified Bullock for an important role in convincing others that photography was an art.

The precisely made genre photographs Bullock produced in the 1890's ranked in quality among the best of the time and were testimony to the artistic capacity of photography. Repeatedly, Bullock's photographs were seen in the major exhibitions, such as the Vienna Salon, the London Salon, the Philadelphia Salon, and finally, as a member of the Photo-Secession. The Photo-Secession, especially during its early days, was the avant-garde in photography, yet one would not really categorize Bullock as an avant-garde photographer. For this reason, it is difficult to categorize him at all, except to say that his was an American vision. Like others of his time, Bullock was enamored with rural American life and landscape. His photographs idealize the distinctively American subjects he chose to depict.

One way to view Bullock's photographs is as historical guideposts. He was a pioneer of art photography who helped lay the foundation for the artistic development of the medium that has occurred throughout the twentieth century. His photographs mark an important stop along an irregular path which led ultimately to the acceptance of photography into the collections of art museums. It is interesting to note that Bullock, who spent the last sixteen years of his life promoting the placement of historical markers for the Historical Society of Chester County, made one for himself in leaving his collection of images to future generations.

[243] Bullock, letter to Alfred Steiglitz, November 24, 1910, The Yale Collection of American Literature, Beineke Rare Book and Manuscript Library, Yale University.

[244] Sadakichi Hartmann, "Puritanism, Its Grandeur and Shame," *Camera Work* 32 (October 1910), p. 17.

[245] John G. Bullock, letter to Alfred Stieglitz, November 18, 1916, The Yale Collection of American Literature, Beineke Rare Book and Manuscript Library, Yale University.

[246] Alfred Stieglitz, letter to John G. Bullock, March 26, 1917, The Yale Collection of American Literature, Beineke Rare Book and Manuscript Library, Yale University.

[247] Charles F. Jenkins, *The Guidebook to Historic Germantown* (Germantown: Site & Relic Society, 1915).

[248] John G. Bullock, notebook, "Historical Germantown," The Germantown Historical Society, Philadelphia, circa 1915.

[249] The lantern slides are held at The Library Company in Philadelphia. About 1931, Bullock gave the negatives from the Germantown survey to the Library of Congress for the newly created Pictorial Archives of Early American Architecture. One of Bullock's lectures was delivered to a meeting of the Chester County Historical Society on January 15, 1929.

[250] "Minutes and Proceedings of the Chester County Historical Society, 1915-1933," mss., Chester County Historical Society, West Chester, Pennsylvania, January 17, 1924.

[251] "Minutes," May 19, 1925 and November 14, 1925.

[252] "Minutes," October 15, 1929.

[253] "Minutes," December 12, 1929 and September 30, 1936.

[254] The clipping, from the *Daily Local News* for November 22, 1938, headlined "Exhibit" said: "John G. Bullock, West Chester—lot of large photographs taken by him."

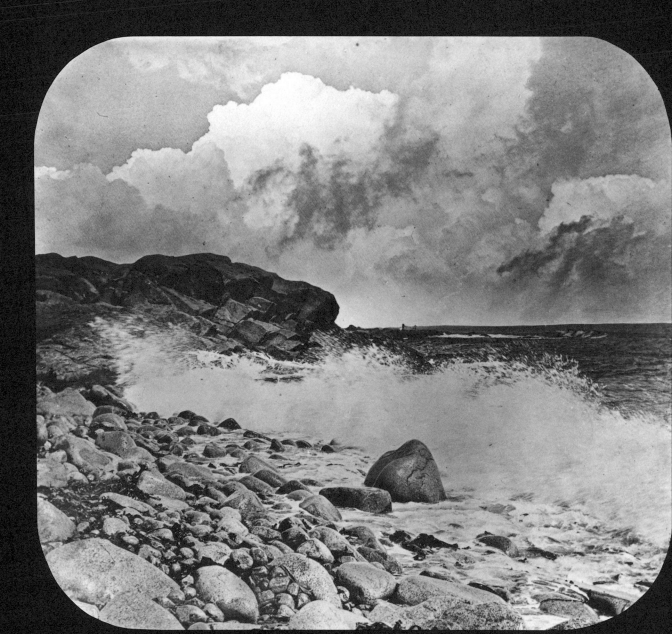

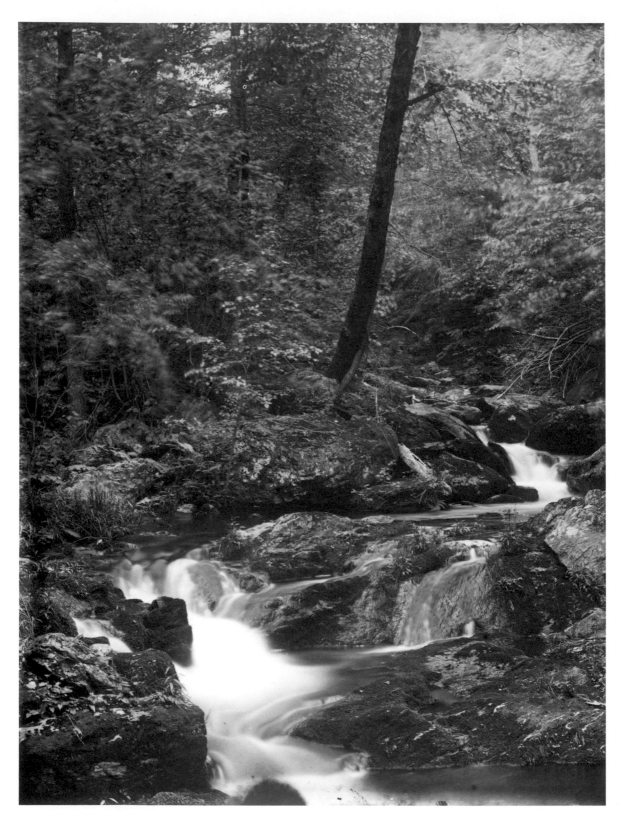

3. Rages Ravine No. 1, June 1885.

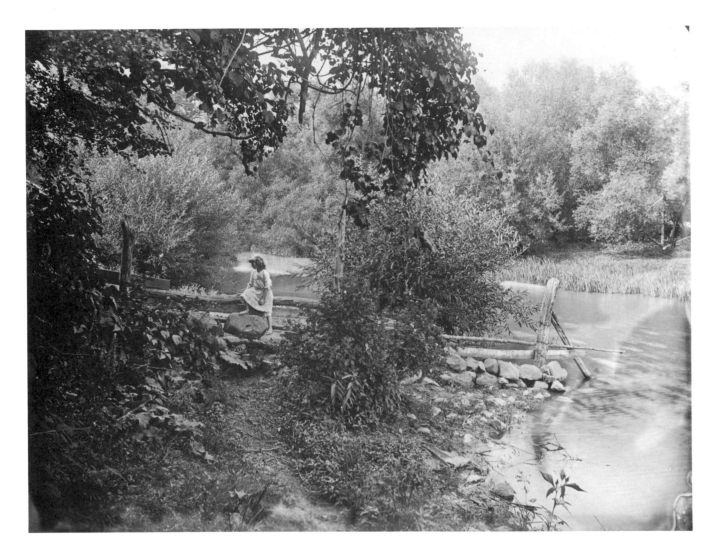

4.  Girl on Fence, Rockland, [Maine], July 16, 1885.

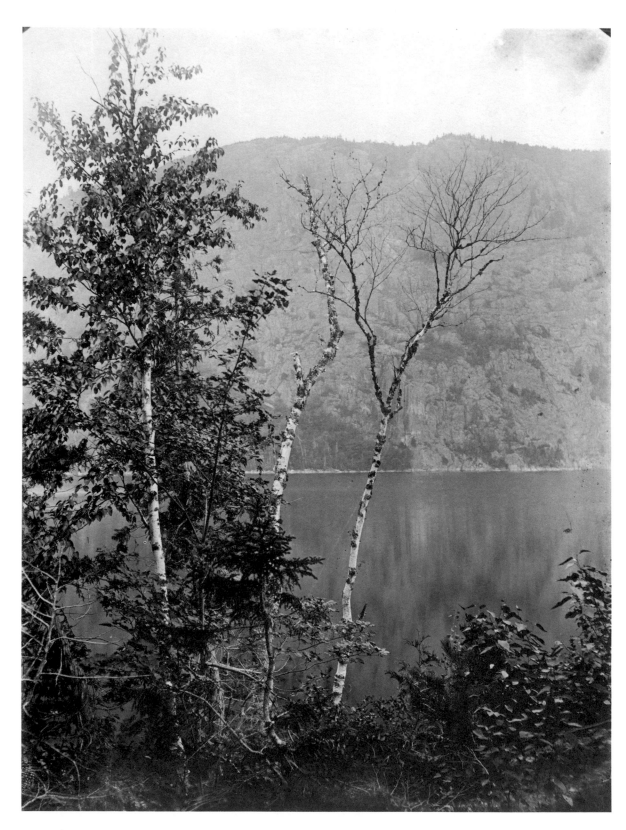

5. Beech Trees Near Pebble Beach, Mt. Kineo, [Maine], August 1885.

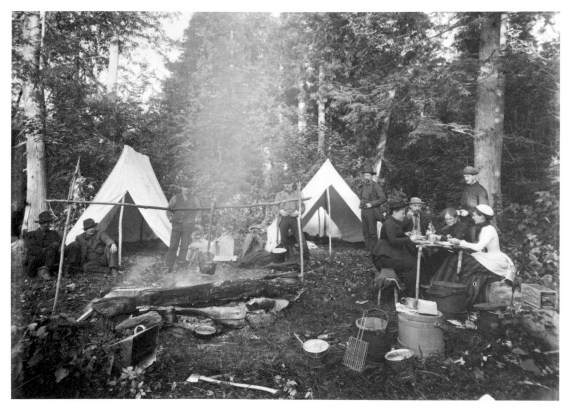

6. Camp Minerva, August 1885.

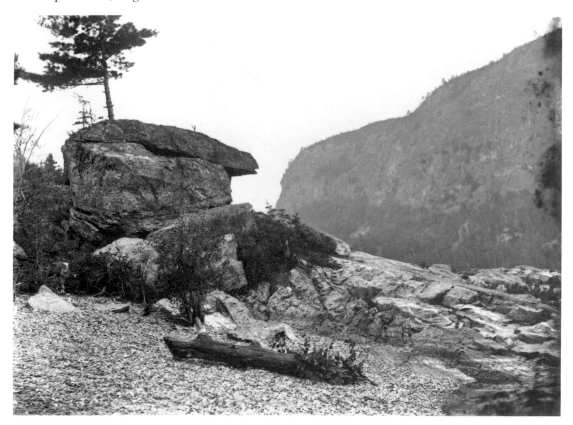

7. Rock at Pebble Beach, [Mt.] Kineo, August 1885.

9. Mr. Jones' Family No. 2, July 26, 1886.

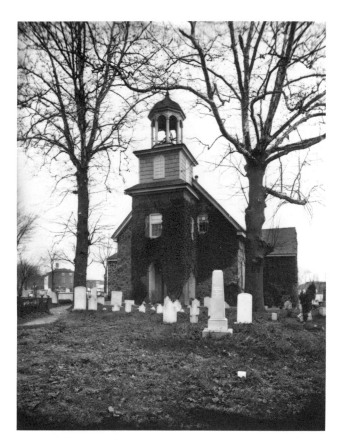

8. Old Swedes Church,
   Wilmington, [Delaware],
   December 17, 1885.

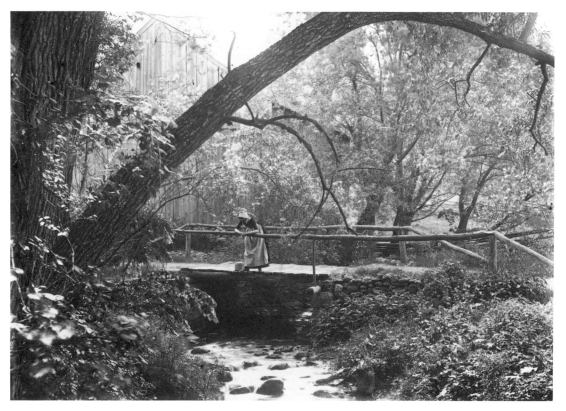

12. Re [Rebie] on Bridge Near So. Edgemont [sic], Massachusetts, June 1888.

13. Weaver's House, June 1888.

14. To Keep the Memory of Orville Dewey 1794–1882, June 1888.

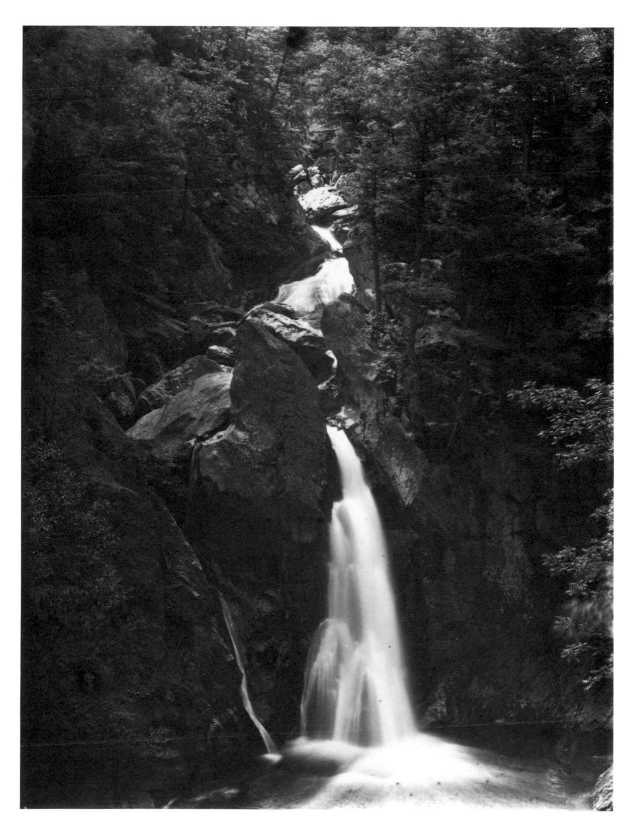

15. Falls, June 1888.

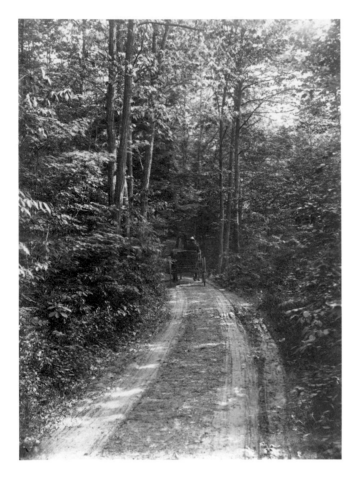

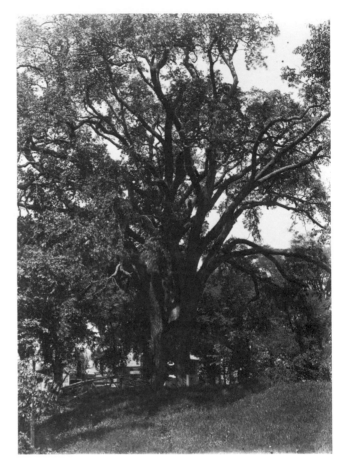

16. Road Through Woods, June 1888.

17. Big Elm, Sheffield, Massachusetts, June 1888.

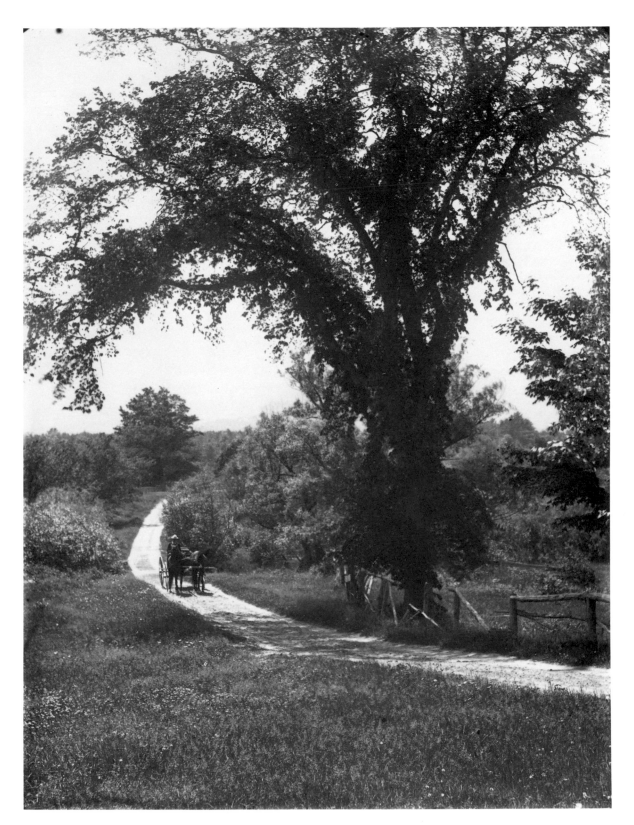

18. Among the Berkshire, Road with Elm Tree Near Salisbury, Connecticut, June 1888.

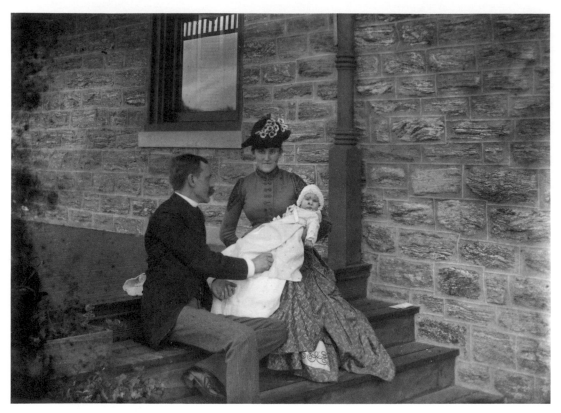

19.  J.G.B., Marjorie, Rebie, June 6, 1889.

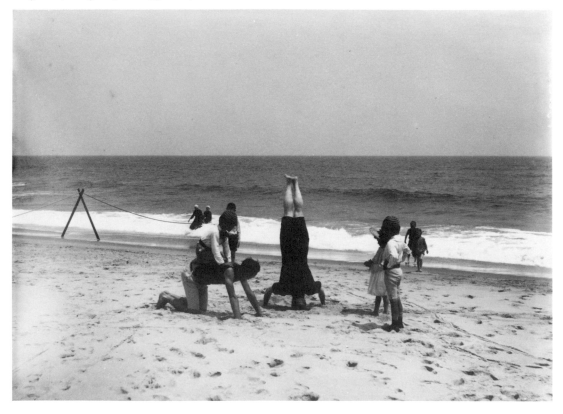

20.  Circus on the Beach, Sea Girt, July 1889.

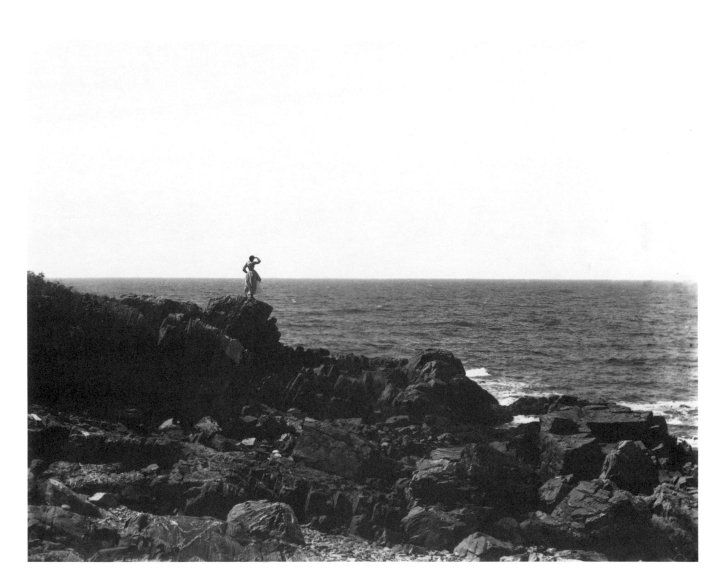

21.  Eastward As Far As the Eye Can See, August 1890.

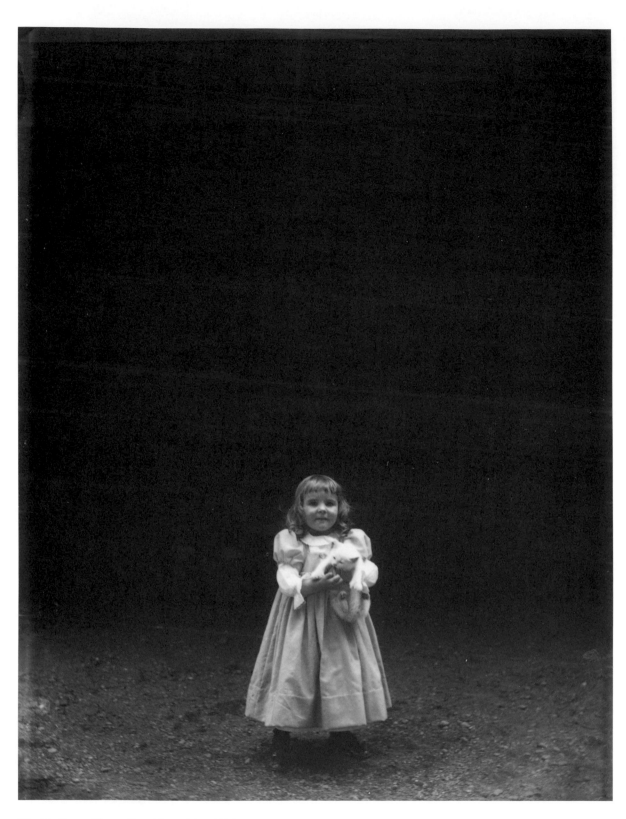

22. Me Pussy Shrug Shoulders, May 1891.

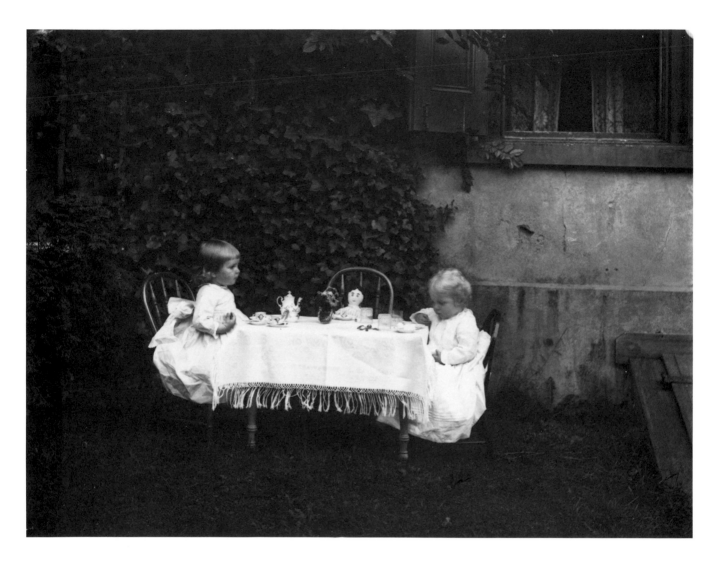

23. [Tea Party, Marjorie Bullock and Friend], circa 1891.

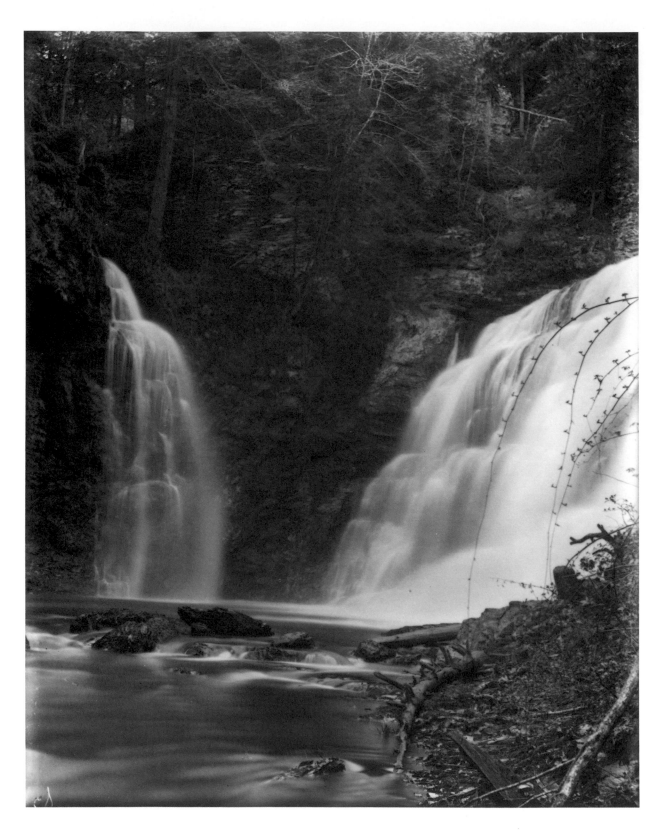

24. Raymondskill Lower Fall with Bridal Veil, Pike County, [Pennsylvania], May 10–16, 1893.

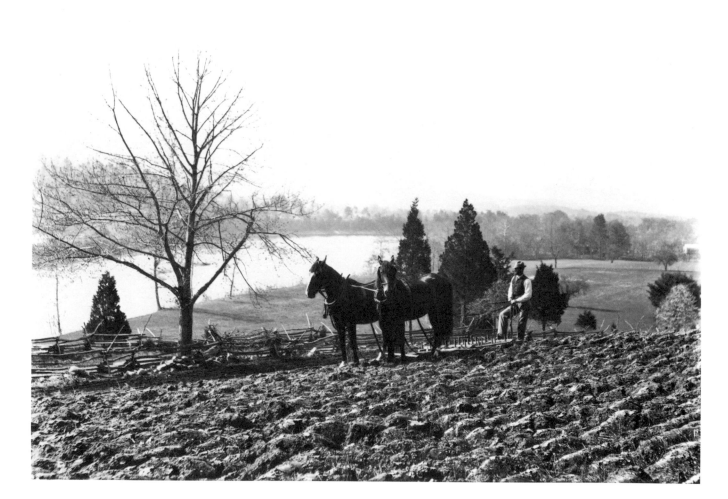

27. Harrowing, Pike County, May 10-16, 1893.

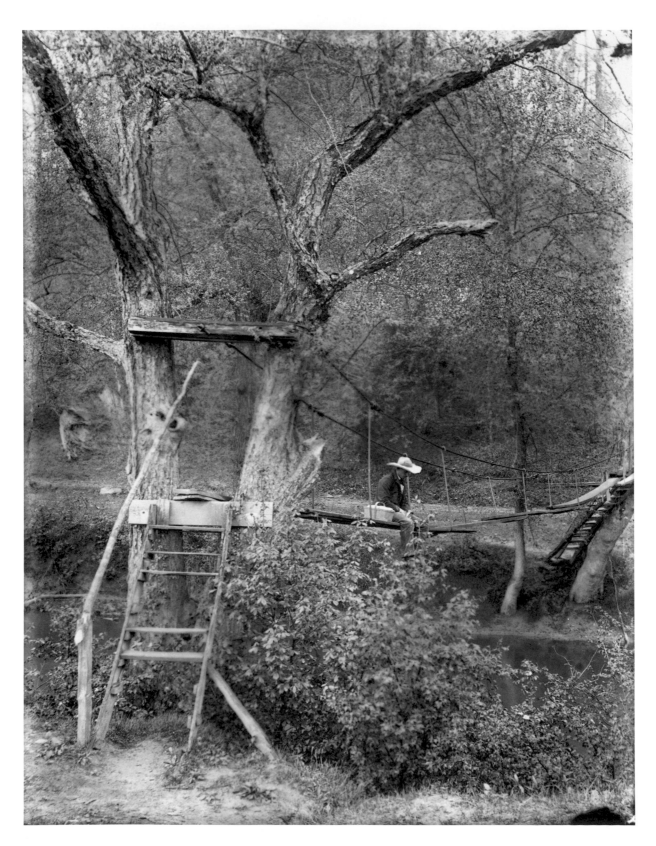

28. The Old Suspension Bridge, May 4, 1894.

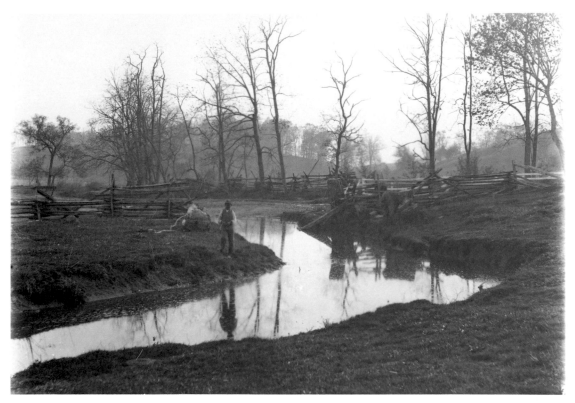

29. Stream at Evening, May 4, 1894.

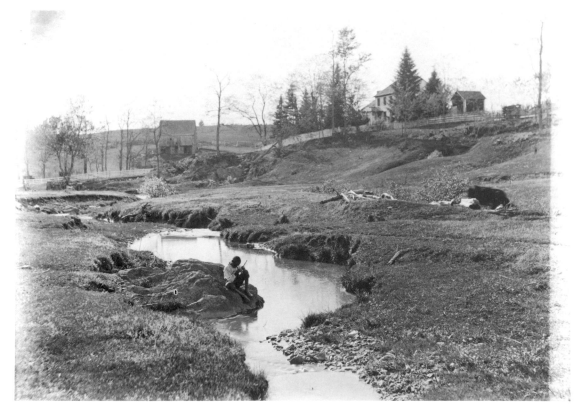

30. Boy Fishing in "Overbrook" Farm, May 7, 1894.

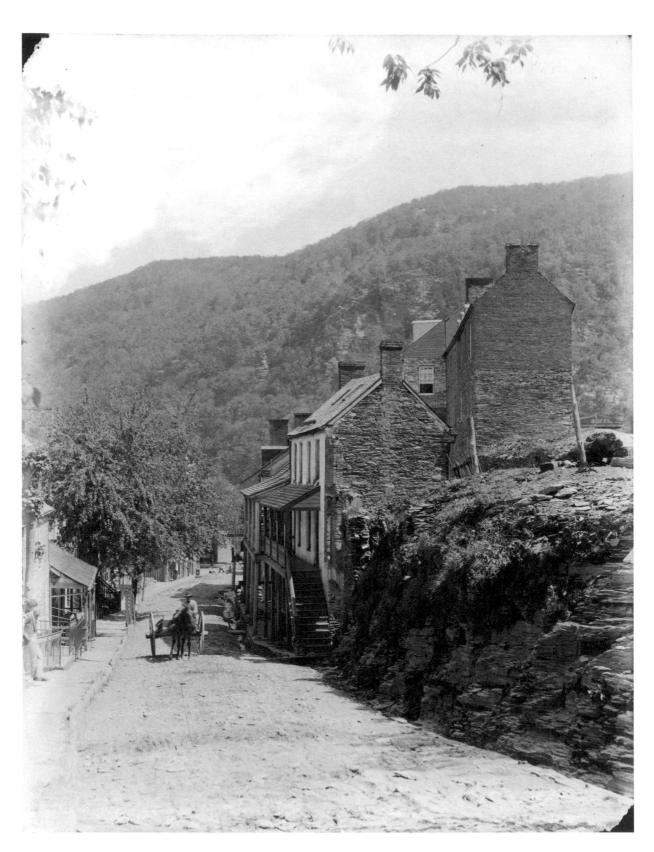

31. Street Scene, Harper's Ferry No. 1, [West Virgina], May 8, 1894.

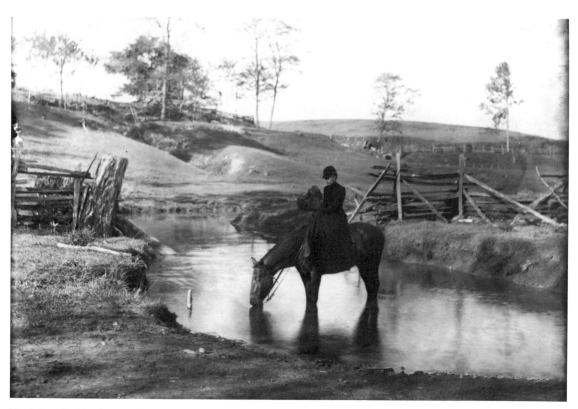

32.  Mary E. Hughes & Her Horse Dolly, May 9, 1894.

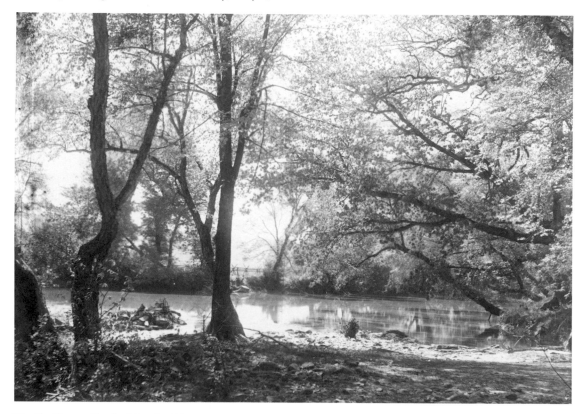

33.  On Goose Creek, May 9, 1894.

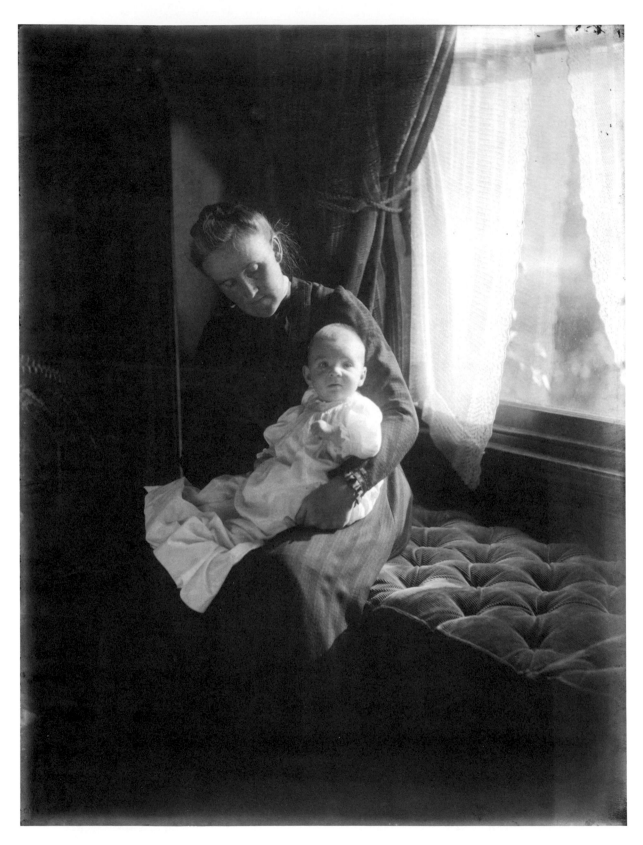

34. Rebie Bullock with Child, circa 1895.

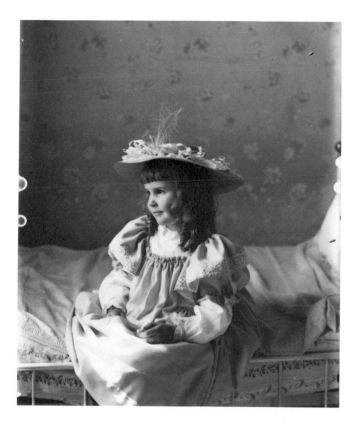

35. [Marjorie], circa 1895.

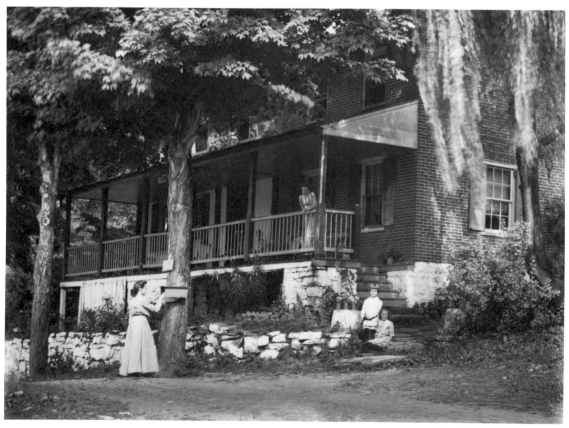

36. [Mailing a Letter], circa 1896.

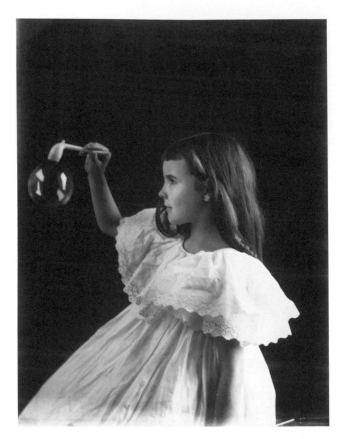

37. Marjorie, Bubbles, Side View, circa 1897.

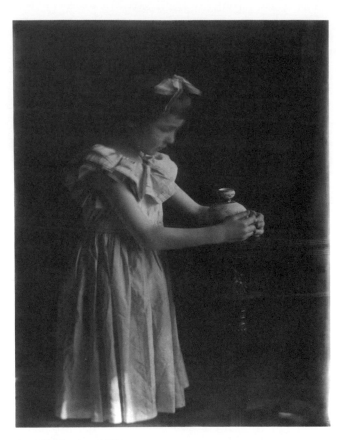

38. [Girl], circa 1897.

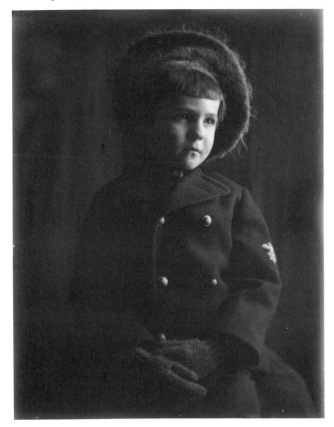

39. [John E. Bullock], circa 1897.

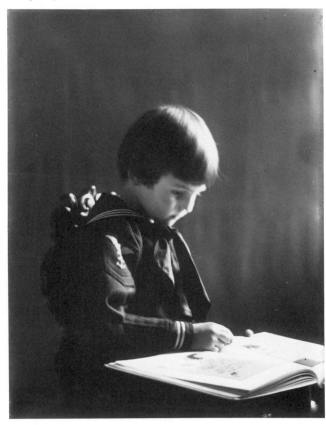

40. [John Reading a Book], circa 1897.

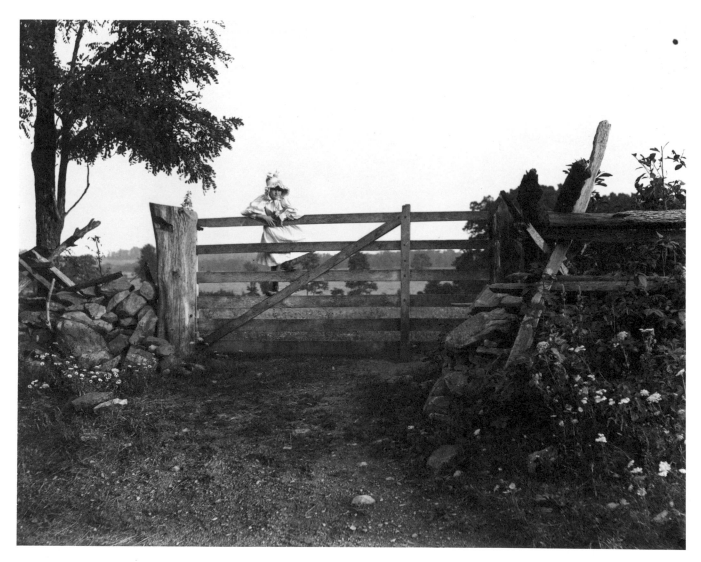

41. Marjorie on Gate, May 9, 1897.

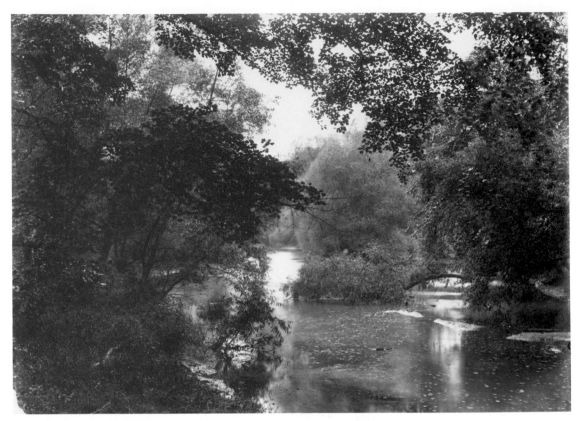

42. On Ketoctin Creek, July 26, 1897.

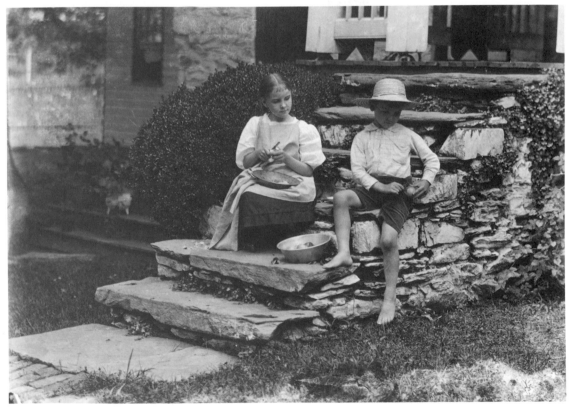

43. Children of Eve, July 27, 1897.

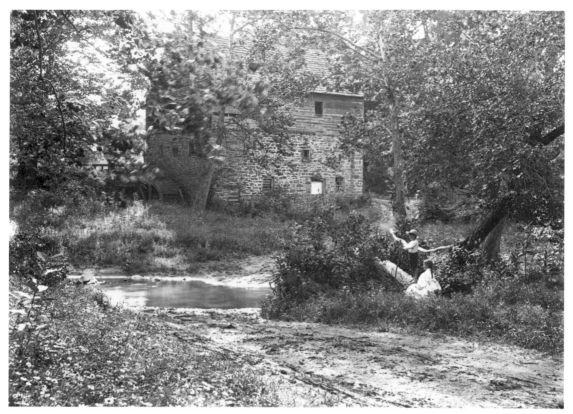

44. Chamblin's Mill, July 28, 1897.

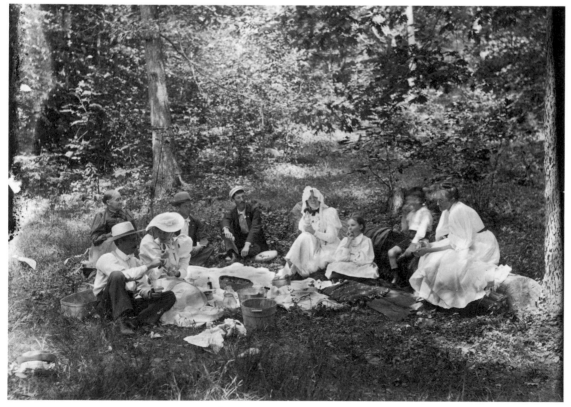

45. Picnic on Goose Creek, [Virgina], July 29, 1897.

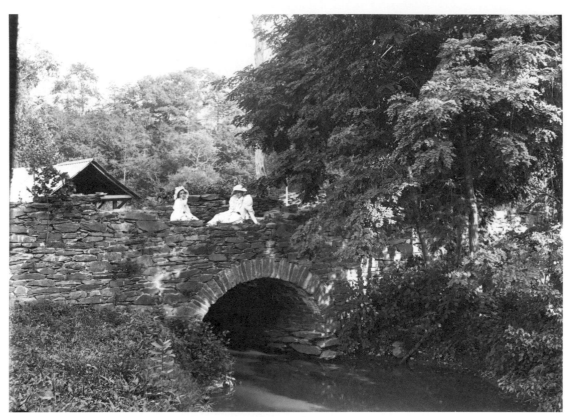

46. Bridge at Oatland Mill, [Marjorie and Corrie Hughes], July 29, 1897.

47. Fording Goose Creek, July 29, 1897.

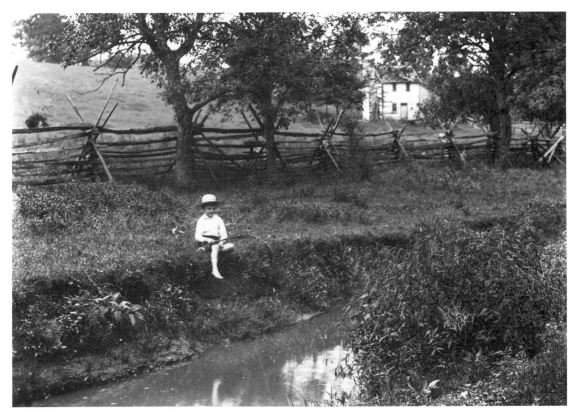

48. John Fishing on Bank of Stream, July 29, 1897.

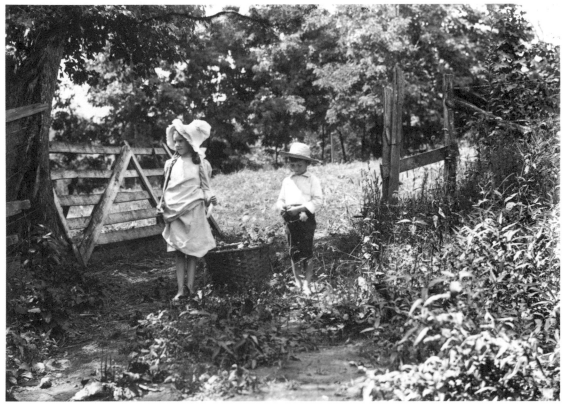

49. Children with Basket, July 30, 1897.

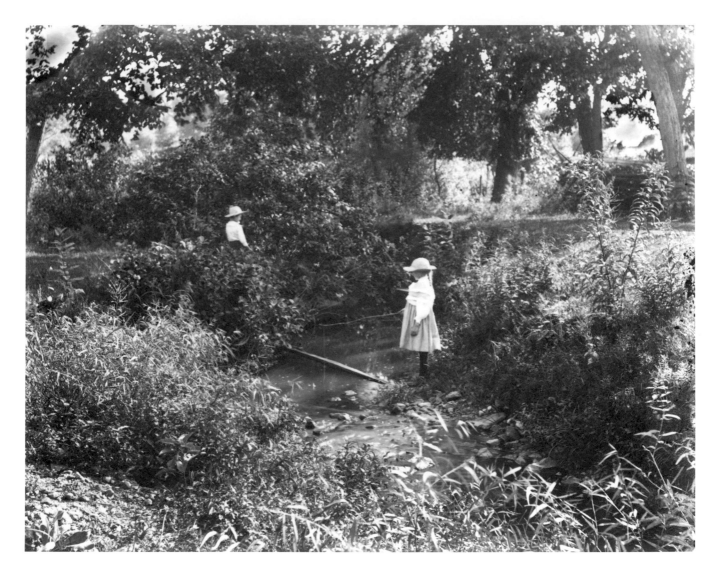

50. Marjorie Fishing in Brook Near the House, July 30, 1897.

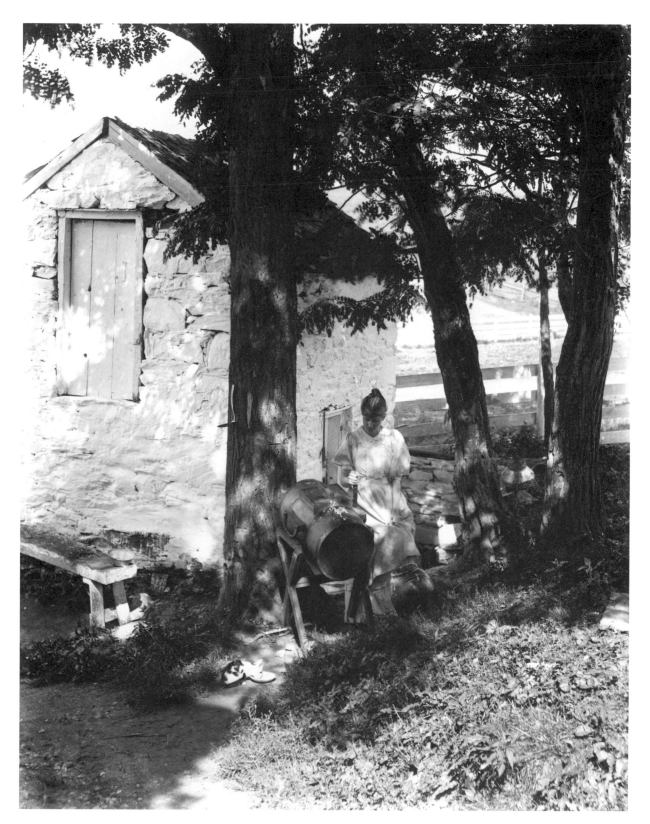

51. Churning, [Corrie Hughes], July 31, 1897.

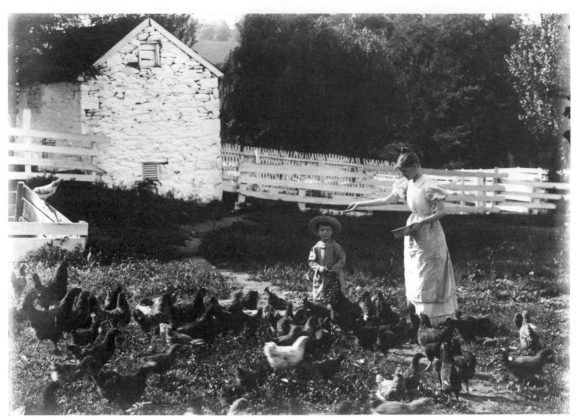

52.  Feeding the Chickens, [Corrie Hughes and John], July 31, 1897.

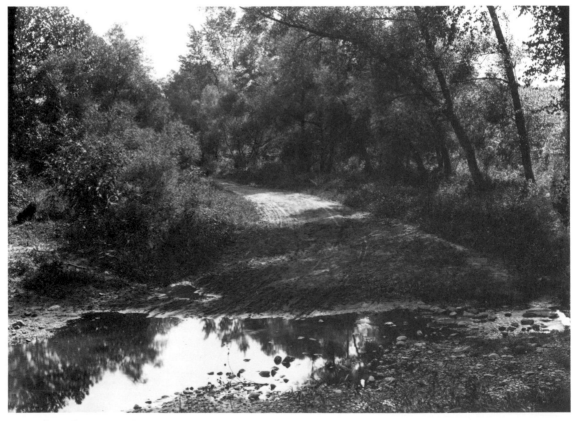

54.  Willows by Road, August 2, 1897.

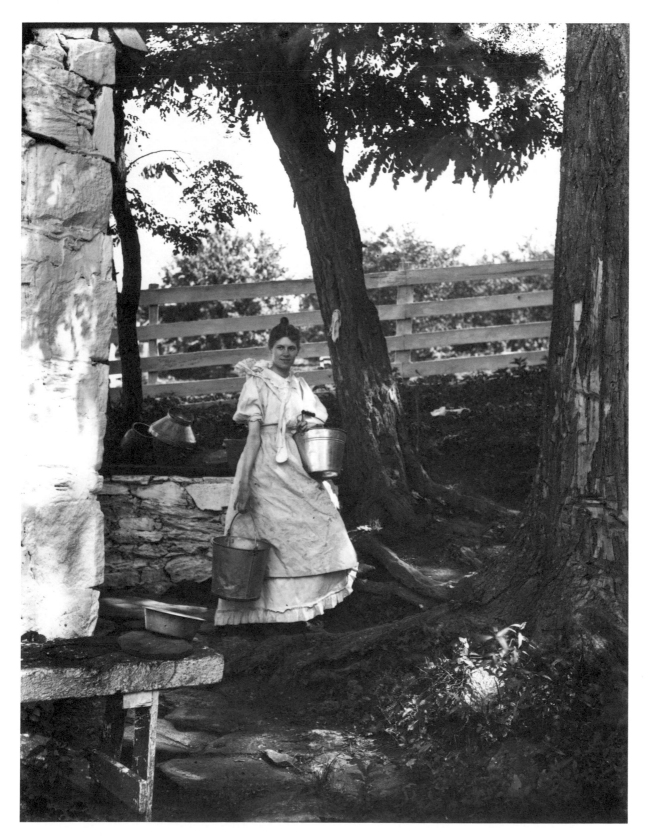

53. Where Are You Going My Pretty Maid, July 31, 1897.

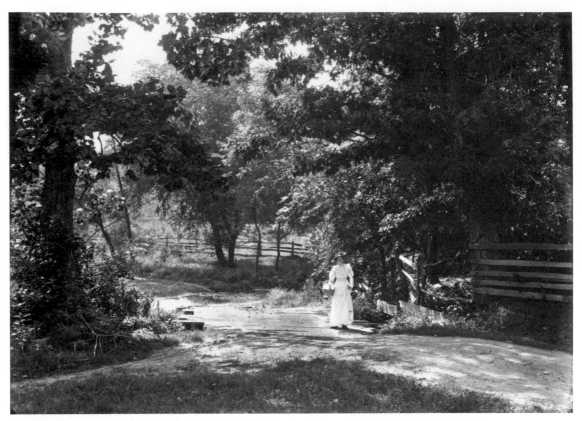

55. Miss Emma Crossing Bridge, August 2, 1897.

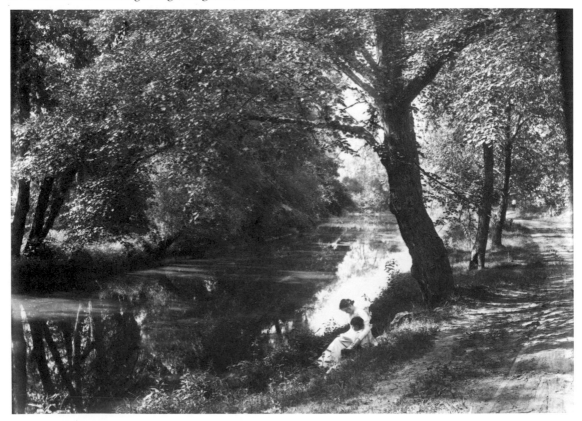

56. By Still Waters, August 2, 1897.

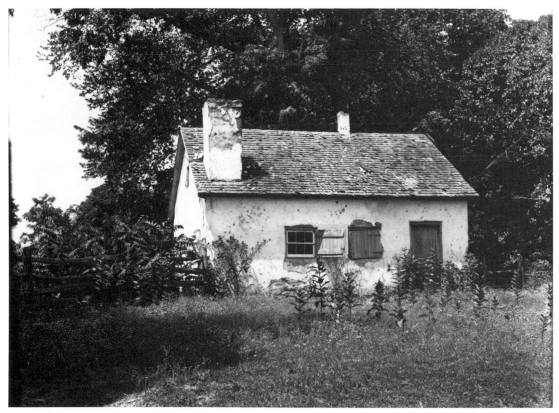

57. The District School, August 2, 1897.

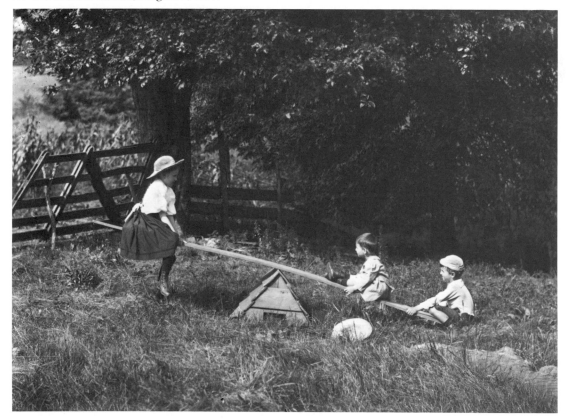

58. Two to One, August 3, 1897.

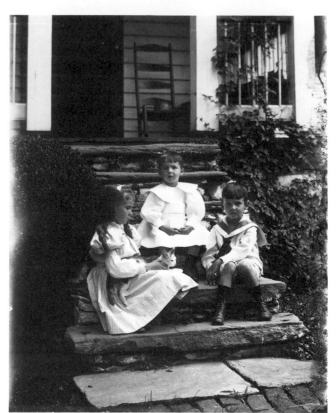

59. Three Children on Step of House,
Overbrook Farm, [Virginia],
August 5, 1897.

62. [Fence Row and Tree], August 1898.

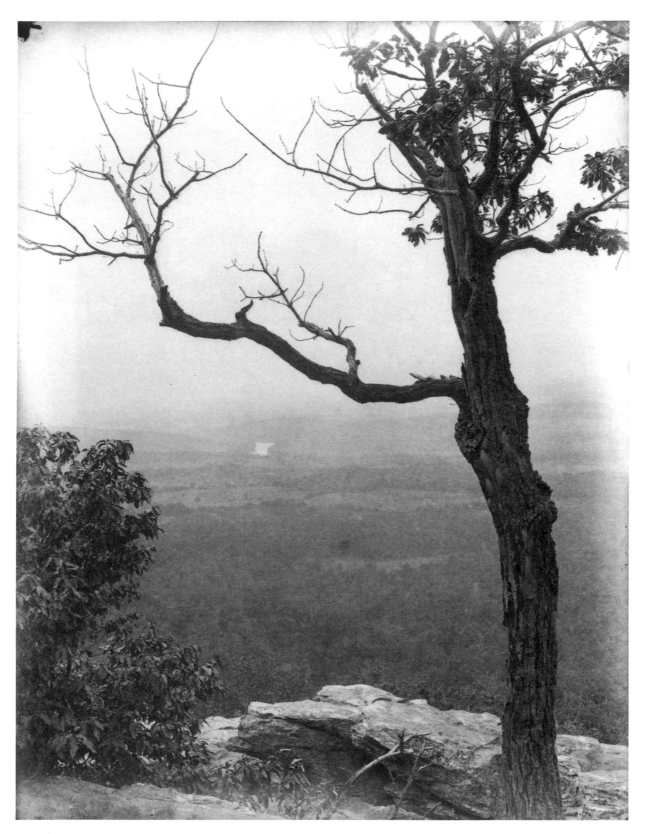

60. Shenandoah Valley from "Bear's Den" on top of Blue Ridge, Looking S.W. over Battlefield to which Sheridan Took His Famous Ride, 20 Miles from Winchester, [Virginia], August 6, 1897.

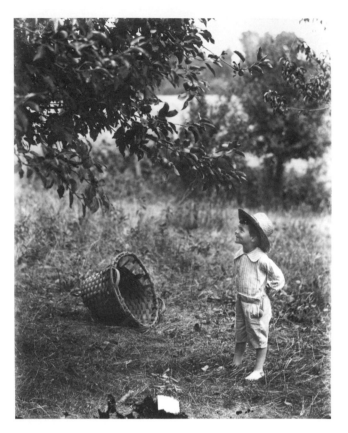

63. If Wishes Were Apples,
August 1, 1898.

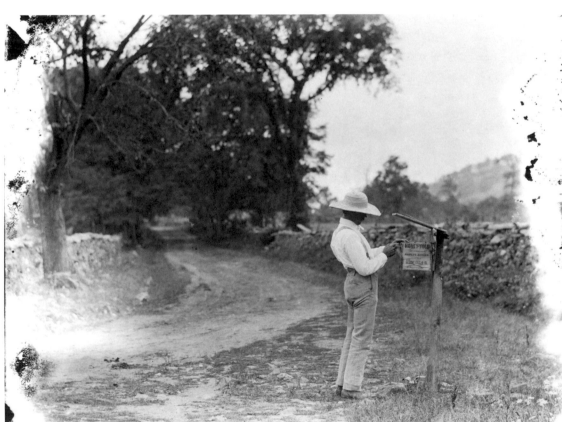

64. Country Letter Box Near Trapp, Virginia, August 2, 1898.

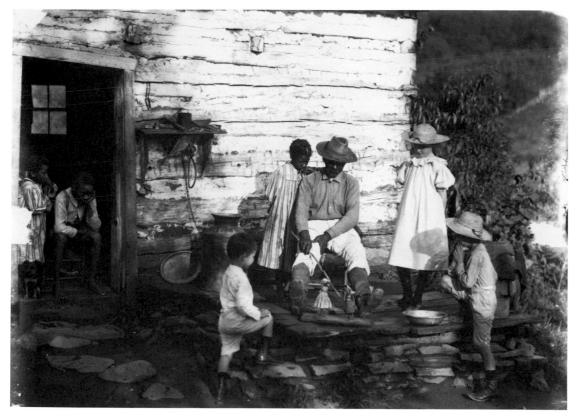

65. Uncle Foster's Entertainment #1, August 2, 1898.

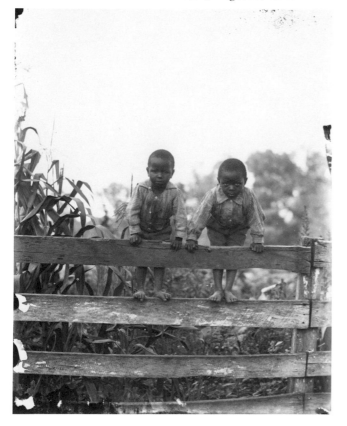

66. Two Boys on a Cornfield Fence, Virginia, August 2, 1898.

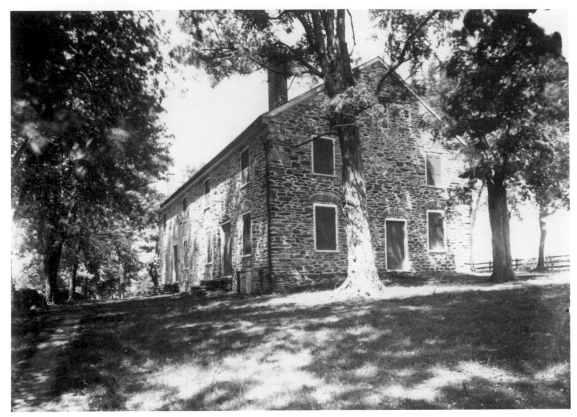

67. Waterford, Va. [Friend's] Meeting House (1775), August 4, 1898.

68. Barefoot Boy, [John],
August 6, 1898.

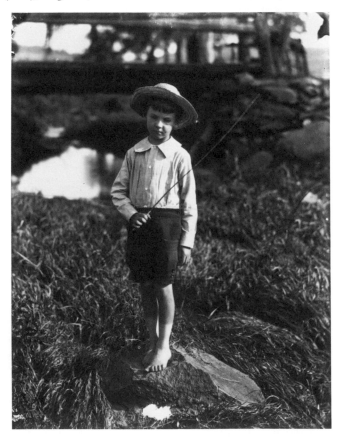

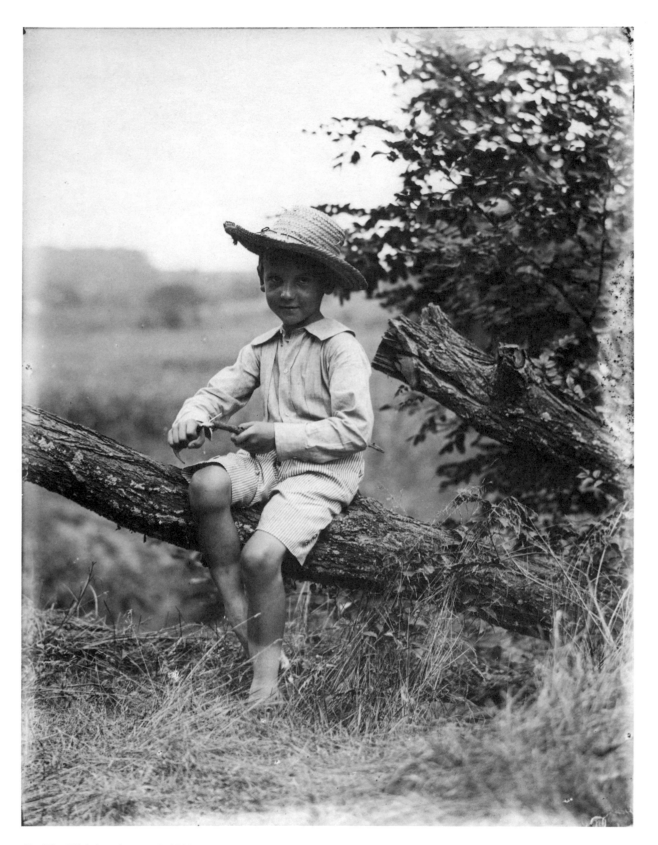

69. The Whittler, August 7, 1898.

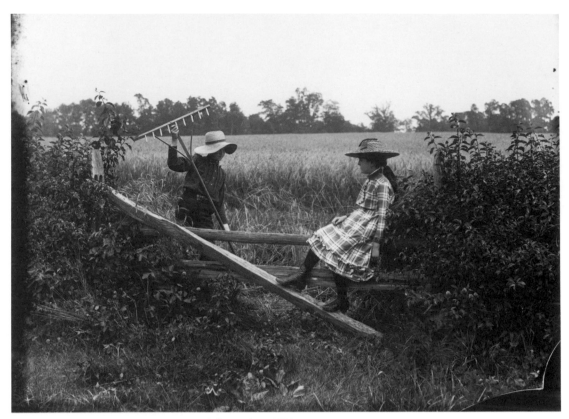

70. An Idle Moment, On Fence Near Salem, circa 1898.

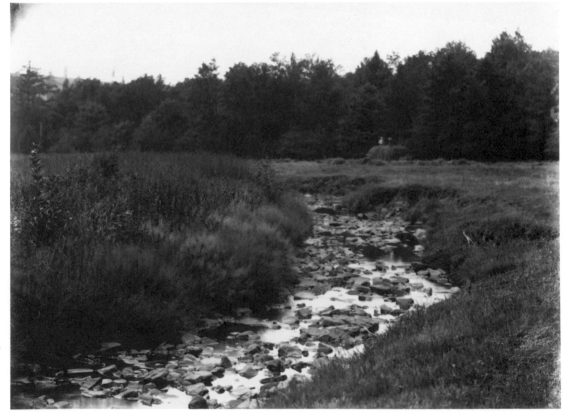

72. Meadow Brook, July 26, 1899.

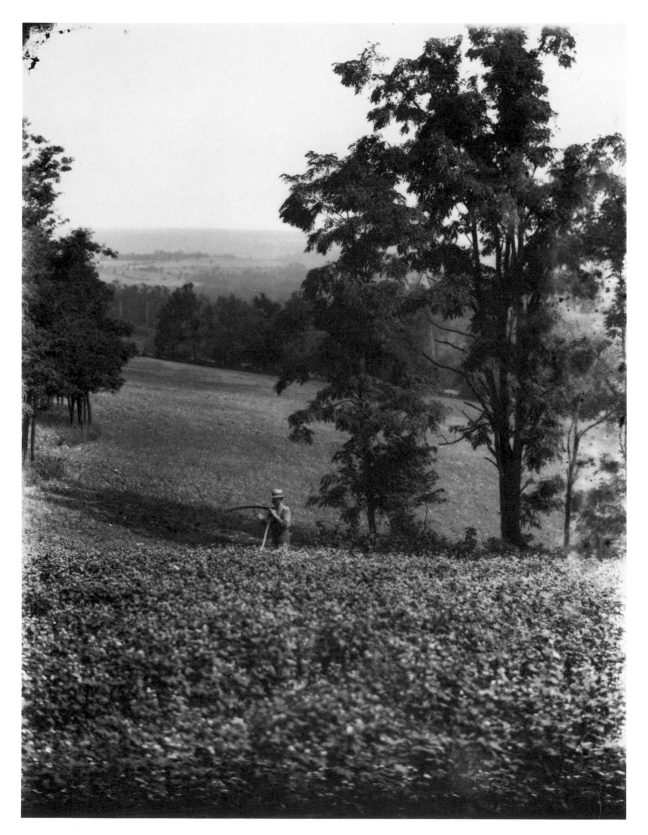

73. Buckwheat Field, July 28, 1899.

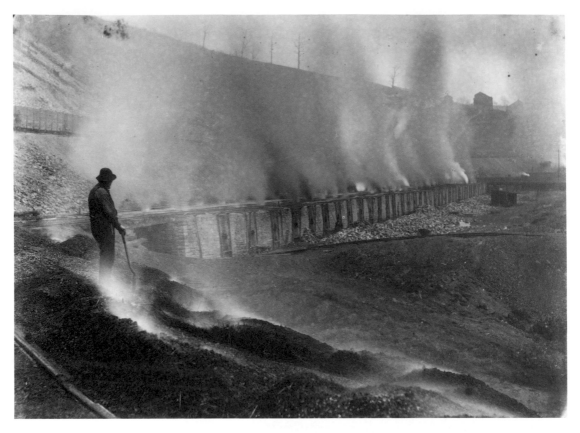

75. The Coke Burner, June 1900.

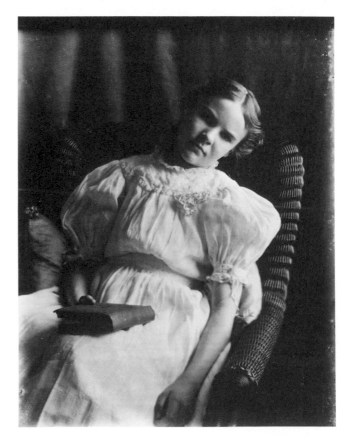

79. Marjorie with a Book, circa 1902.

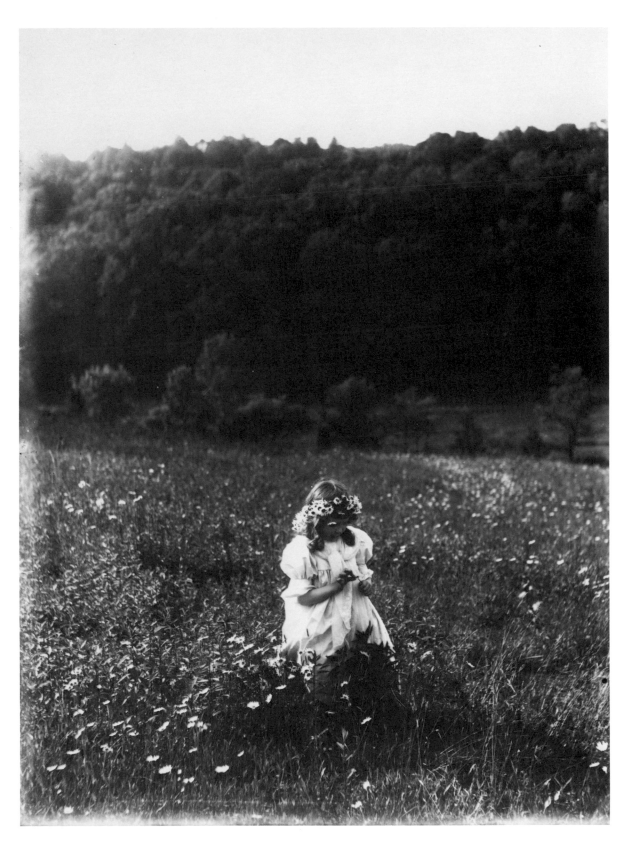

77. Lake Craft, July 1900.

80. [John (?) with Companion at a Religious Retreat], circa 1902.

81. [Marjorie], circa 1902.

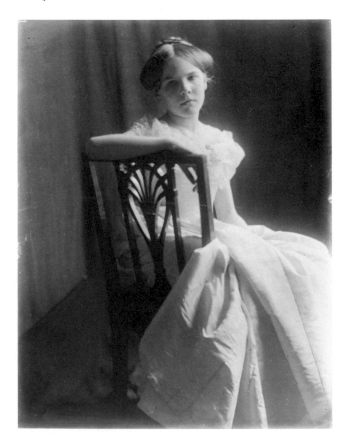

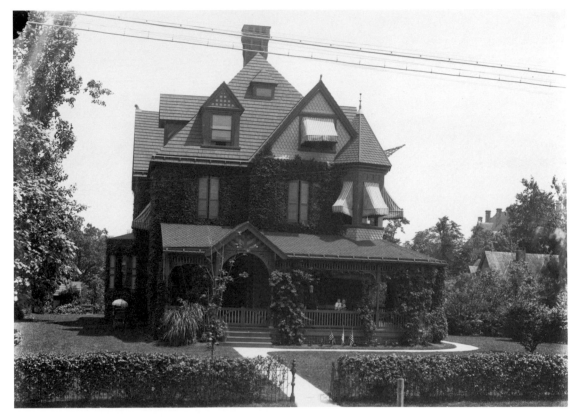

82. House [Bullock's residence at 6439 Greene Street, Germantown], July 4, 1902.

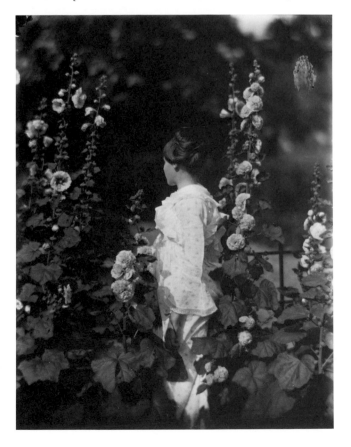

83. [Marjorie in Garden], circa 1903.

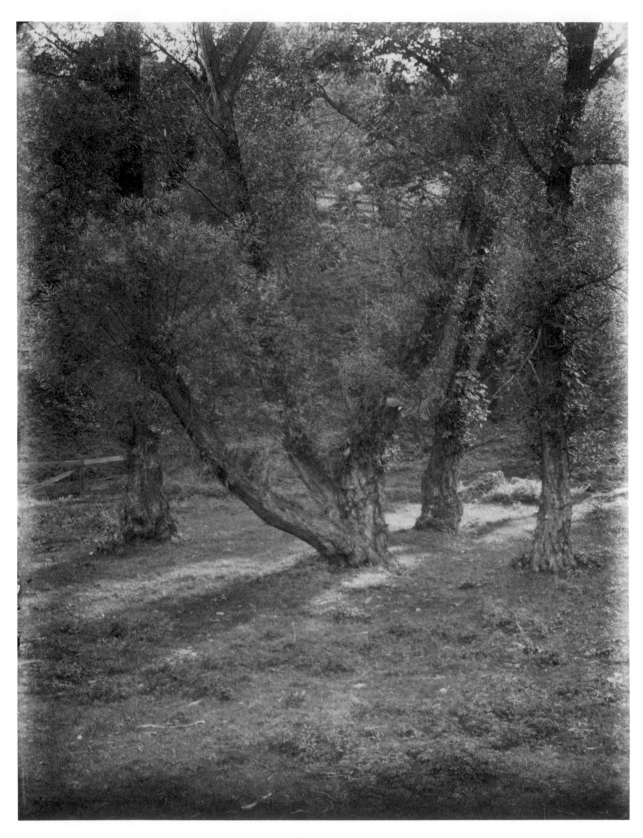

84. Willows on Lincoln Drive, July 26, 1903.

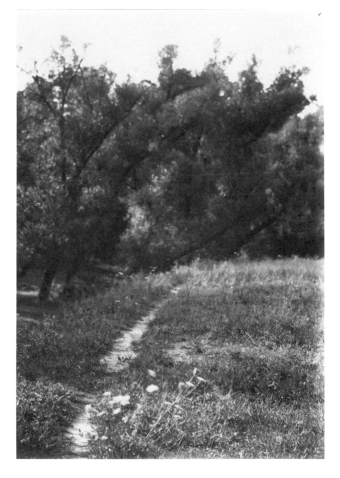

85. Path to the Willows, Lincoln Drive, July 27, 1903.

87. [Boy Sitting on a Split-rail Fence], July 1904.

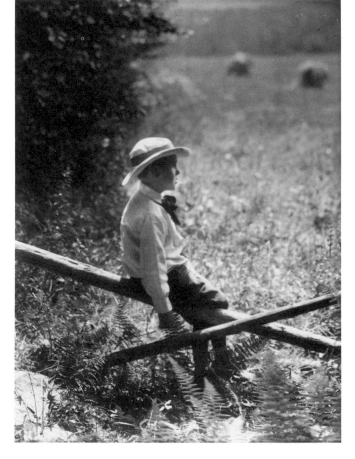

119

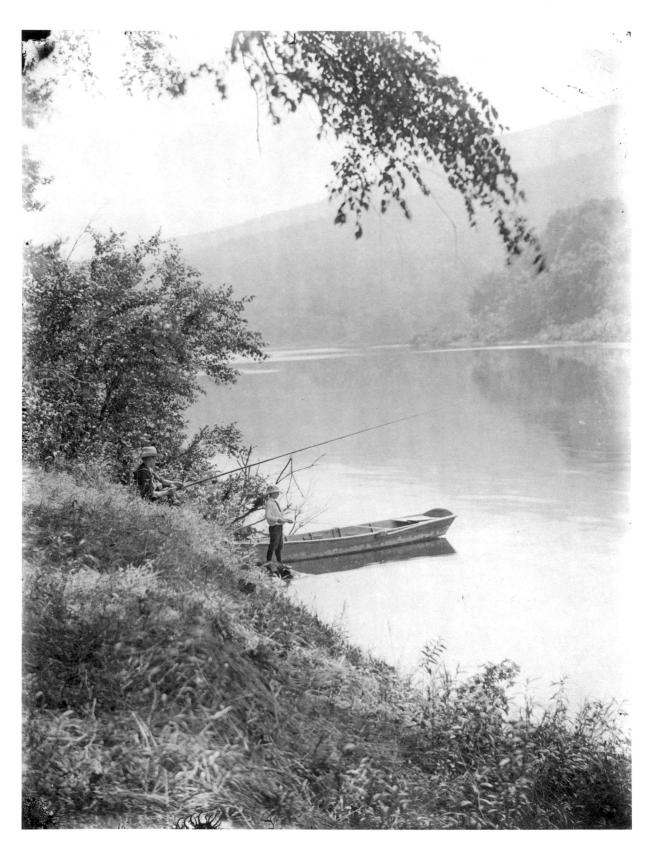

88. [Boys Fishing], circa 1904.

89. Richard H.D. Bullock, 1905.

90. Young Woman, circa 1905.

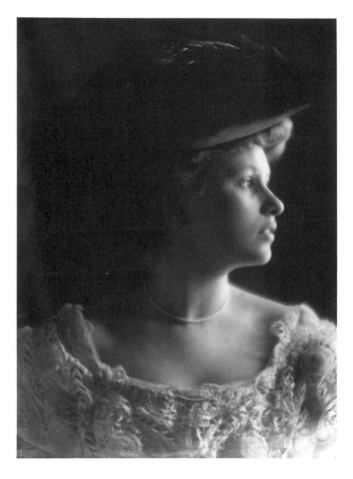

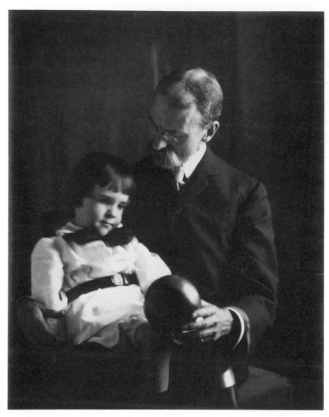

91. [J.G.B. and Richard], circa 1906.

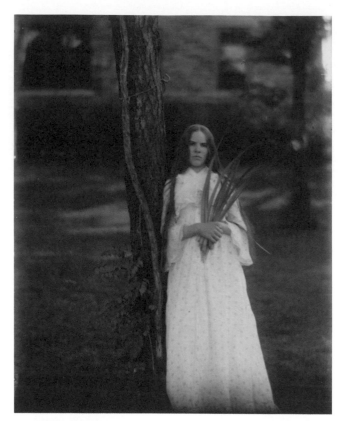

93. [Marjorie], circa 1907.

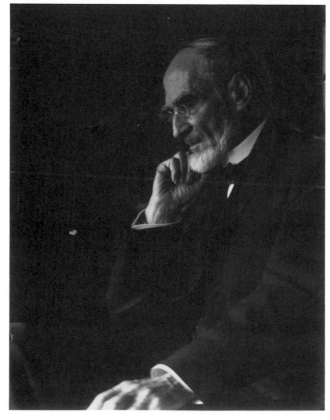

92. Dr. William R. Bullock, September 1907.

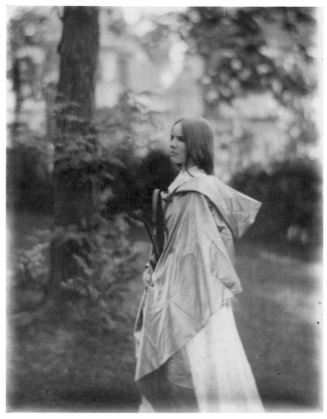

94. [Marjorie with Cape], circa 1907.

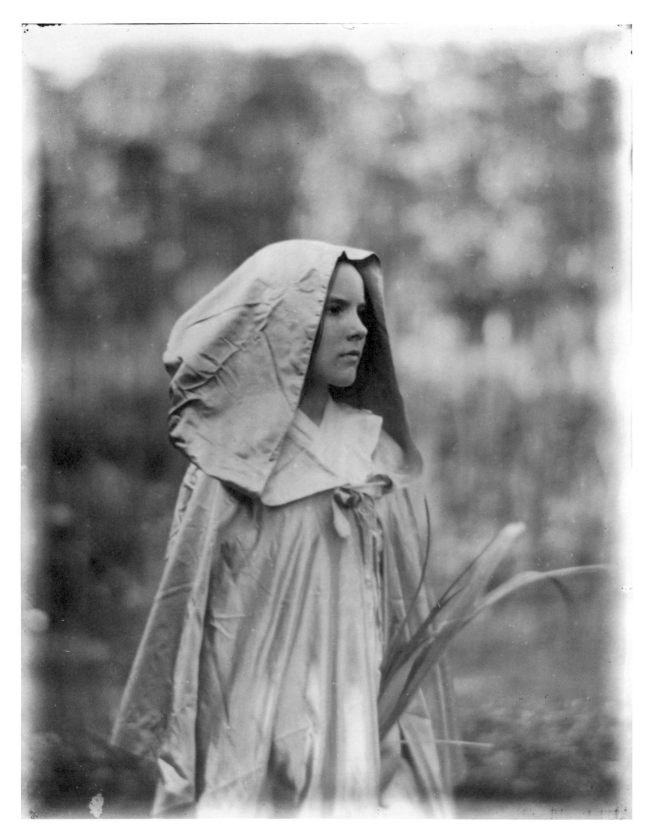

95. [Marjorie in Hooded Cape], circa 1907.

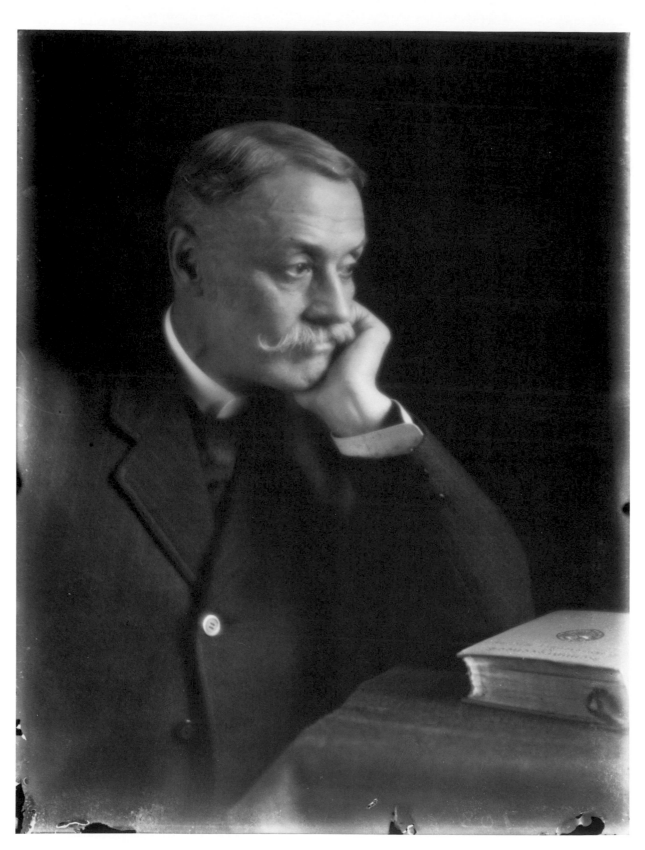

96.  J. Francke Rumsey, December 17, 1907.

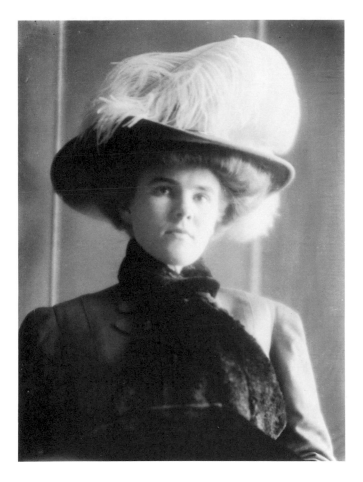

97. [Marjorie in Large Hat], circa 1908.

98. Richard in Long Overcoat, December 1909.

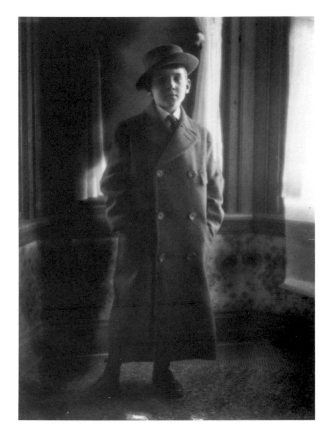

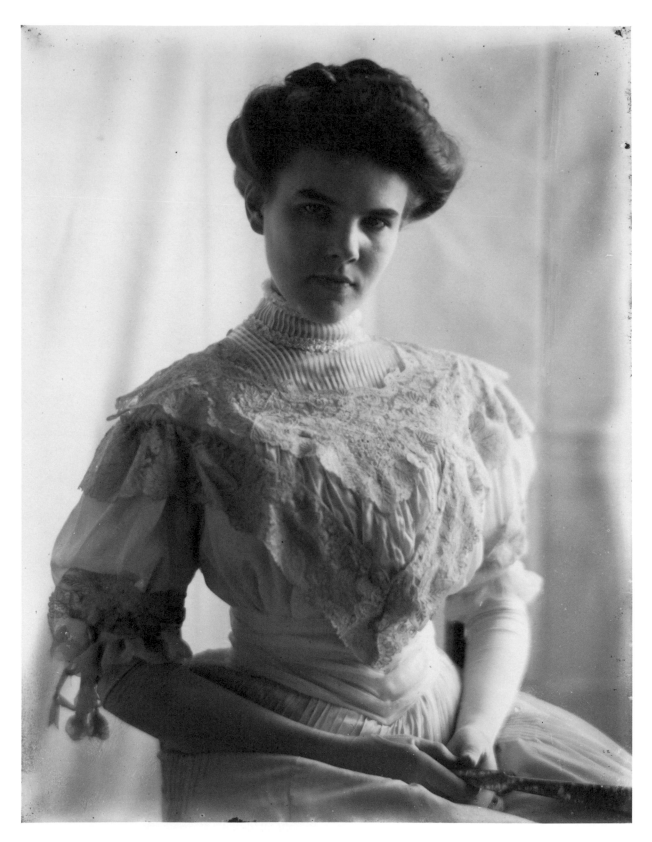

99.  [Marjorie], circa 1909.

100. Frances [Marjorie's daughter] with Sunbonnet,
September 1911.

101. R.H.D. Bullock, December 1911.

102. to 108. Natives of Pocono, circa 1911.

103.

104.

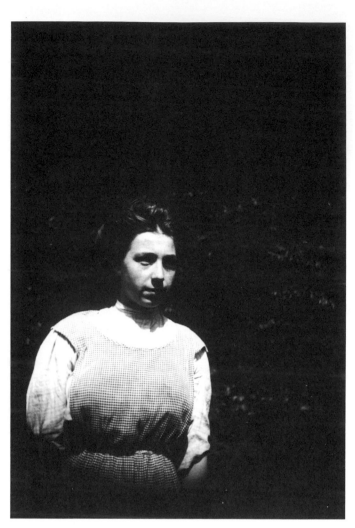

105.

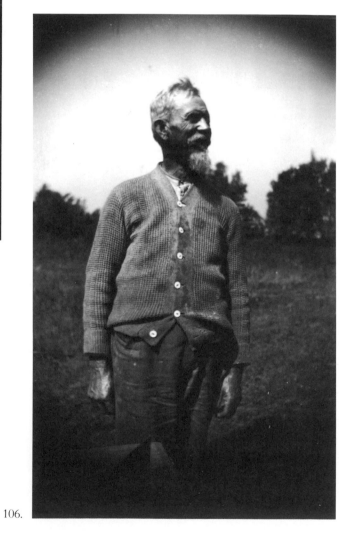

106.

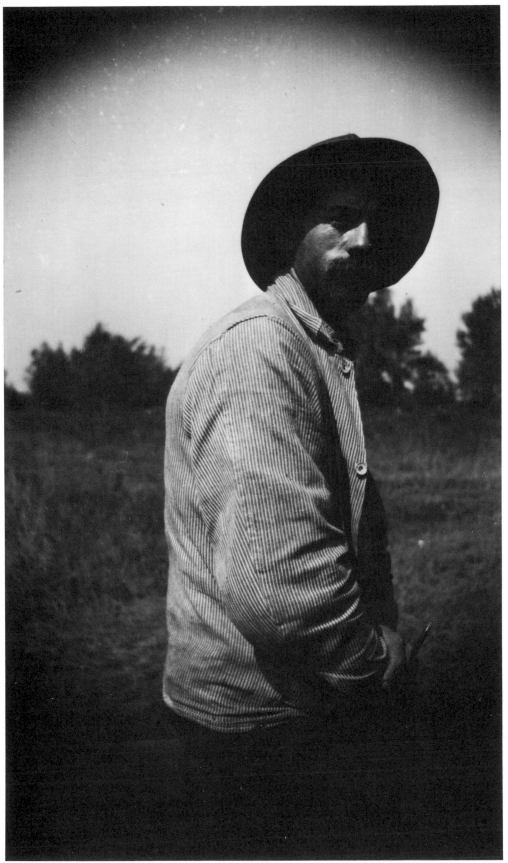

107.

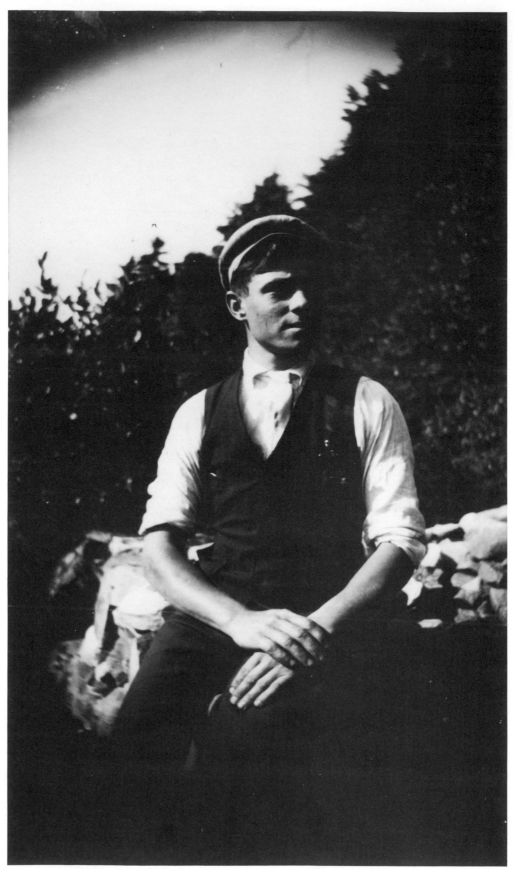

108.

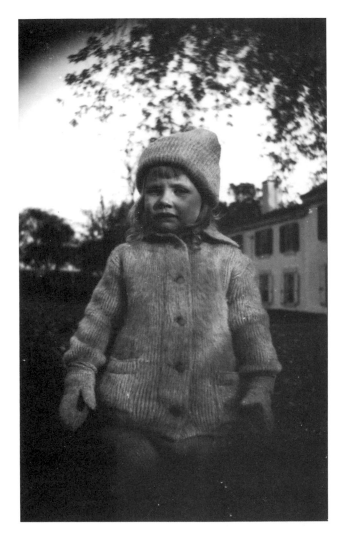

109. Frances, February 1912.

110. Marjorie & Children,
     circa 1912.

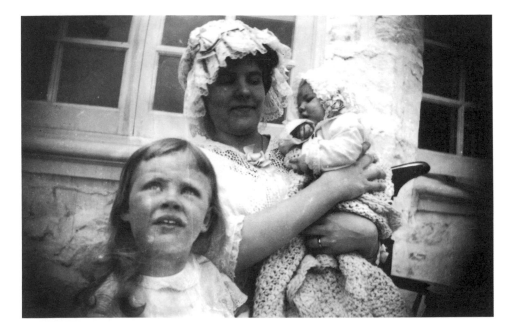

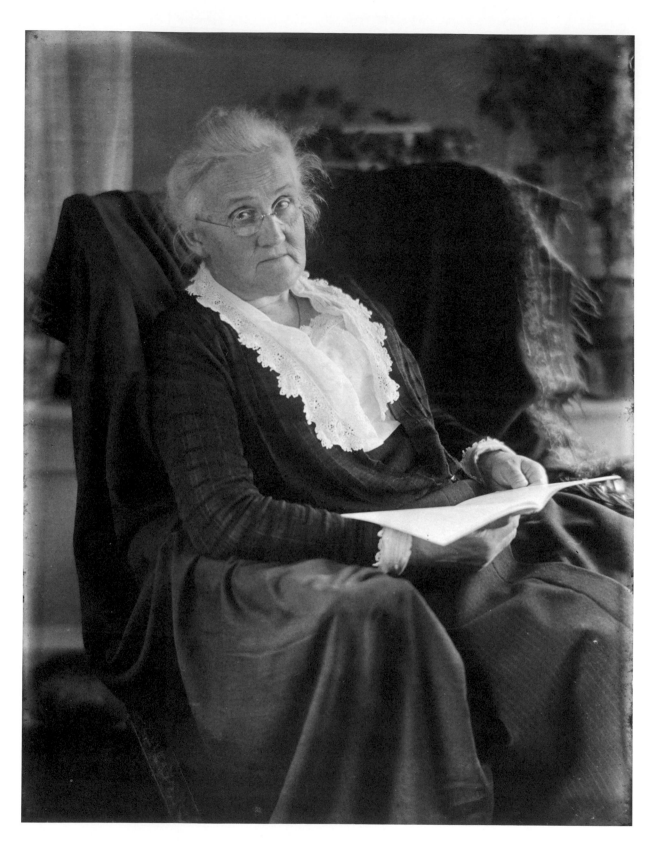

111. [Rebie Bullock], circa 1916.

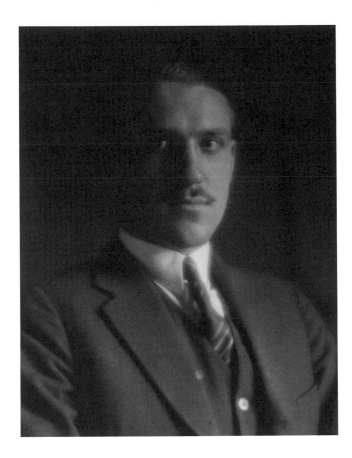

112. [Francke], circa 1916.

113. Richard H.D. Bullock, Age 15, December 1916.

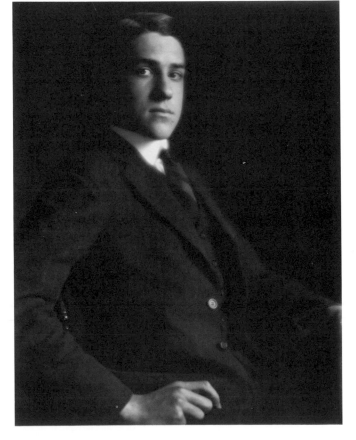

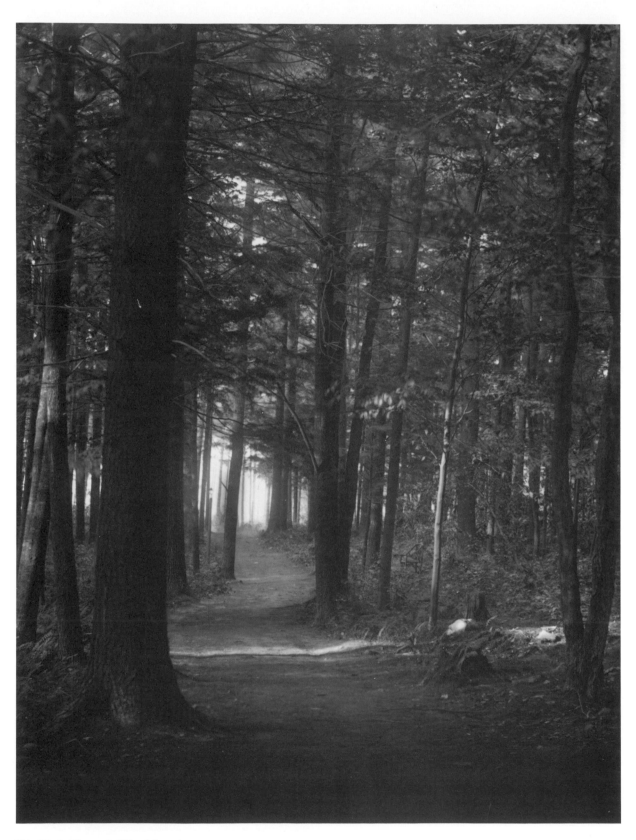

114. [Path Through Woods], n.d.

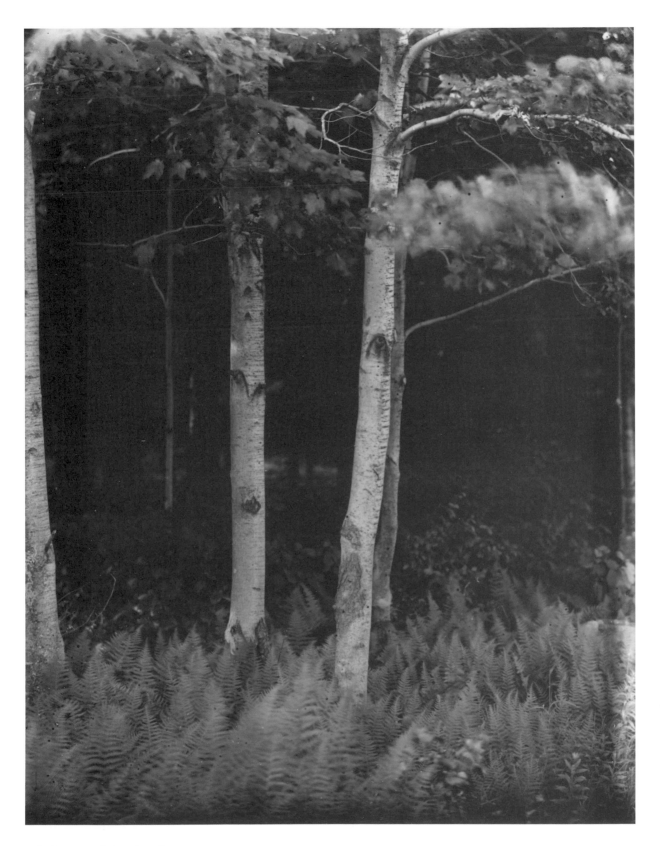

115. [Ferns and Trees], n.d.

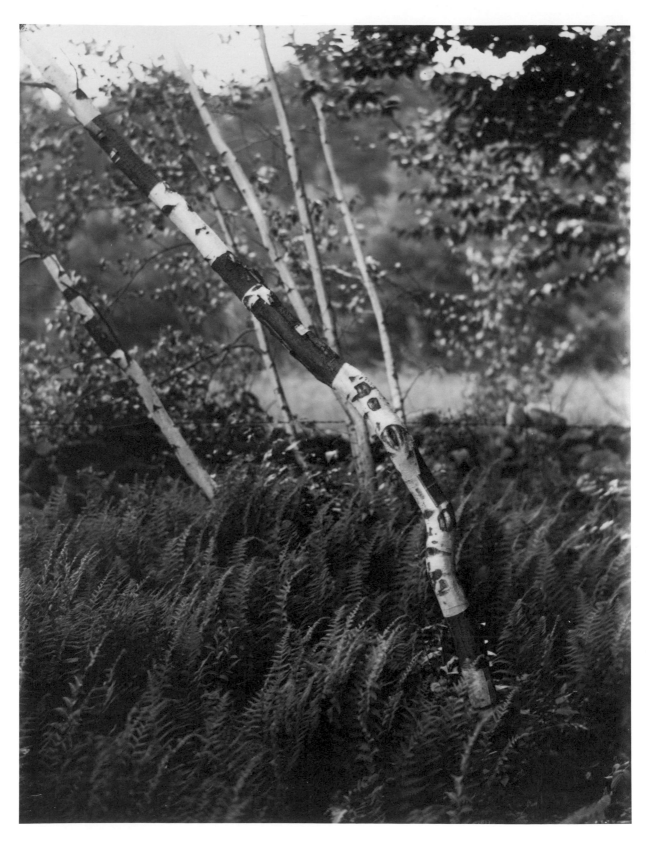

116.  [Ferns and Birches], n.d.

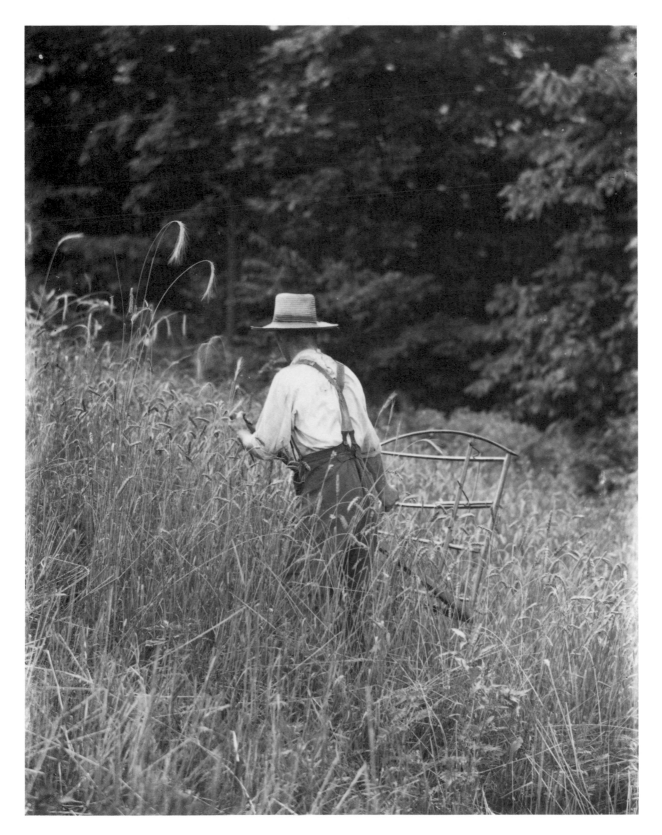

117. [Cutting Wheat], n.d.

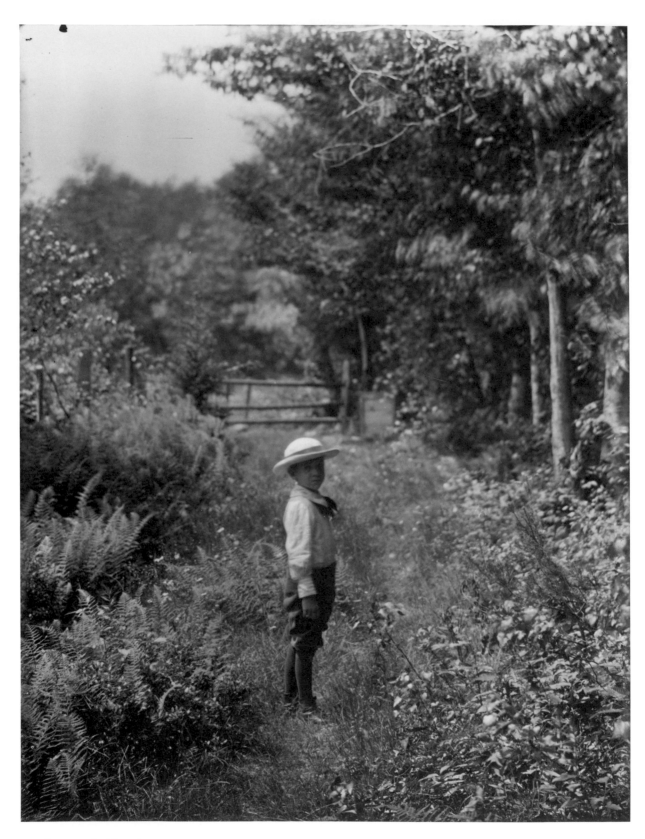

118. [Boy on Path], n.d.

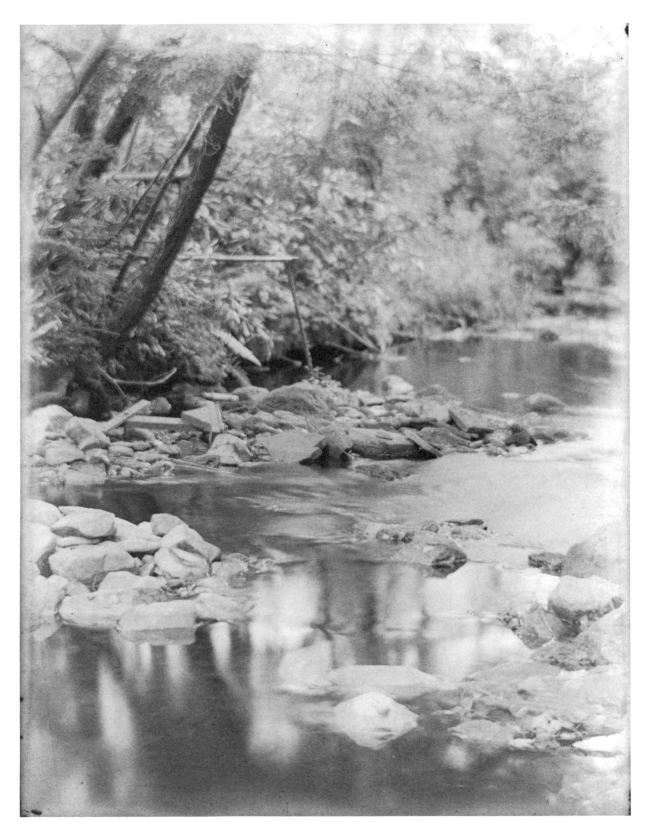

119. [Brook], n.d.

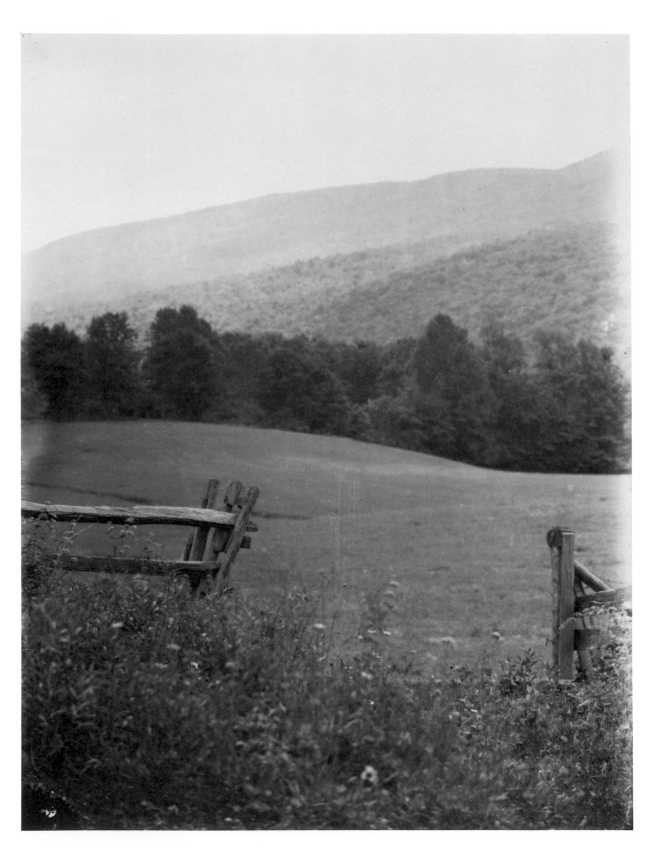

120. [Field and Hills], n.d.

121. [Portrait of an Elderly Man], n.d.

122. [Elderly Man with Microscope
and Flower], n.d.

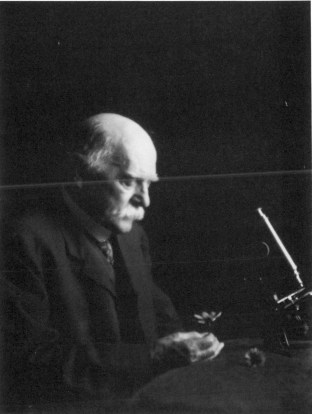

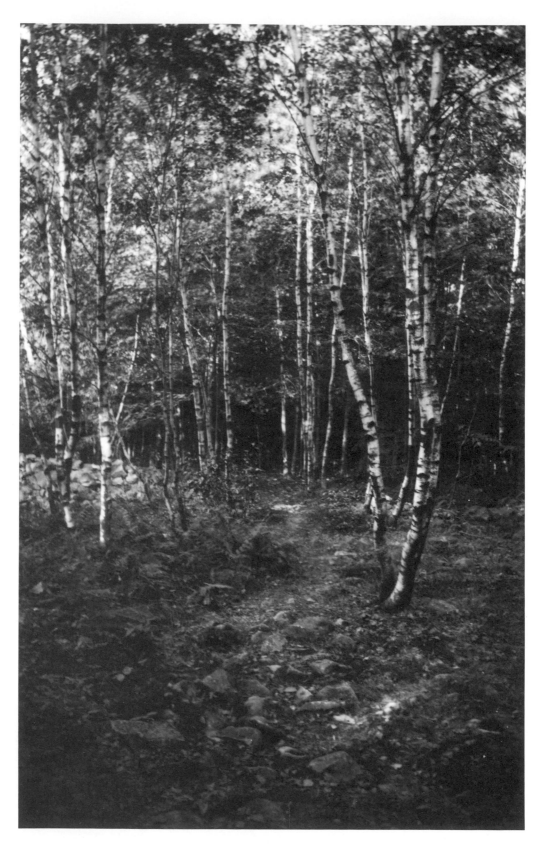

123. Pocono Pines, circa 1922.

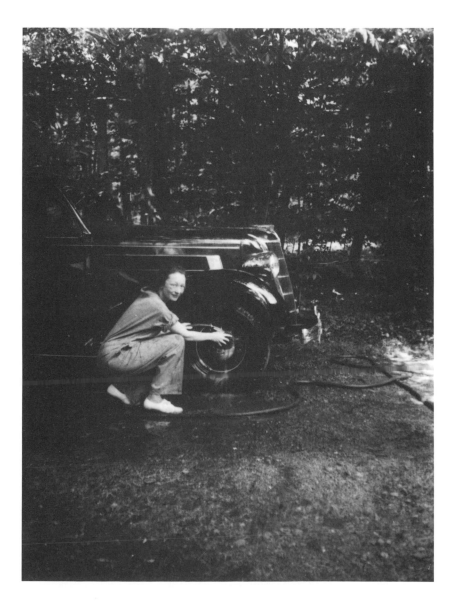

124. Car Wash, [Antoinette Bullock, Pocono Pines], 1935.

# *John G. Bullock's Family Tree*

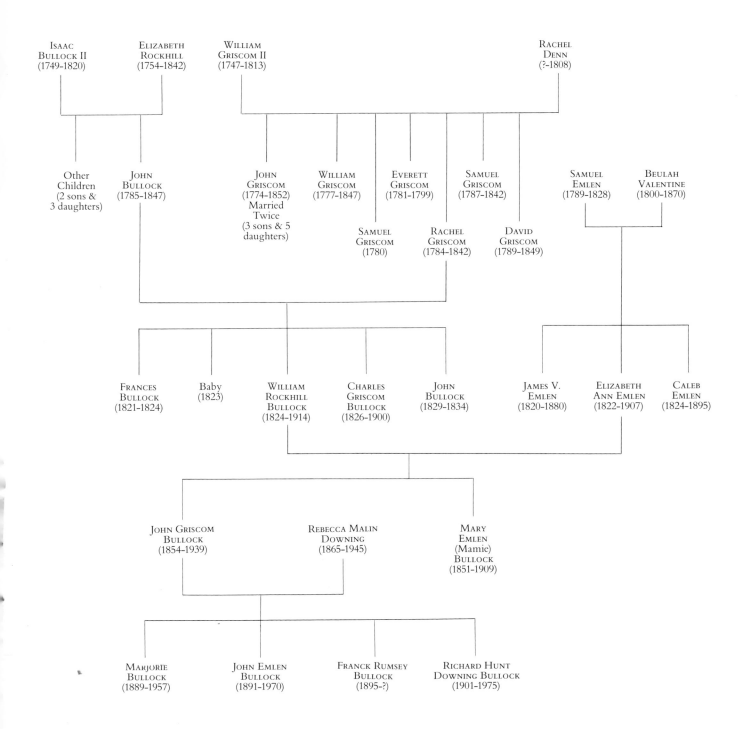

# Exhibitions of
# John G. Bullock's Photographs
# 1885-1939

| Date | Exhibition/Place | Photographs Shown and Awards (If Known) |
|------|------------------|------------------------------------------|
| 1885 | Second Annual Exhibition, Boston (Boston Salon) | |
| 1886 | International Exhibition of Photography, Philadelphia | Diploma |
| 1887 | First Annual Joint Exhibition, New York | Diploma for technical and artistic excellence |
| 1888 | Photographic Society of Philadelphia Members' Exhibition | Honor Picture |
| 1890 | Newcastle-upon-Tyne Exhibition, England | "On the Wawaset" <br> "Beech Trees at Moosehead"—Medal <br> "Moosehead from Kineo" <br> "The Farrier" <br> "Contemplation" <br> "Baby Mine" <br> "Lizzie Cocks (Thin Fan)" <br> "The Dolphin" <br> "Water Cart" <br><br> Additional Bronze Medal for Landscape |
| 1890 | Photographic Society of Philadelphia Competition | "Eastward As Far As the Eye Can See"—Prize <br> "At Anchol" |
| 1891 | Liverpool Exhibition | "Eastward As Far As the Eye Can See" <br> "In the Berkshire" <br> "Currents of the Restless Main" <br> "Along A Bypath" |
| 1891 | Aüsstellung Künstlerischer Photographien at Vienna | "On the Brandywine" <br> "Moosehead From Kineo" <br> "In the Berkshires" <br> "On a Virginia Turnpike" <br> "Far Away" <br> "A Bypath" <br><br> Grand Diploma |
| 1891 | Fourth Annual Joint Exhibition, New York | "Among the Berkshires" <br> "A Bypath" <br><br> **Special Merit Award** |

| | | |
|---|---|---|
| 1892 | Fifth Annual Joint Exhibition, Boston | "Eastward As Far As the Eye Can See"<br>"The Guernsey Herd"<br>"Low Tide at Turbot's Cove"<br>"Fahr Wohl"<br>"Old Drawbridge, Kennebunkport"<br>"The Shipyard, Evening"<br>Diploma |
| 1893 | Sixth Annual Joint Exhibition, Philadelphia | "An Inch Too Short"<br>"The Three Bears"<br>"Once Upon A Time"<br>"A Guernsey" |
| 1893 | Photographic Society of Philadelphia | Honor Picture Award |
| 1893 | London Salon | "Five Landscapes on the Upper Delaware"<br>"Bull-Burrough-Fox Falls (Factory, Dingman's Creek)"<br>"Boy on Fence"<br>"Fisher Boys"<br>"Harrowing"<br>"Boy in Road" |
| 1894 | Premiere Exposition d'Art Photographique, Photo-Club de Paris   (Paris Salon) | [Same prints as the London Salon]<br>"Boy on Fence"—Medal |
| 1894 | Photographic Society of Philadelphia, Competitive Exhibition of Members' Work | "Factory Falls"<br>"Boy on Fence"<br>"Fisher Boys"<br>"Harrowing"—Medal<br>"Boy in Road"<br>"JGB in Road" |
| 1894 | Seventh Annual Joint Exhibition, New York | [Same prints as the Photographic Society of Philadelphia Competitive Exhibition] |
| 1894 | Newcastle-upon-Tyne Exhibition, England | [Same prints as the Paris Salon] |
| 1895 | Fortieth Royal Photographic Society Salon | "Shadows Dark & Sunlight Sheen"<br>"Humble Home"<br>"Marsh Lane"<br>"Early Morning on the Meadow" |
| 1895 | Second Paris Salon | |
| 1895 | Hendrick Art Gallery, Exhibition of the Timmins Collection, Syracuse, New York | "Shadows Dark & Sunlight Sheen"<br>"On the Brandywine" |
| 1897 | Tennessee Centennial Exposition, Nashville | |
| 1898 | Photographic Society of Philadelphia | "Children of Eve"<br>"Country Store"<br>"Landscape" |
| 1898 | Paris Salon | "Lines in Pleasant Places"<br>"Cattle on Road"<br>"Glimpse of the Stream"<br>Medal |
| 1898 | Philadelphia Salon | "Lines in Pleasant Places"<br>Certificate |

| 1898 | Photographic Society of Philadelphia Members' Exhibition | "Lines in Pleasant Places"<br>"Cosmos"<br>"Child Study"<br>"Glimpse of the Stream"<br>"Corn Field" |
|------|----------|----------|
| 1899 | Carnegie Art Galleries, Second Annual International Salon and Exhibition, Pittsburgh Amateur Photographer's Society | "Cosmos"<br>"Child Study" |
| 1899 | London Salon | "Road With Cattle"<br>"Alfred" |
| 1899 | Second Philadelphia Salon | "Road With Cattle"<br>"Alfred" |
| 1900 | Royal Photographic Society, "New School of American Photography" Exhibition | 'The Brook"<br>"'Brothers' (John & Francke Reading)"<br>"Pine Tree on Moosehead (The Cliff)"<br>"Mountain Top (Evening Mist)" |
| 1900 | Chicago Salon | "Tree Study"<br>"The Coke Burner" |
| 1900 | Third Philadelphia Salon | [Same prints as the Chicago Salon] |
| 1900 | Glasgow International Salon | "The Coke Burner" |
| 1900 | Newark (Ohio) Exhibition | "The Coke Burner"<br>"Tree Study"<br>"Road With Cattle" |
| 1901 | Photographic Society of Philadelphia Members' Exhibition | "Farm Team"<br>"The Brook"<br>"Loading Hay"<br>"Road Study (Landscape) at Summit, Pa." |
| 1901 | New York Camera Club Exhibition of Work from the Photographic Society of Philadelphia | "The Brook"<br>"Loading Hay" |
| 1901 | London Salon | "The Coke Burner" |
| 1901 | New York Camera Club Exhibition of Bullock, Redfield, and Stirling | Thirty-three prints |
| 1901 | Glasgow International Salon | |
| 1901 | Photo-Club de Paris, "New School of American Photography" Exhibition | [Same prints as the Royal Photographic Society Exhibition, 1900] |
| 1902 | National Arts Club Exhibition of "American Pictorial Photography" Arranged by the Photo-Secession | "The Coke Burner"<br>"The White Wall" |
| 1902 | Esposizione Internationale di Arte Decorativa Moderna, Turin, Italy | "The Coke Burner" |
| 1902 | London Salon | "The White Wall"<br>"Lake Craft" |
| 1903 | Photo-Secession Exhibition at the Denver Camera Club Salon | "The White Wall"<br>"Landscape. Trees & Clouds" |
| 1903 | Photo-Secession Exhibition at the Cleveland Camera Club | [Same prints as the Denver Camera Club Salon] |

| 1903 | Photo-Secession Exhibition at the Hamburg Jubilee, Germany | "Music Box" "On Beach" Three "Landscapes" |
|------|------|------|
| 1903 | Photo-Secession Exhibition at Cercle Photographique ("L'Effort") Brussels | "The White Wall" |
| 1903 | Photo-Secession Exhibition at the St. Petersburg (Russia) International Art Exhibition | [Same print as the Brussels Exhibition] |
| 1903 | San Francisco Salon | |
| 1903 | Photo-Secession Exhibition at the Paris Salon | "The White Wall" Medal |
| 1903 | Photo-Secession Exhibition at the Chicago Salon | "Landscape" "Music Box" "Landscape. Trees & Clouds" "On the Beach in Mist" |
| 1904 | Photo-Secession Exhibition at the International Art Exhibition, Bradford, England | |
| 1904 | Photo-Secession Exhibition at The First International Photographic Salon, The Hague | |
| 1904 | Photo-Secession Exhibition at the Corcoran Gallery of Art, Washington, D.C. | |
| 1904 | Photo-Secession Exhibition at the Pittsburgh Salon | |
| 1904 | London Salon | "Mist on Beach" "Landscape (Tulpehocken Trees & Cloud Effect)" |
| 1905 | Exhibition of Members' Work, Little Galleries of the Photo-Secession, New York | "Stubble Field" |
| 1905 | London Salon | |
| 1905 | VII Ausstellung Das Wiener Photo-Klub | |
| 1906 | An Exhibition of Photographs Arranged by the Photo-Secession at the Pennsylvania Academy of the Fine Arts | |
| 1907 | Exhibition of Members' Work, Little Galleries of the Photo-Secession, New York | |
| 1909 | London Salon | |
| 1910 | Albright Art Gallery International Exhibition of Pictorial Photography | "Monuments and Sand" "The White Wall" "The Tree, Landscape" |
| 1938 | West Chester, Pennsylvania (?) | |

# Select Bibliography

## Publications Written or Edited By John G. Bullock

*The Bud.* Vol. XV, No. IV (October 1872) - Vol. XVI, No. I (January 1873).

Bullock, John G. *The City Journal.* Vol. 2, No. 5 (March 11, 1867) - Vol. 3, No. 9 (April 9, 1868).

_____. Diary. 1867-1882. John G. Bullock Papers. Richard H.D. and Sandra Leaf Bullock.

_____. Notebook. "Historical Germantown." The Germantown Historical Society, Philadelphia. c.1915.

*Haverfordian.* 1875, pp. 13-14.

*Jolts and Scrambles or "We Uns and Our Doin's."* Philadelphia: Privately Printed, 1884.

*'O Tettic.* 1874, p. 4.

*The Quaker Alumnus.* Vol. 1, No. 1 (July 1878) - Vol. 1, No. 4 (April 1879).

## General Publications

*The American Amateur Photographer.* Vol. III (March 1891) - Vol. XVI (April 1902).

Bacon, Margaret H. *The Quiet Rebels: The Story of the Quakers in America.* New York: Basic Books, 1969.

Baigell, Matthew. *A History of American Painting.* New York: Praeger, 1971.

Brey, William. *John Carbutt on the Frontiers of Photography.* Cherry Hill, New Jersey: Willowdale Press, 1984.

Browne, John C. *History of the Photographic Society of Philadelphia.* Philadelphia: Photographic Society of Philadelphia, 1884.

Burt, Nathaniel and Wallace E. Davies. "The Iron Age, 1876-1905." *Philadelphia: A 300 Year History.* Ed. Russell F. Weigley. New York: Norton, 1982. pp. 471-523.

*Camera Notes.* Vol. I (July 1898) – Vol. VI (October 1902).

*Camera Work.* Vol. I (January 1903) – Vol. XLIX-L (July 1917).

Carr, Gerald L. *Frederick Edwin Church: The Icebergs.* Dallas: Dallas Museum of Fine Arts, 1980.

Clark, Dennis. "Philadelphia 1876: Celebration and Illusion." *Philadelphia: 1776-2076, A Three Hundred Year View.* Port Washington, New York: Kennikat Press, 1975. pp. 41-63.

A Committee of the Alumni Association. *Biographical Catalog of the Matriculates of Haverford College.* Philadelphia: The Alumni Association, 1922.

Committee on Historical Volume. *The First Century of the Philadelphia College of Pharmacy 1821-1921.* Ed. Joseph W. England. Philadelphia: Philadelphia College of Pharmacy and Science, 1922.

Darrah, William Culp. *Stereo Views: A History of Stereographs in America and Their Collection.* Gettysburg: Times and News Publishing Co., 1964.

Doty, Robert. *Photo-Secession: Photography as Fine Art.* Rochester: George Eastman House, 1960.

Elliott, Clark A. *Biographical Dictionary of American Science: The Seventeenth Century Through the Nineteenth Centuries.* Westport, Connecticut: Greenwood Press, 1979. pp. 110-111.

Goodrich, Lloyd. *What Is American in American Art.* New York: Clarkson N. Potter, 1971.

Griscom, John. "A Year In Europe." *Reports On European Education.* Ed. Edgar W. Knight. New York: McGraw-Hill, 1930. pp. 16-111.

Hallmark, Harrydele. "Possibilities of the Camera." *The Philadelphia Press.* Vol. XVI (November 13, 1898), Second Part, p. 17.

Harker, Margaret. *Henry Peach Robinson: Master of Photographic Art 1830-1901*. Oxford: Basil Blackwell, 1988.

_____. *The Linked Ring*. London: Heineman, 1979.

Hills, Patricia. *Eastman Johnson*. New York: Clarkson Potter, 1972.

Homer, William Innes. *Alfred Stieglitz and the Photo-Secession*. Boston: Little, Brown, 1983.

_____, with contributions by Mark Aronson, Anne B. Fehr, Susan Isaacs, Marguerite McLaughry. *Pictorial Photography in Philadelphia: The Pennsylvania Academy's Salons*. Philadelphia: Pennsylvania Academy of the Fine Arts, 1984.

Huntington, David C. *The Landscapes of Frederic Edwin Church*. New York: George Braziller, 1966.

*International Exhibition. 1876 Official Catalogue*. Revised ed. Philadelphia: John R. Nagle, 1976. p. 102.

Jenkins, Charles F. *The Guidebook to Historic Germantown*. Germantown: Site & Relic Society, 1915.

Jones, Howard Mumford. "The Renaissance and American Origins." *Ideas in America*. Cambridge, Massachusetts: Harvard University Press, 1945. pp. 140-151.

Jones, Rufus M. *Haverford College: A History and An Interpretation*. New York: Macmillan, 1933.

*Journal of the Photographic Society of Philadelphia*. Vol. I (January 1893) – Vol. VIII (December 1902).

Jussim, Estelle. *Slave to Beauty: The Eccentric Life and Controversial Career of F. Holland Day, Photographer, Publisher, Aesthete*. Boston: D.R. Godine, 1981.

Lowe, Sue Davidson. *Stieglitz: A Memoir/Biography*. New York: Farrar, Straus, Giroux, 1983.

Maass, John. "Preface, The Centennial Success Story." *1876 A Centennial Exhibition*. Ed. Robert C. Post. Washington, D.C.: The National Museum of History and Technology, 1976, pp. 11-23.

Mallet, J.W. "General Report of the Judges of Group III." *International Exhibition, 1876. Reports and Awards*. Ed. Francis A. Walker. 8 vols. Washington, D.C.: Government Printing Office, 1880. Vol. IV, p. 279.

McCoubrey, John W. *American Tradition in Painting*. New York: George Braziller, 1963.

"Minutes and Proceedings of the Chester County Historical Society." Manuscript. 1923-1939. Chester County Historical Society, West Chester, Pennsylvania.

"Minutes Photographic Society of Philadelphia April 18, 1878—." Sipley Collection. International Museum of Photography at George Eastman House, Rochester, New York.

Moll, Clarence Russell. "A History of Pennsylvania Military College—1821-1954." Ph.D. dissertation, New York University, 1954. pp. 18-26.

Moore, Clarence B. "Leading Amateurs in Photography." *Cosmopolitan* 12 (February 1892). pp. 420-433.

Morgan, H. Wayne, ed. *The Guilded Age*. Revised ed. Syracuse: Syracuse University Press, 1970.

Naef, Weston J. *The Collection of Alfred Stieglitz: Fifty Pioneers of Modern Photography*. New York: The Metropolitan Museum of Art/The Viking Press, 1978.

Newhall, Nancy. *P.H. Emerson: The Fight for Photography as a Fine Art*. New York: Aperture, 1975.

*The National Cyclopedia of American Biography*. Vol. IX, XI. New York: James T. White, 1909; Ann Arbor: University Microfilms, 1967.

Nicholson, Frederick J. *Quakers and the Arts*. London: Friends Home Service Committee, 1968.

Norman, Dorothy. *Alfred Stieglitz: An American Seer*. New York: Random House, 1973.

Paley, William. *A View of the Evidences of Christianity*. New York: James Miller, 1869.

Panzer, Mary. *Philadelphia Naturalistic Photography 1865-1906*. New Haven: Yale University Art Gallery, 1982.

*Pennsylvania Academy of the Fine Arts. Ninety-Third Annual Report*. Philadelphia: Pennsylvania Academy of the Fine Arts, 1900.

*Philadelphia Evening Item*. Vol. 54 (November 19, 1900), p. 1.

*Philadelphia Photographer*. Vol. XIX, No. 220 (April 1882) – Vol. XXV, No. 324 (June 1888).

*The Philadelphia Press*. Vol. XLI (November 13, 1898), p. 17.

*The Photographic Times and American Photographer*. Vol. 14 (November 1884) – Vol. XX (May 1890).

*The Photo-Secession*. Vol. 1 (December 1902) – Vol. 7 (June 1909).

Pisano, Ronald G. *William Merritt Chase in the Company of Friends*. Southampton, New York: The Parrish Art Museum, 1979.

Robinson, Henry Peach. *Pictorial Effect in Photography*. London: Piper and Carter, 1869; Pawlet, Vermont: Helios, 1971.

Stebbins, Robert A. *Amateurs: On the Margin Between Work and Leisure*. Beverly Hills and London: Sage Publications, 1979.

Timmins, William D. and Robert W. Yarrington, Jr. *Betsy Ross: The Griscom Legacy*. Woodstown, New Jersey: The Salem County, N.J. Cultural and Heritage Commission, 1983.

Vogel, Robert M. "Steam Power." *1876 A Centennial Exhibition*. Ed. Robert C. Post. Washington, D.C.: The National Museum of History and Technology, 1976. pp. 29-33.

Weaver, Mike. *Alvin Langdon Coburn: Symbolist Photographer 1882-1966*. New York: Aperture, 1986.

Weir, John F. "Group XXVII. Plastic and Graphic Art." *International Exhibition, 1876. Reports and Awards*. Ed. Francis A. Walker. 8 vols. Washington, D.C.: Government Printing Office, 1880. Vol. VII, pp. 608-716.

Wilmerding, John. *American Art*. New York: Penguin Books, 1976.

Wilson, Richard Guy, Diane H. Pilgrim, and Richard N. Murray. *The American Renaissance 1876-1917*. New York: The Brooklyn Museum, 1979.

# Index

Designed by Gerard A. Valerio

Composed in Bembo and Centaur by Composition Systems, Inc., Falls Church, Virginia

Printed and bound by the John D. Lucas Printing Company, Baltimore, Maryland